FORMULA ONE
THE CHAMPIONS

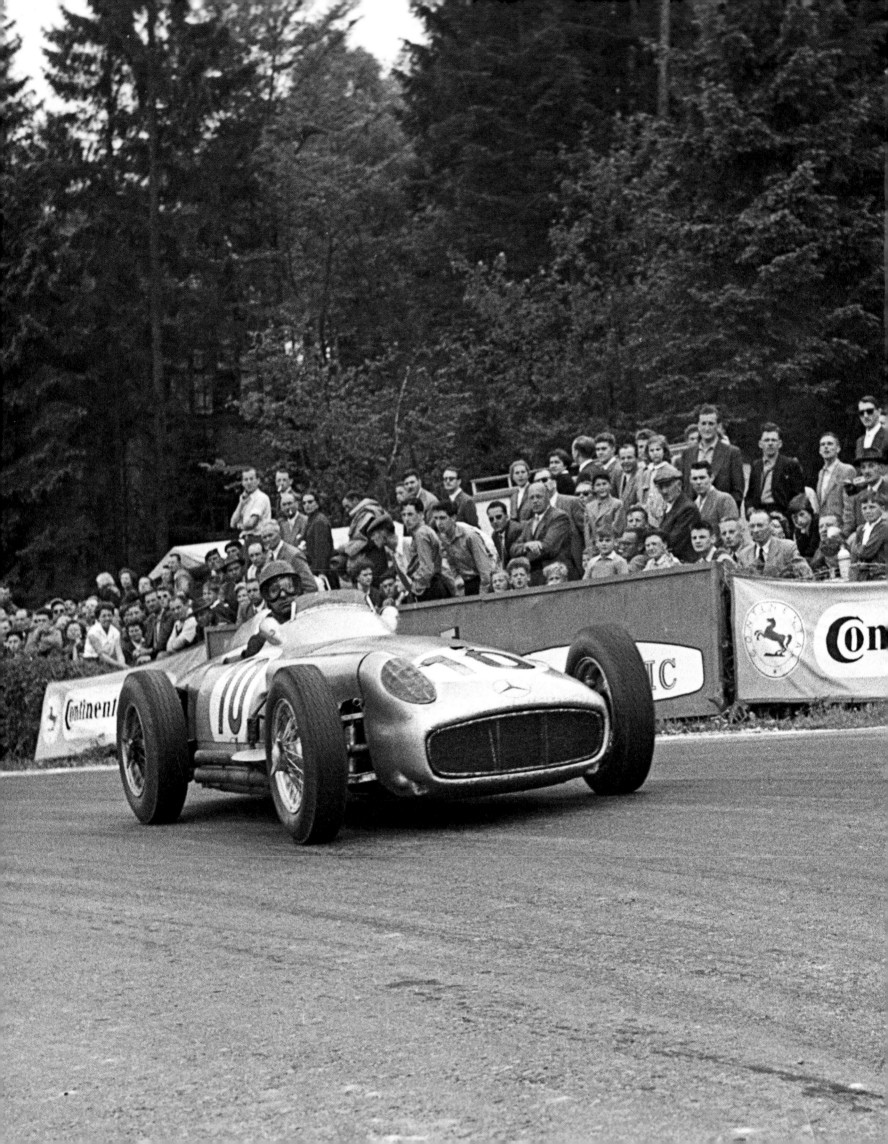

Maurice Hamilton

Photographs by
Bernard & Paul-Henri Cahier

Foreword by Bernie Ecclestone

FORMULA ONE
THE CHAMPIONS
THE LEGENDARY DRIVERS OF F1

WHITE
LION
PUBLISHING

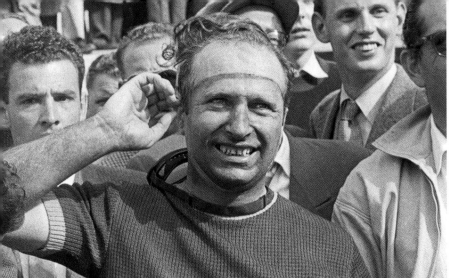
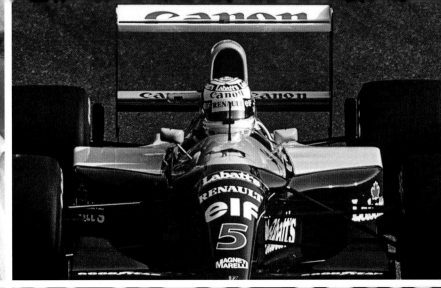

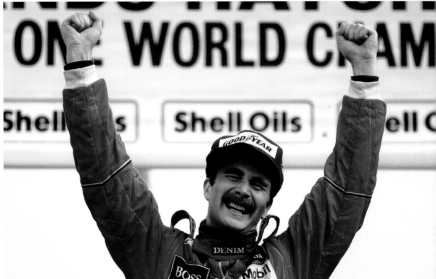
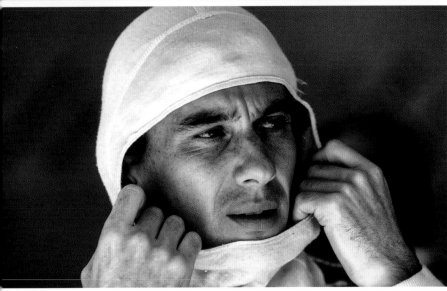
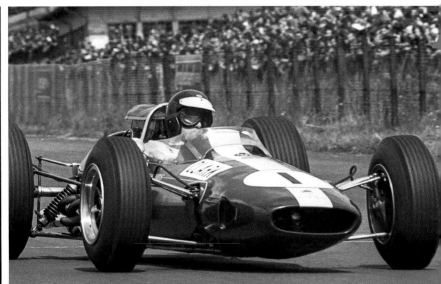

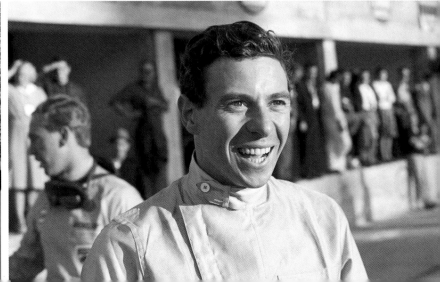

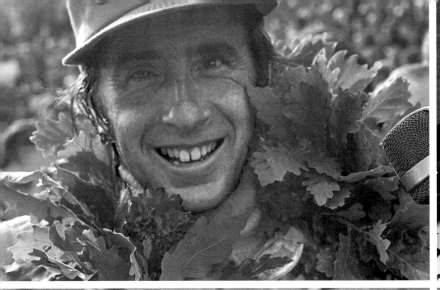

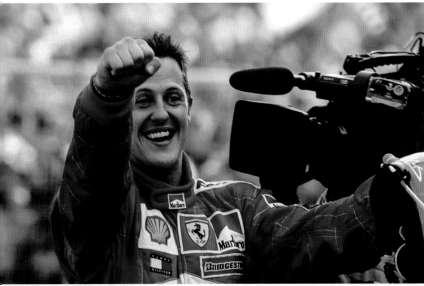

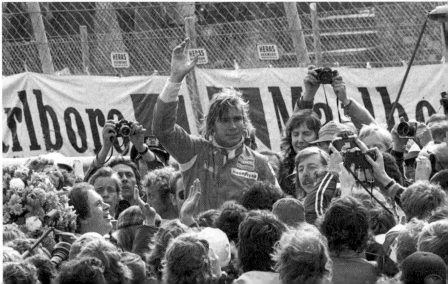

Contents

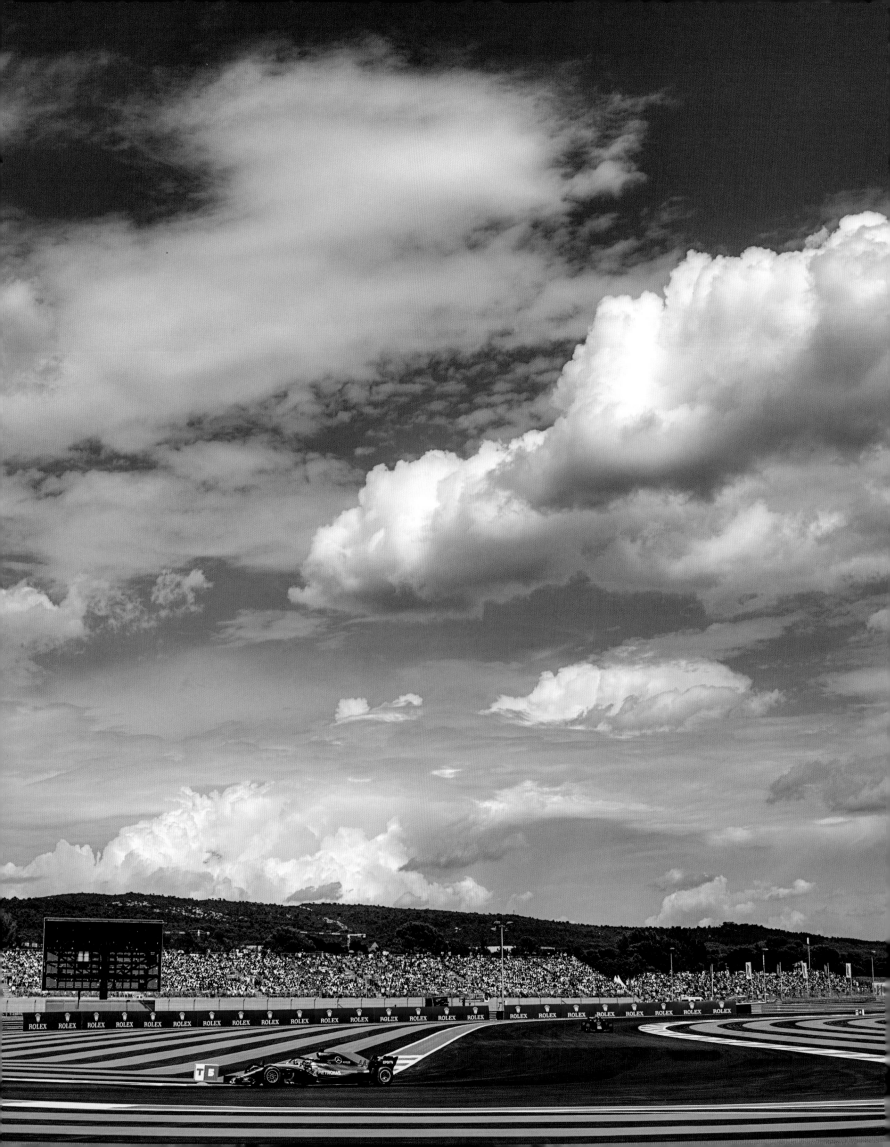

Foreword
Bernie Ecclestone

Seeing every Formula 1 World Champion gathered together in this book reminds me that, one way or another, I knew them all.

I've obviously known some better than others. In fact, I'd say from Jack Brabham on, I'd call them all 'mates'. That's what our relationship was about. I can honestly say I never fell out with any of them, not even the champions who drove for me when I ran the Brabham team.

And when I was running Formula 1, there was never an occasion when I asked any of them to do something that they didn't go on and do without making a fuss – or asking for lots of money to do it! If I asked them to go to South Africa or somewhere, they'd say: 'We'll find time'. There would be no dispute or lengthy negotiation.

You might be surprised to learn that I don't think the reigning World Champion, whomever he might have been, was that important from my point of view running Formula 1. I draw the parallel with Ferrari. As far as I was concerned in business, Ferrari was worth more if someone else was winning. I'd rather have Ferrari not winning a World Championship for 10 years than some teams winning the championship every year. It's the same with drivers; for me, it was the individuals and their particular characters that counted rather than simply being the reigning champion.

I don't think you could really say that winning was the single most important thing in the lives of any these champions. They wanted to win – obviously – because that's why they do it. But it wasn't the be-all-and-end-all. Anyone who competes in business – any business – wants to do a good job; to be the best in their particular field. They're competitive. And all of these World Champions are exactly the same.

Some were better than others at, say, getting the whole team around them, or being technically brilliant, or even being super quick drivers. But they were united by being very competitive and extremely astute.

A few of them were prepared to give up a lot more than others to be World Champion. Some, particularly those drivers not quite as naturally gifted as their rivals, were prepared to do things that perhaps they didn't particularly want to do because they knew it was part of what was needed. That's what made them stand out.

Each driver was different and appealed for different reasons. Fangio, for example, is one of the very few drivers of whom I have a framed photo in my office; I knew him very well; he was a proper guy. Graham Hill drove for me but I wasn't as close to Jim Clark as I was with many of the others such as, say, James Hunt. I managed Jochen Rindt and that automatically made that relationship very special and different from the rest.

When people ask me who was the best driver, I always say Alain Prost. It's not that I particularly liked Alain in the sense of someone you would be close to. But he could have won even more championships than the four he has to his name. It was the way he drove. From the moment the race started, he would be out on his own, looking after the brakes, the tyres, the gearbox, whatever. He'd bring the car home. You almost didn't notice him out front, doing the job. I always thought he was the best.

But we're splitting hairs. The fact is that every single driver in this book delivered when it mattered. They're very special people and it's been a privilege to have known them.

Introduction

The Formula 1 Drivers' World Championship is the ultimate accolade in motor sport. Thirty-four men have been bestowed with the title since its introduction in 1950. These individual characters of widely differing classes and creeds may have been shaped by fourteen nationalities but every World Champion has been united by a singular determination to maximise a very special skill. The fact that such relentless resolve and thrilling talent had to be maintained across an entire season has helped elevate each driver into a pantheon of sporting achievement that sets them apart from the rest.

That is not to say that other drivers were less deserving; merely that this select group worked the demanding and diverse circumstances to best advantage. Their stories, gathered within the covers of this book, may vary greatly but the end result was always the same: recognition as the top driver in the world, regardless of how the accolade was achieved.

Debate has raged – and will doubtless continue to fulminate for another seventy years – over which driver is the best of the best. It is impossible to say. But that will not deter energetic and informed discussion, usually predicated on a personal preference swayed by affection.

Such feelings of fondness are inevitable in a sport providing a platform for breath-taking ability that is played out against a potentially hazardous backdrop. Motor racing, through its wheel-to-wheel high-velocity environment, frequently gives virtuosity an extra edge. Each of these champions will have experienced and delivered that pulse-raising dynamic many times over. This collection of pen portraits will hopefully help you choose which one best meets your criteria and preferences.

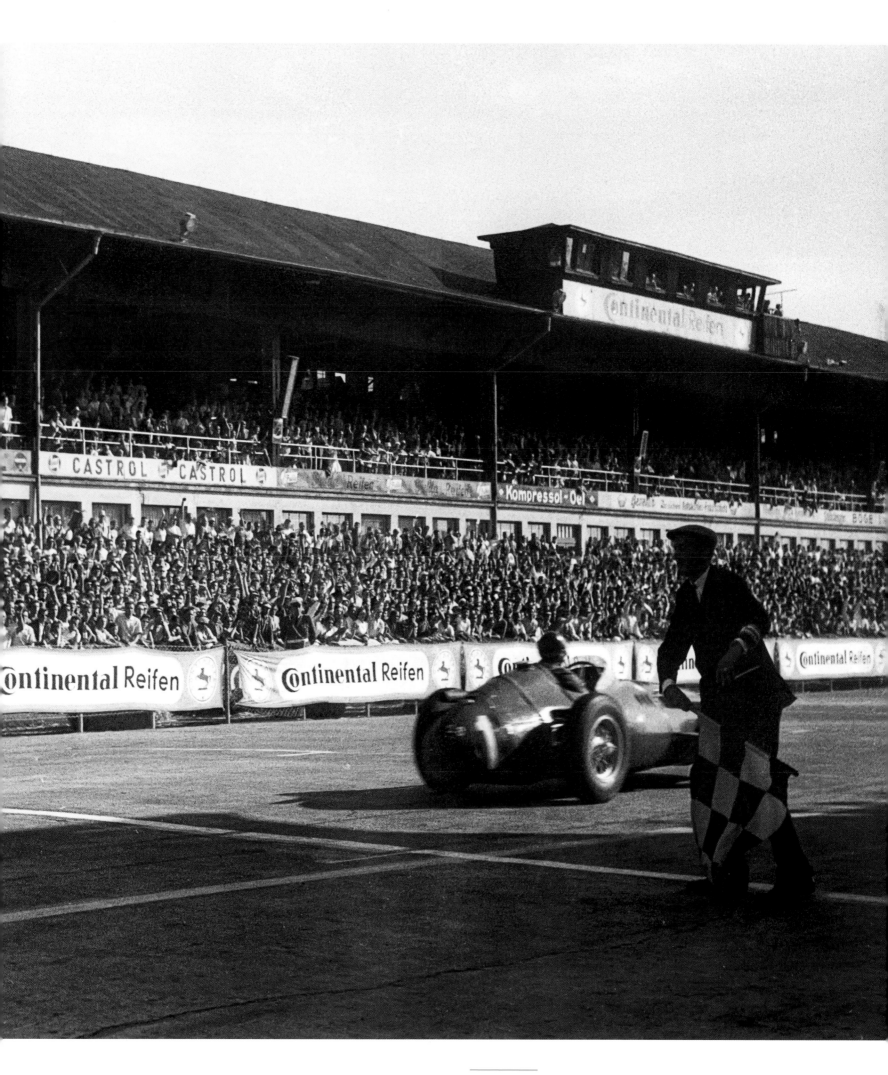

'For any driver, you want to win anything you compete in – but the World Championship is the ultimate goal. It means greatness – but not just for the driver; it's for you and your team. It's an overwhelming moment when you finally do it. You suddenly think about so many things; the sacrifices that have been made; the support from your family; about what this means to so many people. And then it begins to sink in: Yes! You're World Champion!'

Lewis Hamilton

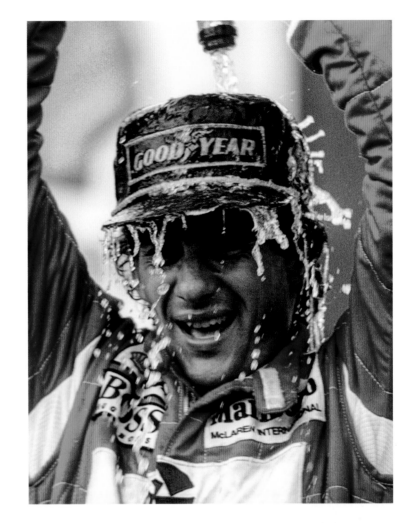

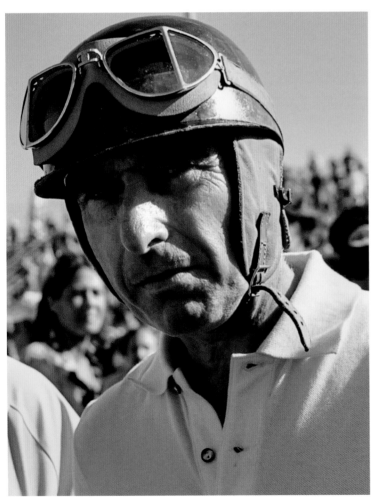

The final official arbiter each season is a collection of points, the man with the most being declared World Champion despite his closest rival perhaps being perceived to have done more for less. The bottom line is nevertheless absolute in terms of the record book and nullifies argument over the influence of running and deciding championships in different ways across seven decades.

The cars in the 1950s were slower, but the races lasted longer. Today's Grands Prix will be over in half the time, but there are more of them. A contemporary driver has a significantly increased chance of seeing the chequered flag rather than the inside of a hospital – or worse. In the early days, competitors could score points even if they shared cars, an impossibility – assuming it were allowed – with current cars that are shaped around each driver like some shrink-wrapped carbon crusader.

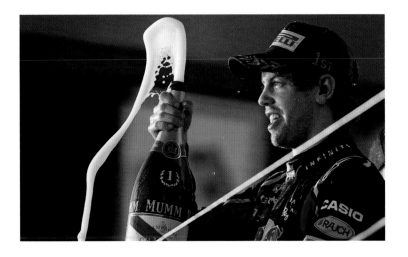

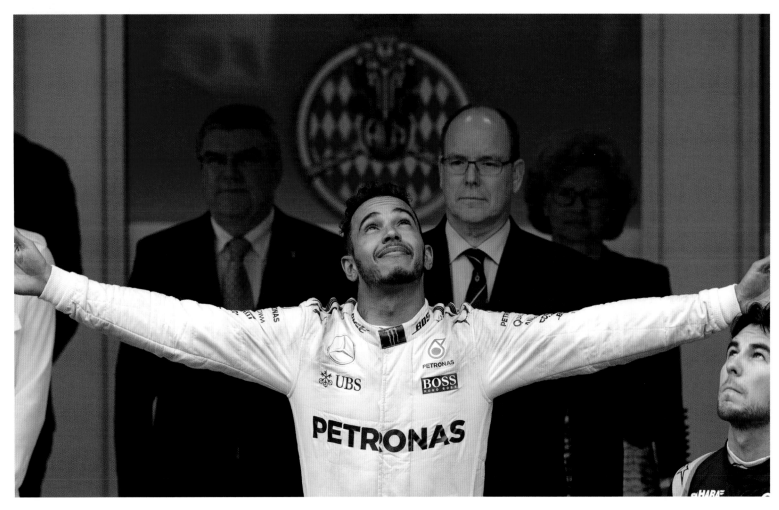

Opposite top Ayrton Senna, a charismatic three-time World Champion, greatly admired his fellow South American, Juan Manuel Fangio (*opposite bottom left*)

Opposite bottom right Michael Schumacher raised the bar, seemingly beyond reach, with seven World Championships and 91 victories

Left Sebastian Vettel became the youngest World Champion at the age of 23 when he won the first of four titles in 2010

Below That winning feeling. Lewis Hamilton experienced it more than 80 times, including the Monaco Grand Prix in 2016

Eight points were awarded to the winner in 1950; today's victor receives over three times as many. Not every race counted during certain periods in the past; now every Grand Prix has points parity across an entire season. Juan Manuel Fangio won his final World Championship in 1957 at the age of forty-six; Sebastian Vettel was half that age when he won his first in 2010. Michael Schumacher set a record with thirteen Grand Prix wins in 2004; Mike Hawthorn and Keke Rosberg each won the title with just one victory in 1958 and 1982 respectively.

Different days; but the same aim. Different drivers; but each one a champion.

Words can only achieve so much when describing this intriguing variation across more than a thousand races. Bernard Cahier and his son, Paul-Henri, bring period depth to this narrative through frequently intimate and consistently revealing work that elevates the subject to a form of automotive art. Their lenses have captured images that sum up each driver in an instant and expose his character as well as the unique world in which he worked.

This evocative selection from the Cahier archive spans vastly different decades and yet unites them because of one exceptional theme: every Grand Prix driver pictured within these pages is part of an elite band of thirty-four emerging from more than six hundred who have fought for the title since the dawn of the championship during an era barely recognisable today.

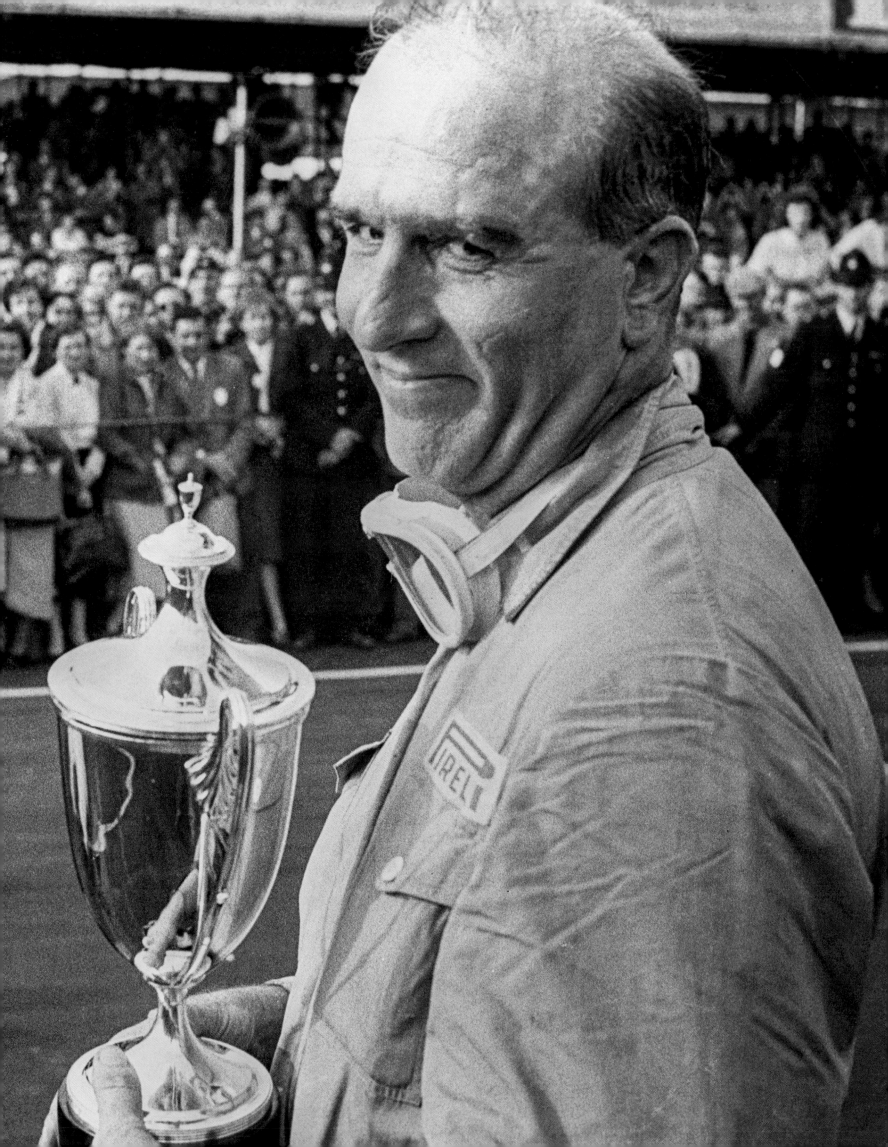

Giuseppe 'Nino' Farina: the first World Champion, a man of many parts and forever associated with his upright driving position in the Alfa Romeo 158 (*right*)

Dr Giuseppe 'Nino' Farina

1950

There was more to Dr Giuseppe Farina than the neat statistical landmarks that came with winning the inaugural round of the Formula 1 World Championship at Silverstone in May 1950 and going on to become the first World Champion.

Born in Turin in 1906, Farina was a lawyer, a doctor of political economy and a cavalry officer in the Italian army. An accomplished skier, footballer and horse rider, he also became a racing driver. Known as 'Nino' to his friends, Farina was a rather haughty individual who saw Grand Prix driving as a profession for people of substance rather than a mere sport for artisans. A letter in recent years to *Motor Sport* magazine describes how a young British enthusiast at Goodwood in 1951, seeking Farina's autograph, called '*Uno momento, Nino*' to attract his attention. Thinking it had to be an acquaintance, the World Champion

turned round with a smile. His expression changed swiftly when the man who detested posing for photographs realised it was a mere autograph hunter.

That sense of lofty superiority would extend to a distinctive driving style as Farina sat well back with his arms outstretched, in contrast to the more popular method of crouching over the large steering wheel. But the outward impression of calmness belied an inner steel and fearlessness that fellow competitors knew all about. He pushed the limits of both what was acceptable as a driver and the capability of his machinery; Farina's race cars needed to be as strong as the resolve of his rivals not to be intimidated.

Farina's early career – he was Italian Champion between 1937 and 1939 – was interrupted by the Second World War. His smooth

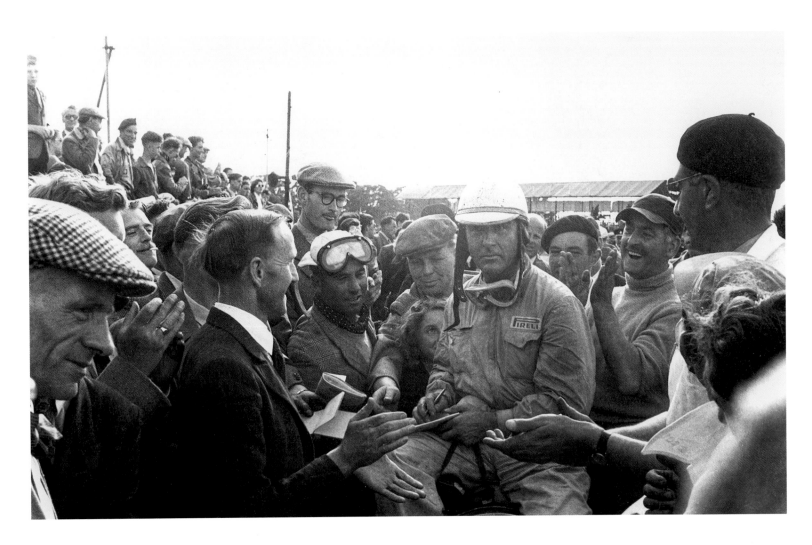

Above Farina (pictured at Silverstone in 1953) was not keen on signing autographs

Opposite Farina's association with the Ferrari 500 was never fruitful. He finished fifth in the 1953 French Grand Prix at Reims

style had not gone unnoticed, particularly by Tazio Nuvolari, the legendary Italian driver who had taken Farina under his wing. On the resumption of racing in 1946 he drove for Maserati and Ferrari, but his most successful association was with Alfa Romeo, Farina joining Juan Manuel Fangio and Luigi Fagioli as the Italian marque prepared for the introduction of the World Championship at Silverstone in 1950.

Farina dominated the historic British Grand Prix, leading from pole and setting fastest lap. His hard and fast driving also won the Swiss and Italian Grands Prix to beat Fangio to the title. One seasoned observer described Farina as 'not the best driver of his era, but he was very competent at all times'.

Competence alone would not be enough in 1951 when Farina won just one Grand Prix and Fangio claimed three to take the championship. Two of the races that year were won by Alberto Ascari, Farina's junior by twelve years and leader of the Ferrari team. When Alfa Romeo withdrew at the end of the year, Farina joined Ferrari, but found it difficult to be second best as Ascari dominated the 1952 and 1953 seasons.

Refusing to back off and accept his advancing years, Farina tried too hard and became accident prone, managing just one more championship Grand Prix victory in 1953 before scaling down his involvement in racing.

Practising for a sportscar race at Monza in 1954, part of his transmission broke, punctured the fuel tank and set the Ferrari on fire. For the rest of his career, Farina was only able to race by taking morphine injections to kill enduring pain from the burns. It was in this condition, at the age of forty-eight, that he finished

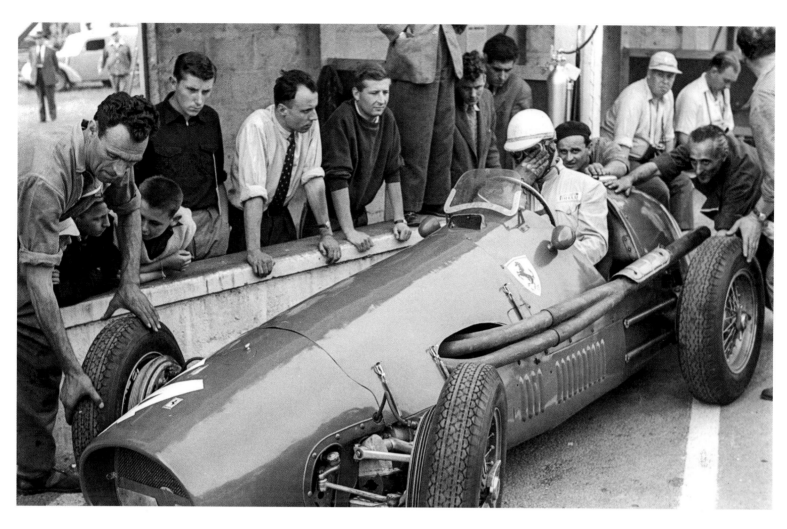

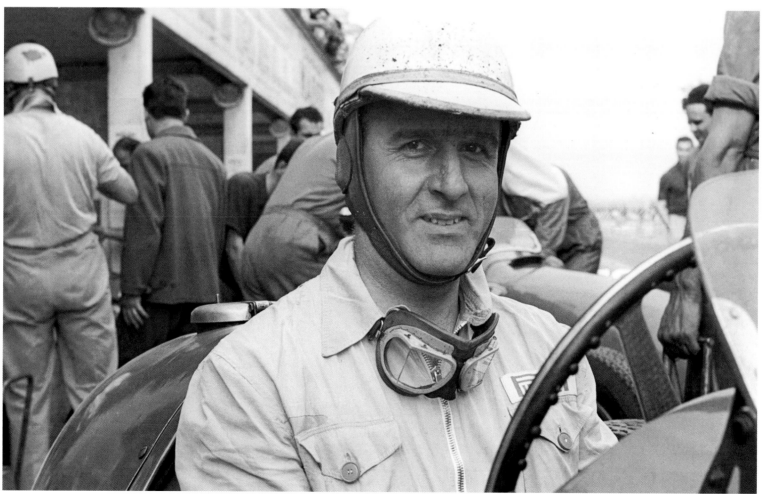

'Farina was a man capable of
any performance demanded of
him; a man of steel, inside and out;
a man who was a racing champion
in every sense of the word.'
Enzo Ferrari

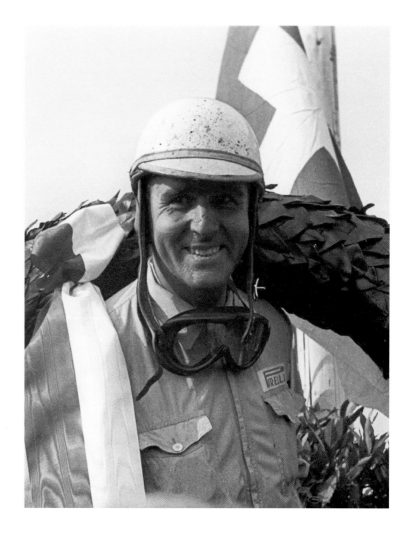

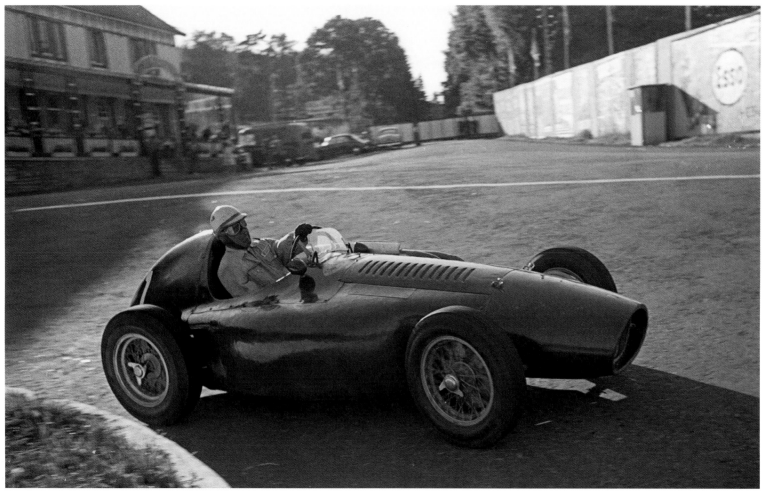

Opposite top The 1953 German Grand Prix at the Nürburgring Nordschleife provided Farina with his only victory in 1953, when he finished third in the championship

Opposite bottom The Belgian was one of just two championship Grands Prix in which Farina took part in 1954. He retired his Ferrari 553 after qualifying third at Spa-Francorchamps

Below top Farina with Juan Manuel Fangio (*centre*) and Felice Bonetto (*right*) on the grid at Monza before the start of the 1953 Italian Grand Prix

Below bottom Farina's rather forlorn look at Spa-Francorchamps in 1955 sums up what would be his last Grand Prix

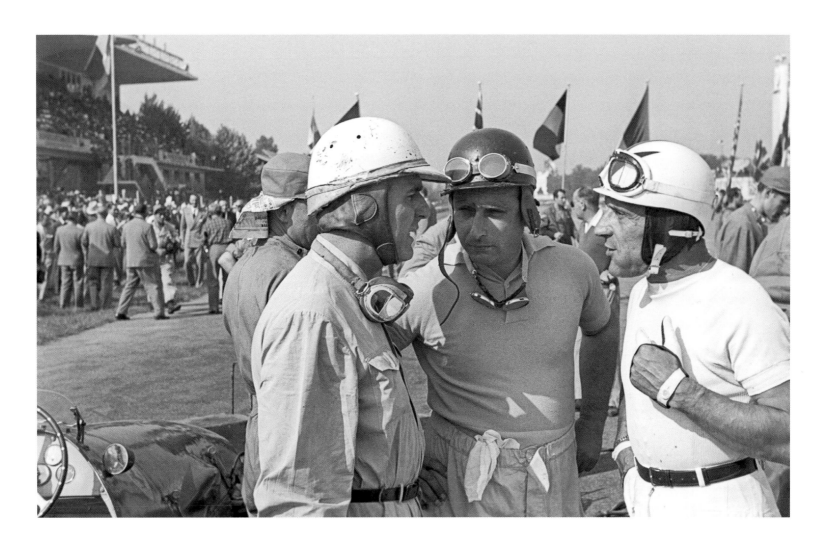

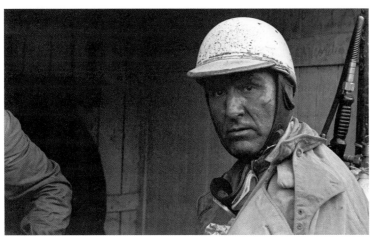

second in the 1955 Argentine Grand Prix. Ultimately, however, time – and the loss of his friend Alberto Ascari – took its toll and retirement finally beckoned.

Having survived one or two serious accidents on the race track, Farina would lose his life when his Lotus Cortina skidded and crashed on a wet road near Chambéry while en route to the 1966 French Grand Prix at Reims.

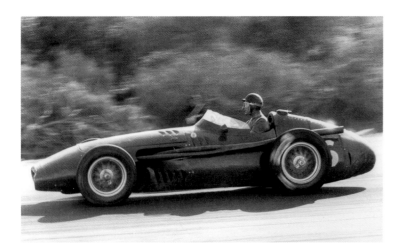

Juan Manuel Fangio

1951, 1954, 1955, 1956, 1957

The designation 'legend' could be applied to many names in this book, but no one merits it more than Juan Manuel Fangio.

Everything about this man – everlasting humility, a sense of propriety, the profound respect of his rivals – accompanies achievements that were extraordinary in the 1950s and gained even more admiration and awe with the passage of time.

In eight seasons from 1950 to 1958 – he didn't compete in the 1952 championship – Fangio drove in fifty-one World Championship Grands Prix and won twenty-four of them. He started all but two from the front row of the grid, claimed twenty-nine pole positions and set twenty-three fastest laps. World Champion five times, he raced for Alfa Romeo, Ferrari, Mercedes-Benz and Maserati, the variety of teams indicating his intuitive adaptability, never mind his status as the greatest driver of his

generation – and, many will argue, of all time. The fact that he did most of it in his forties merely added to the sense of reverence attached to such a modest man.

The son of a stonemason from a humble background in the Argentine city of Balcarce, Juan Manuel Fangio made his name at the wheel of an old Ford taxi, converted to take on the rigours of long-distance races over dirt roads. When he won the Gran Premio Internacional del Norte, a 10,000km marathon across the Andes to Peru and back, his reputation was assured, but the intervention of the Second World War appeared to put his potential international racing career on hold before it had even started.

Financed by the Argentine Automobile Club, Fangio came to Europe in 1949, worried that he might be too late at the age of thirty-eight. When he won seven times, however, Alfa Romeo

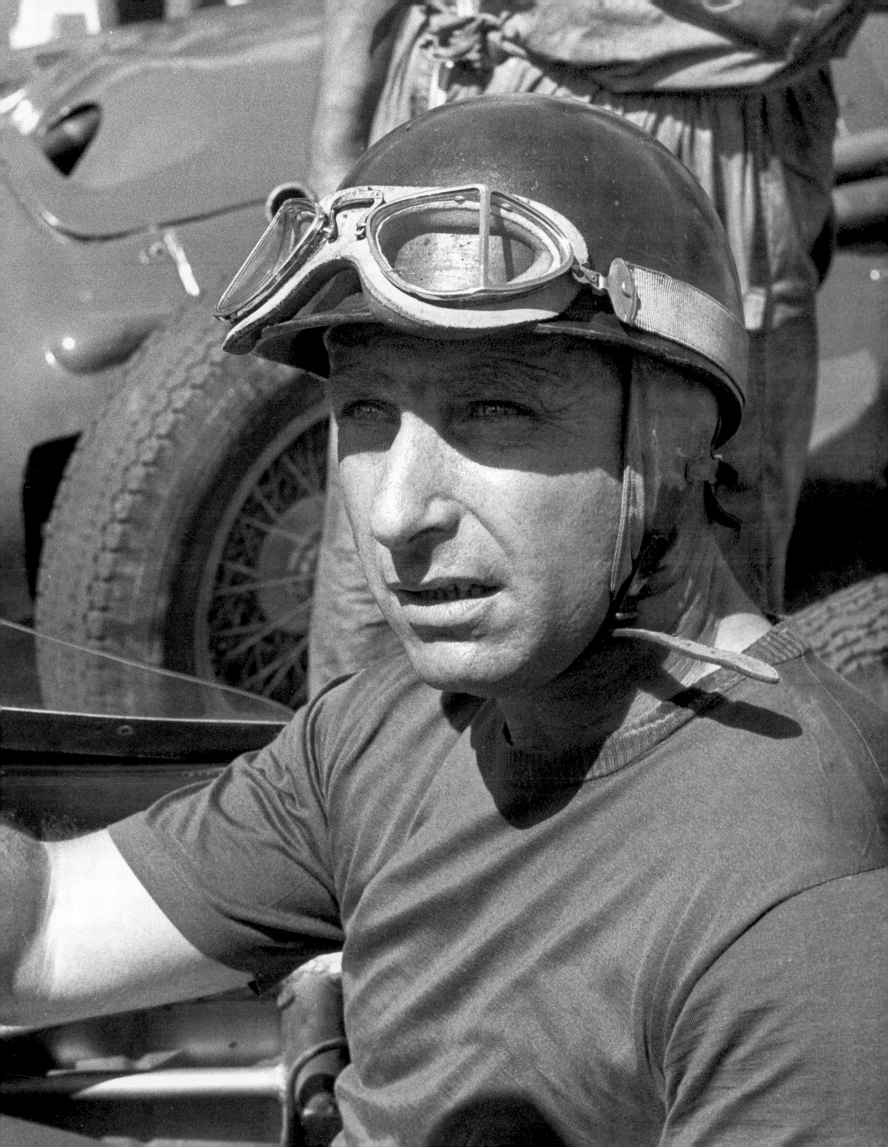

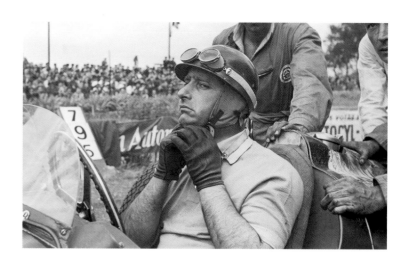

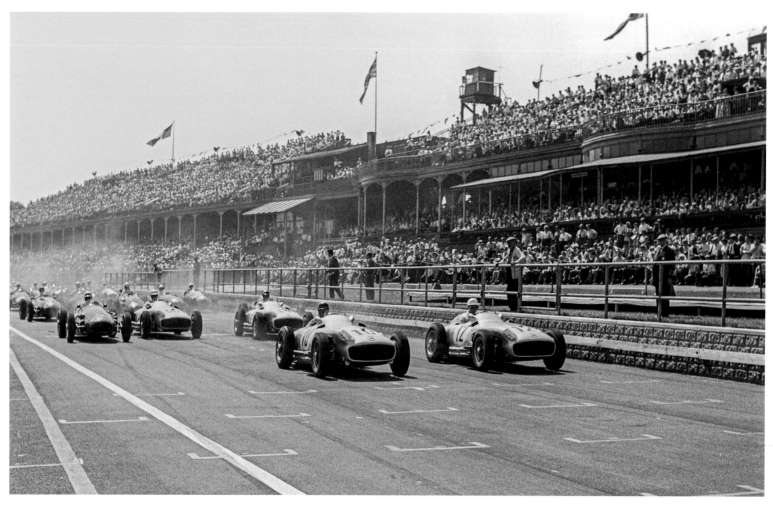

showed interest. Handed a blank contract by the Italian team, Fangio signed without hesitation and passed it back. 'Pay me what you think I'm worth,' he told them. 'I'm going to drive for you anyway.'

It was to be a fruitful liaison, with the Alfetta 159 becoming his favourite car in sentimental terms in 1951 as he won his first World Championship at the end of a memorable battle with Ferrari's Alberto Ascari. A change of formula specification prompted Alfa to withdraw the following year, Fangio driving in non-championship races for Maserati and, occasionally, BRM. A professional loyalty to both teams would cause the only serious accident of his F1 career.

Having raced the BRM V16 in the Ulster Grand Prix on a Saturday, Fangio's plans to go straight from Northern Ireland to the next

day's non-championship Monza Grand Prix were put in disarray by technical problems and bad weather. Having got as far as Paris, and anxious not to let down Maserati in their home race, Fangio borrowed a car and drove through the night, arriving at Monza in time to start the race – but without the benefit of sleep or practice.

Fangio's life hung in the balance after breaking his neck when thrown from the Maserati as it ran wide on the second lap and rolled into the trees. He was out of action for many months and swore never again to ignore the perils of fatigue. But a determination to race remained as strong as ever, as would an ability to concentrate totally throughout races usually lasting for three hours and more.

When Mercedes returned to Grand Prix racing in 1954, Fangio was their first choice. The hugely efficient German marque would

Opposite top A determined look as Fangio prepares to start from pole and wrestle with the BRM V16 in the non-championship race at Albi in 1953

Opposite bottom Storming off the line at Aintree, Fangio edges into the lead of the British Grand Prix ahead of his Mercedes-Benz team-mate, Stirling Moss (No 12)

Left Preparing for the 1956 British Grand Prix and victory at Silverstone with the Lancia-Ferrari D50

Below Listening to Mike Hawthorn (*right*) before the start of Fangio's final Grand Prix at Reims in 1958

Overleaf The start of something big. Fangio on his way to a debut victory for Mercedes-Benz with their streamlined W196 at Reims in 1954

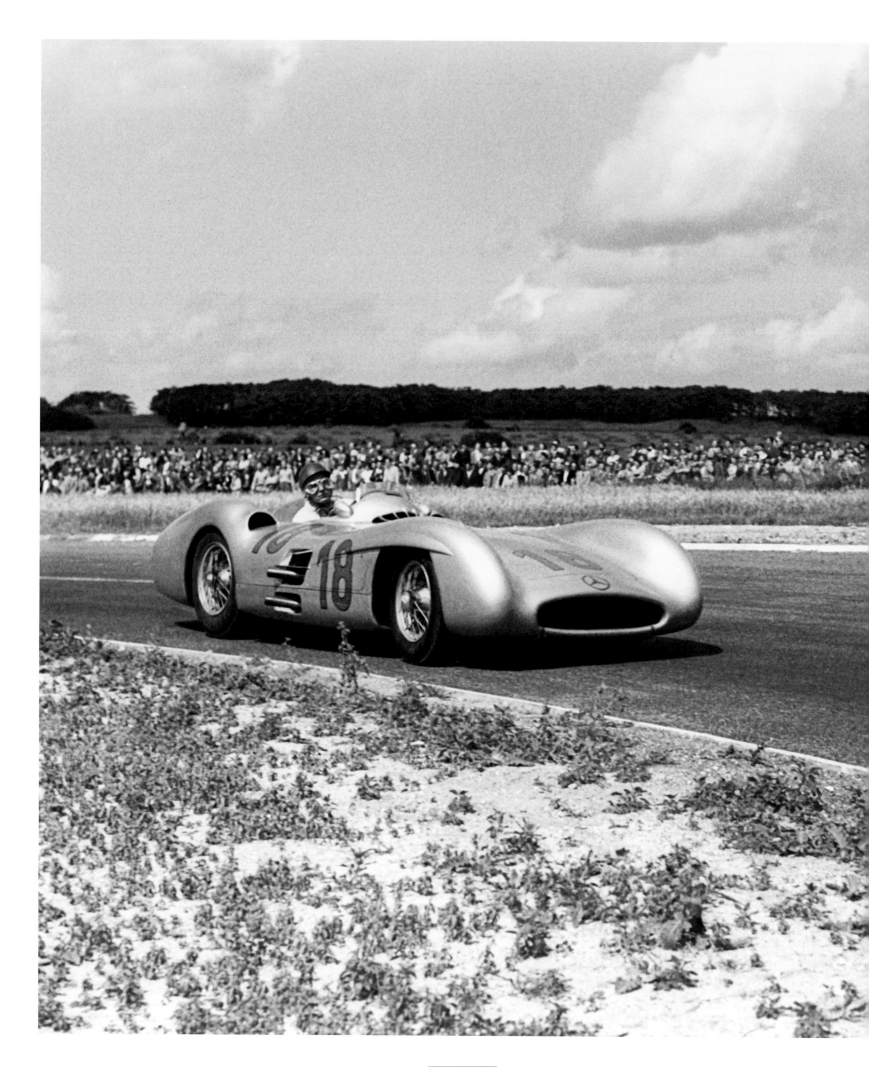

'Fear, I understand well. I am petrified by snakes and all my life I have been uneasy when walking alone in the dark. But fear in a racing car? No, I never once felt it. Of course, in my day there were fewer races but far more fatal accidents. Always I was very sad, but I could not let it influence me. It never once crossed my mind that I was going to be killed. Always I knew there was some force helping me.'

race for just eighteen months (the campaign foreshortened by a tragedy when one of their cars went into the crowd at Le Mans in 1955). During that time, Fangio took part in twelve Grands Prix, winning eight, finishing on the podium on two further occasions and taking his second and third world titles with ease.

Stirling Moss, in his first works drive, could not have had a better tutor as he sat in the team leader's wheel tracks. Only once did Moss finish ahead, winning the 1955 British Grand Prix. It was no coincidence, perhaps, that his German team-mate, Karl Kling, also won on home ground, a car's length ahead of Fangio. Neither driver ever knew whether the maestro had deliberately held back since it would not have been beyond the Argentine's basic sense of decency.

When Fangio accepted an offer from Ferrari in 1956, he never believed that feeling of correctness was reciprocated – with one notable exception when his car failed during the final race of the season in Italy. Enzo Ferrari encouraged intense rivalry between his drivers but Peter Collins put that to one side at Monza, handing over his Ferrari – as permitted by the regulations – to allow Fangio to continue and win his fourth title. Fangio was deeply touched and later hugged the Briton and thanked him (through an interpreter; Fangio spoke very little English) for his 'English sense of sportsmanship'.

Collins was not alone in being in awe of Fangio's prowess and he would receive a first-hand demonstration of it at the Nürburgring Nordschleife the following year. Fangio may have turned forty-six in June 1957 but he was to have one of his greatest seasons – certainly, his greatest race – courtesy of the Maserati 250F.

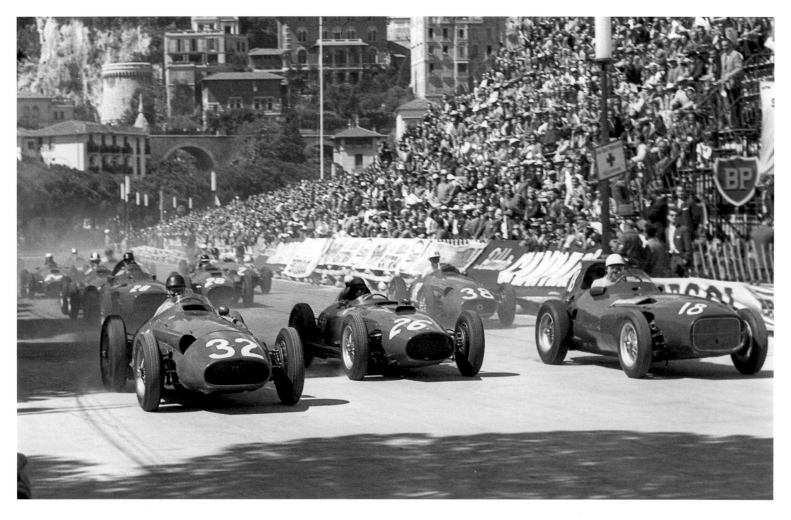

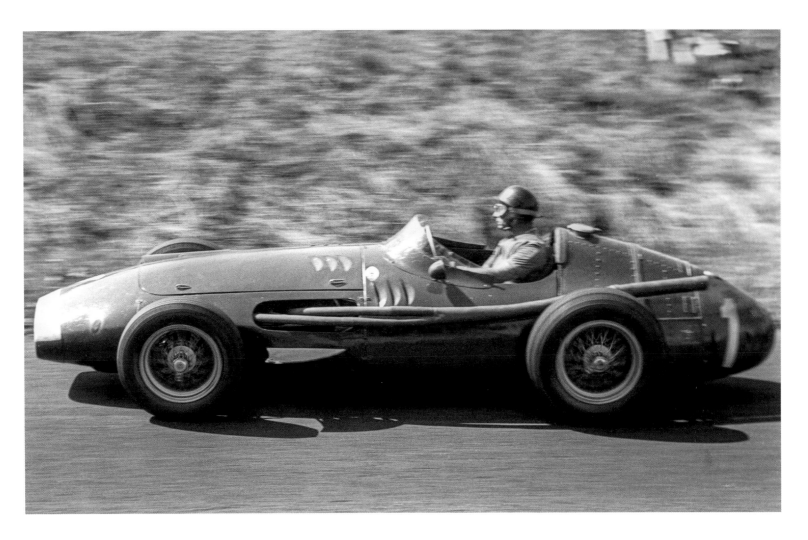

Opposite top Fangio's Maserati 250F (32) beats the Ferrari of Peter Collins and Stirling Moss's Vanwall (18) off the line at Monaco in 1957 on his way to scoring his second win on the streets of Monte Carlo

Opposite bottom Relishing the twists and turns of the Nürburgring Nordschleife with the Maserati 250F in 1957

Above A marriage made in Heaven: Fangio, the Maserati 250 and his day of days in the 1957 German Grand Prix

A return to the Italian marque united Fangio with a car he could bend to his will, the 250F being as delightful to drive as it was to behold. Moss had joined Vanwall and, between them, Fangio and his former team-mate won every race. But none was so memorable as the German Grand Prix.

Fangio had taken pole position but, unlike the Ferraris of Collins and Mike Hawthorn, decided to run light at the start and make a pit stop to refuel. Everything went according to plan until a bungled stop turned a 28-second lead into a 51-second deficit. Hawthorn and Collins thought the race was theirs and made no allowance for Fangio having his day of days. Slashing an astonishing twenty-four seconds off his own lap record, Fangio caught and passed the Ferraris as if they were standing still on the penultimate lap.

He later admitted he had never driven like that before, and would never do so again. Having become champion for a fifth time, Fangio would take part in just two more Grands Prix in 1958 before deciding to retire.

As President of Mercedes-Benz Argentina, Fangio maintained a strong link with the company and with motor sport. His presence was widely sought. Despite a stocky appearance – he stood 5ft 7in and was nicknamed 'El Chueco' because of his bandy legs – there was something mesmeric about this softly spoken man with the piercing steel-blue eyes. You could sense he had entered a room without seeing him.

Faultlessly polite, graciously composed, Fangio maintained that same aura of quiet majesty he had displayed so effectively to become a legend at the wheel of a racing car.

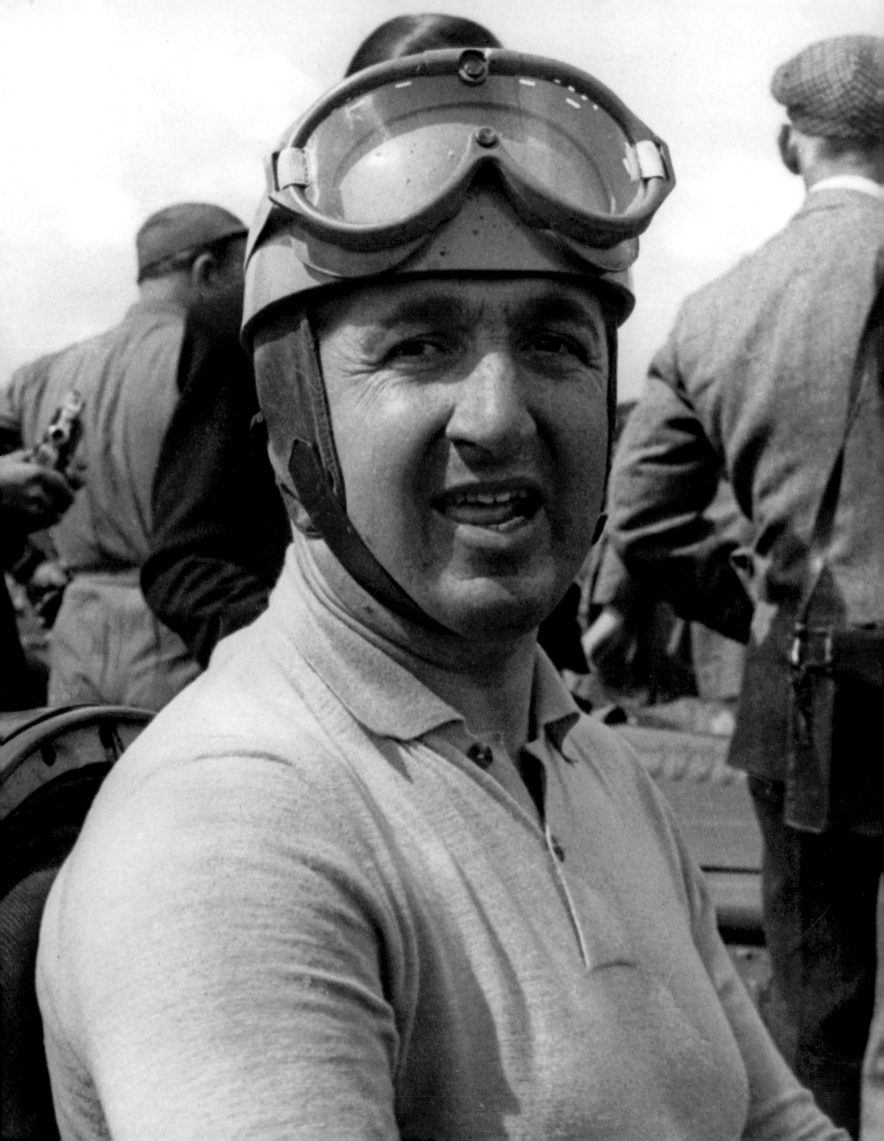

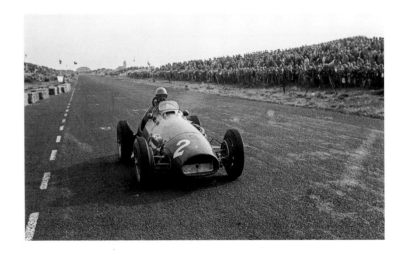

Alberto Ascari

1952, 1953

Milan came to a standstill on the day they buried Alberto Ascari. Italy was in deep shock, not only because the nation had lost its greatest racing driver, but also thanks to the bizarre circumstances surrounding this tragedy.

Ascari had died at the wheel of a racing car nearly thirty years after his father, Antonio, had been killed during the French Grand Prix on 26 July 1925. There had been no logical explanation for either crash. Both men were thirty-six years old and they both met their deaths four days after surviving potentially serious accidents.

More than that, on the day of his fatal crash, the deeply superstitious Alberto had defied many of the beliefs that drove his irrational concerns. Motor racing in the 1950s was deemed to be already dangerous enough without tempting fate in this unexpected manner.

Despite motor sport's predatory nature, the loss of the double World Champion had caught many unawares, coming as it did on a Thursday during a test session at which Ascari was not supposed to be present. Mystery piled upon mystery in the minds of thousands lining the city's sorrowful streets as the funeral cortege passed by.

Alberto Ascari was born in Milan on 13 July 1918. A period spent racing motorbikes was, almost inevitably, followed by cars, Alberto taking part in a few races before war in Europe intervened. On the cessation of hostilities, he was reluctant at first to resume competing, preferring to focus on the welfare of his wife and two young children and a transport business run in partnership with his friend, Luigi Villoresi.

No mean driver himself, Villoresi had always recognised Ascari's

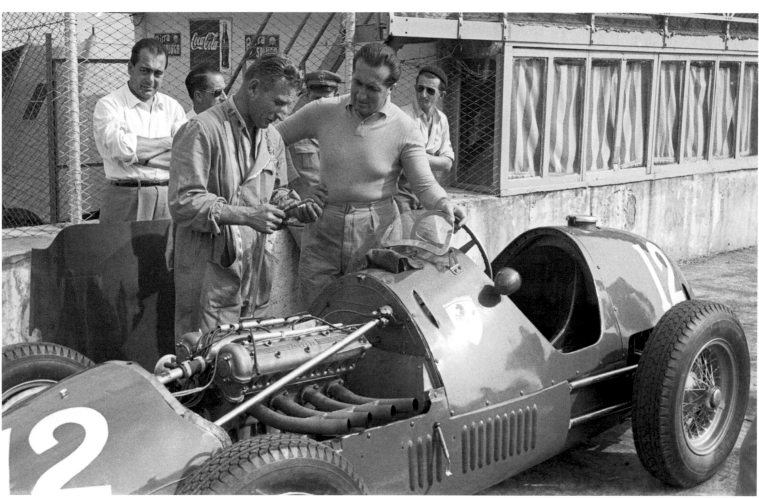

calm, natural ability. It didn't take much to persuade Alberto to get behind the wheel of a privately entered Maserati, which eventually led to a drive with Ferrari for 1949, Ascari creating a milestone at Berne by giving Enzo his first-ever Grand Prix win.

Alfa Romeo were better prepared for the launch of the F1 World Championship in 1950 but the following season saw truly epic battles between Fangio and Ascari, the Argentine eventually bringing the title to Alfa Romeo for a second time.

Realising the days of the Alfetta's supremacy were coming to an end, Alfa Romeo withdrew from racing and left a huge hole in the 1952 championship. Race organisers, fearing a Ferrari whitewash, turned to Formula 2, a move backed by the sport's governing body as they granted these races World Championship status while waiting for the arrival of a new formula in 1954. By a

happy coincidence, Ferrari happened to have an F2 car that was extremely competitive.

Between June 1952 and June 1953, Ascari won nine races in succession. The Ferrari 500 may have been the best car, but Alberto made good use of it, employing his precise and unflustered style to demolish the opposition. He never put a wheel out of place; never made an error after setting a demoralising tone with blistering starts. Across two seasons, he won both world titles and twenty races (including non-championship F1 events).

In 1954, he won none. In fact, he scarcely raced. A disagreement with Ferrari over financial terms had prompted a switch to Lancia. Italian fans, shocked by the break-up of such a perfect partnership, consoled themselves that this was a move to a revolutionary new car, the Lancia D50. In fact, it would be a

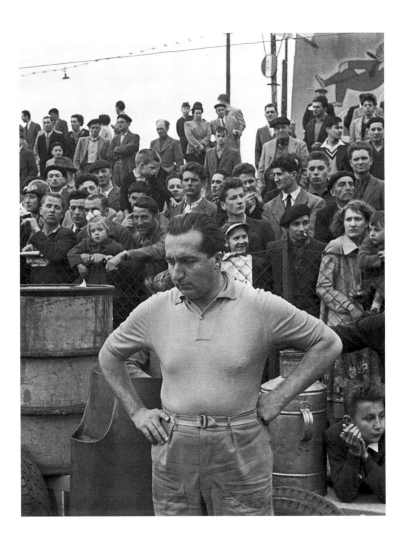

Opposite Ascari's stock rose even higher at home in 1952 when he won the Italian Grand Prix for the second year in succession, this time with the 2-litre Ferrari 500

Left Ascari looks suitably non-plussed following a rare retirement during the 1953 Albi non-championship F1 race in France

Below Rounding La Source during the Belgian Grand Prix and heading for a third successive win at the start of the 1953 season

Overleaf Pressing on with the Lancia D50 at Monaco before crashing into the harbour. Ascari survived that spectacular incident but was killed four days later

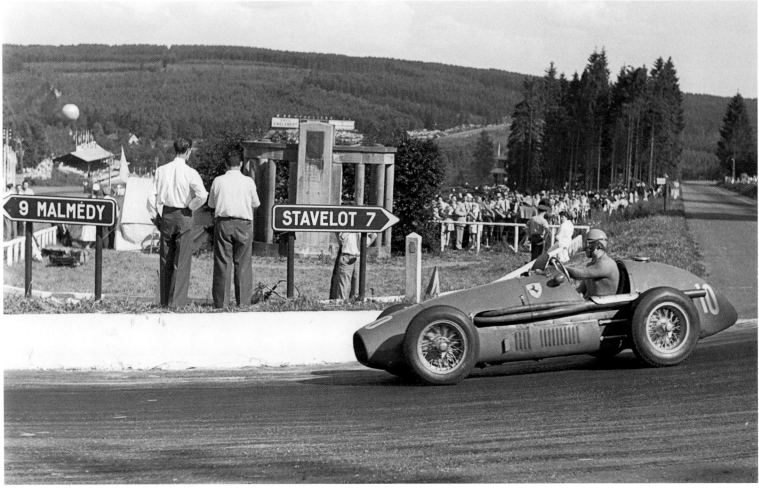

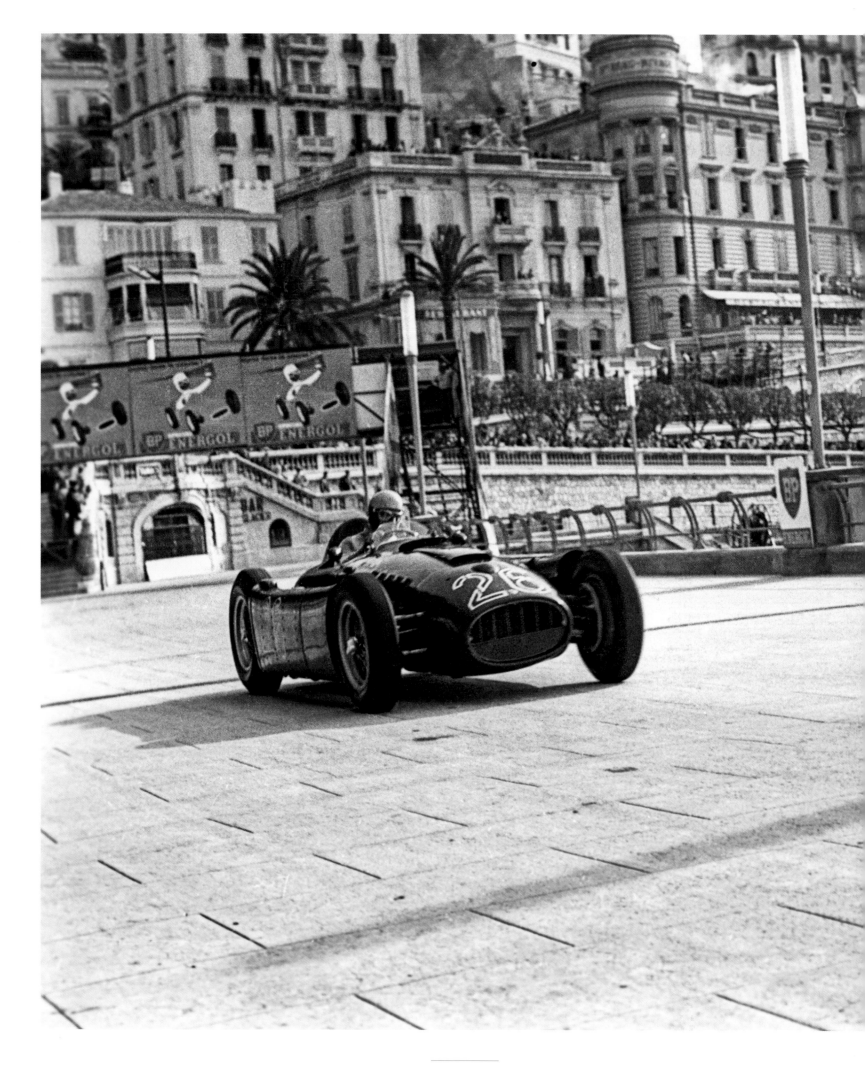

'I am risking my life thousands of times to pursue victory around the world. Like my father, I only obey my instinct; without it, I would not know how to live, I would not succeed in making any sense of my days.'

disaster, production running behind schedule; when the D50 finally appeared towards the end of 1954, it was fast but required all of Ascari's considerable skill to tame it.

Improvements for 1955 were promising, with Ascari winning two non-championship races before the first round of the World Championship in Monte Carlo. When the pair of Mercedes fell by the wayside late in the race, Ascari was poised to take the lead. But a combination of failing brakes and oil at the chicane sent the dark-red car through the flimsy barrier and into the harbour. The Lancia sank to the bottom, with the driver surfacing with no more than a cut nose.

Ascari would have noted such miraculous good fortune as he recovered quietly in his Milan apartment. A deep superstition included a fear of black cats so strong that he would turn around and drive in the opposite direction rather than pass one on the street. Much of his anxiety was founded on the death of his father on 26 July 1925. Alberto would never race on the twenty-sixth and insisted on wearing his lucky light-blue helmet.

There was absolutely no thought of him driving when he made the short journey to Monza on 26 May to watch Eugenio Castellotti test a Ferrari they were due to share in a sportscar race the following weekend.

Early in the afternoon, it was with some surprise that onlookers saw Ascari ask to take over for a few laps, saying he wanted to check there were no ill effects from his Monaco accident four days before. Surprise turned to astonishment when he simply took off his jacket and donned Castellotti's white crash helmet. 'I'll only make three or four laps. I'll drive slowly!' he said, before accelerating onto an empty track he knew so well.

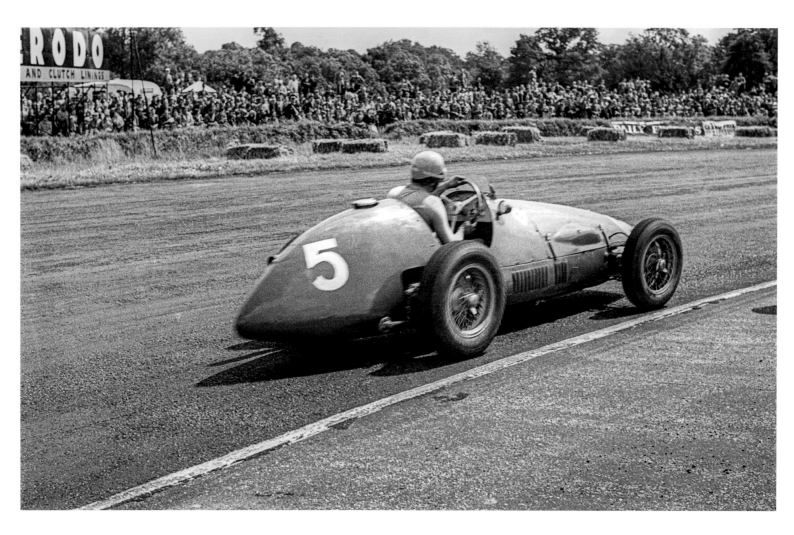

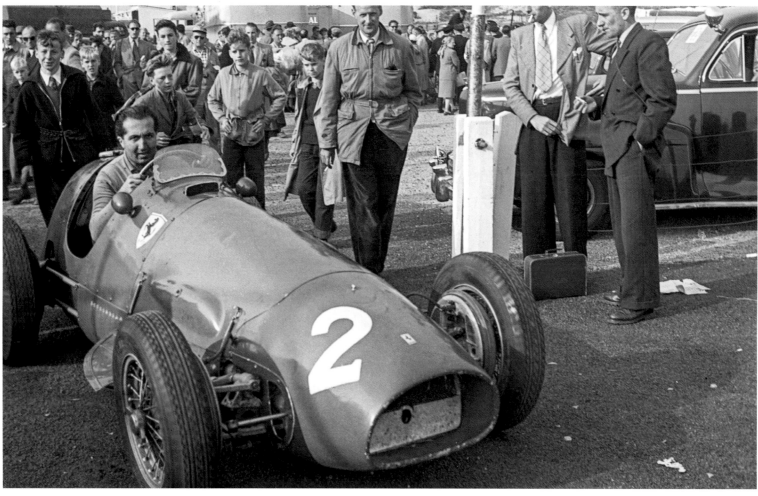

Opposite Both the British (*top*) and Dutch Grands Prix fell to Ascari with the Ferrari 500 in 1953

Below Victory in the 1953 Swiss Grand Prix on the fearsome Bremgarten road circuit would be Ascari's last win in the World Championship

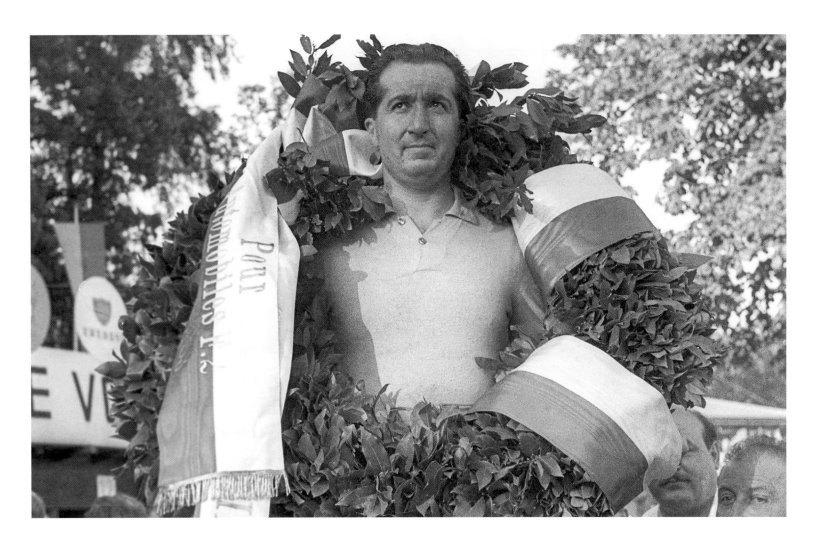

The first two laps were indeed leisurely but, at the start of the third, he was up to speed. He never completed the lap. The Ferrari left the road at Vialone, an easy left-hand curve (now the site of the Ascari chicane). The driver, motivated entirely by perfection and precision, died of his injuries after being thrown from the car.

Italy was immediately plunged into confusion and mourning over the loss of arguably its greatest motor-racing champion of all time.

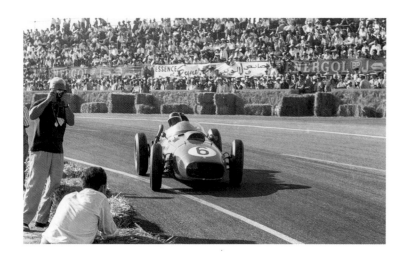

Opposite Minus bow tie but with his trademark corduroy peaked cap, Mike Hawthorn spots Bernard Cahier's camera at Monaco in 1956

Left Hawthorn urges the understeering Ferrari Dino 246 towards second place and the championship in Morocco during his final race in October 1958

Mike Hawthorn

1958

It was a sign of the times that news of the first British driver ever to be chosen by Ferrari scarcely received a mention in the press. Today, such a significant story would be headlined and dissected across social media. But at the end of 1952, Mike Hawthorn's signature on a Ferrari contract was worth only a couple of lines – if that – tucked away on the sports pages.

The Englishman had made his debut in a sprint on Brighton seafront just two years before and had yet to truly establish himself internationally. The flair and speed were there, as demonstrated by progress at the wheel of a Cooper-Bristol when Hawthorn made his Grand Prix debut as a private entrant in the 1952 Belgian Grand Prix, finishing fourth. Times were so relaxed that someone recommended that Enzo Ferrari give the 23-year-old a test drive, which he duly did and rewarded Hawthorn with a contract for 1953.

Mike really made the headlines six months later at Reims in France, winning his first Grand Prix after a flat-out wheel-to-wheel battle with no less a name than Juan Manuel Fangio. This remarkable rise lost some of its momentum in 1954 when Mercedes-Benz arrived to totally dominate, Hawthorn not helping his cause the following year with a switch to the uncompetitive Vanwall team.

He did win Le Mans in 1955 but that victory for Jaguar was to be clouded dreadfully. In the middle of a furious battle with Fangio's Mercedes, Hawthorn was making his way towards the pits for a scheduled stop when the Mercedes of Pierre Levegh struck the back of an Austin Healey after it had pulled out to avoid Hawthorn's slowing D-Type. The Mercedes became airborne and killed more than eighty spectators. Hawthorn was to be exonerated completely by an official inquiry but the horror and its implications

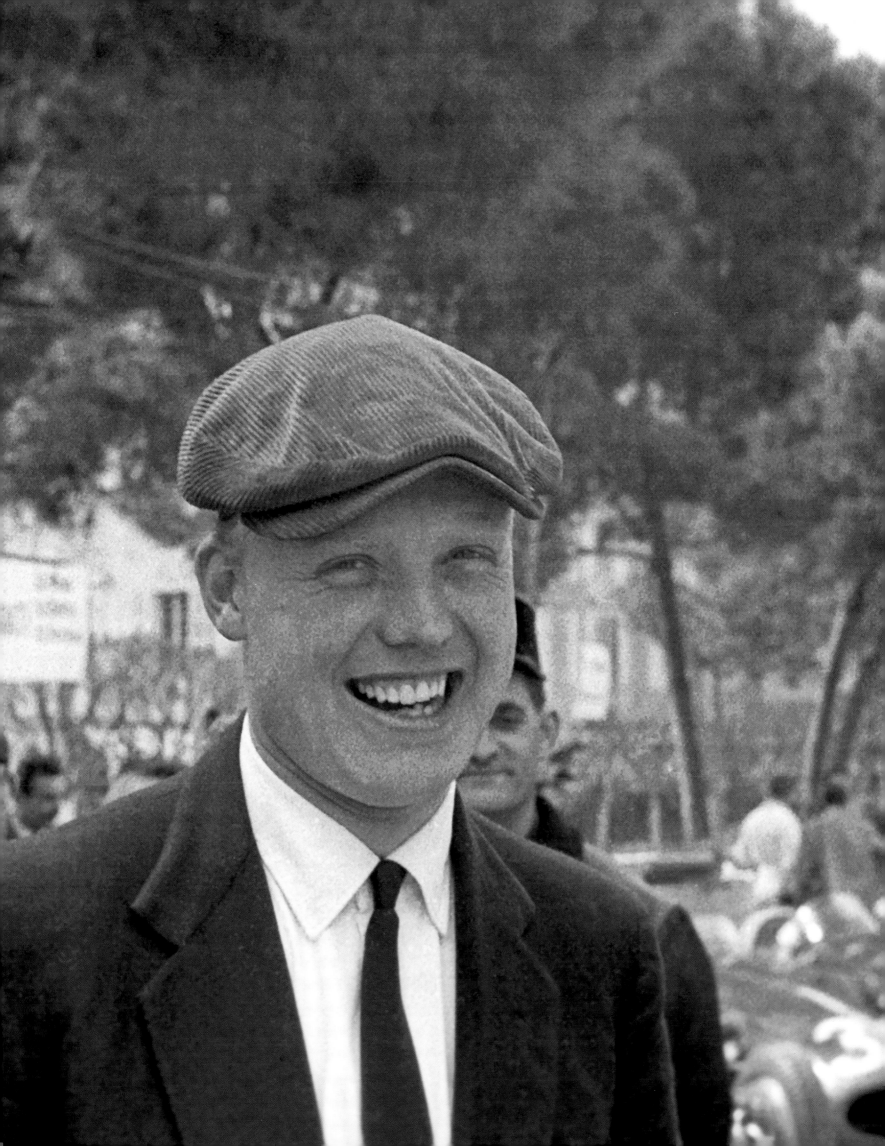

'The full realisation (of being World Champion) did not dawn upon me until I reached my garage in Farnham. My office was submerged beneath sacks of mail; the telephone rang unceasingly. Invitations poured in with every delivery asking me to speak at this dinner, be guest of honour at that function, open fetes, close bazaars, appear here, there and everywhere. About the only thing I was not invited to do was to stand as a Liberal candidate at the next election.'

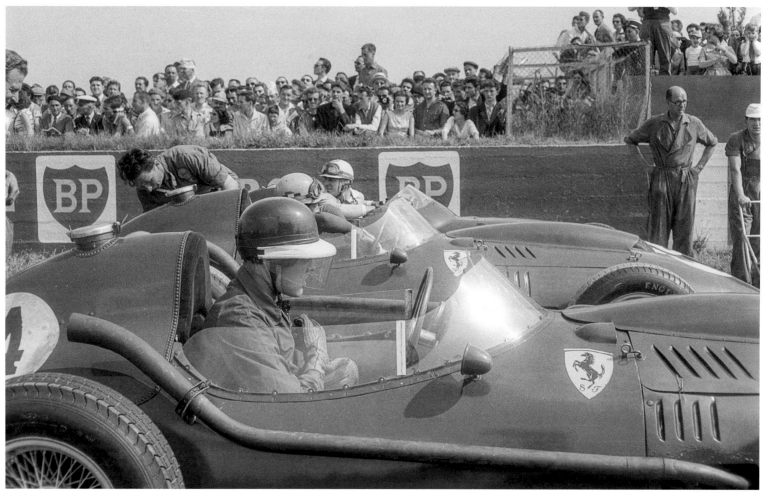

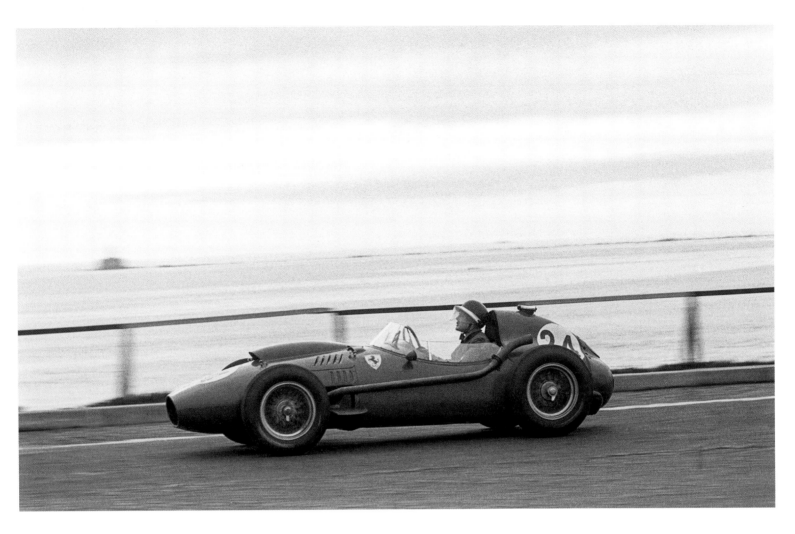

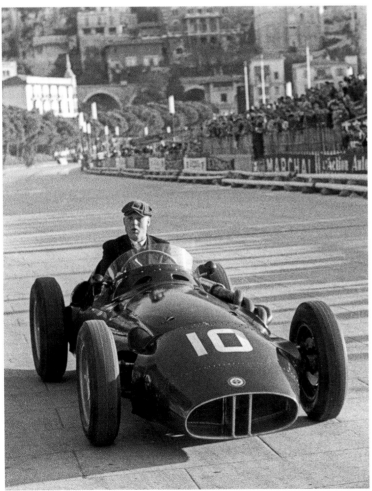

Opposite top Hawthorn, at Morocco in 1957, always favoured an open visor rather than goggles

Opposite bottom Hawthorn, starting from pole at Reims alongside his Ferrari team-mate Luigi Musso and the BRM of Harry Schell in 1958. Victory in the French Grand Prix would be Hawthorn's only win in his championship year and a day of mixed emotions following a fatal accident for Musso

Above Nose up under fierce acceleration, the lines of Hawthorn's championship-winning Ferrari Dino 246 are shown to good effect against the North Atlantic backdrop in Portugal 1958

Left Hawthorn's troubled season with BRM in 1956 is summed up at Monaco, where he failed to start thanks to engine problems during practice. He heads for the pits after what will turn out to have been a fruitless journey from the BRM garage on the edge of town

Above Dealing with cobbled streets and tramlines, Hawthorn's Ferrari is chased by the Vanwall of Stirling Moss during the 1958 Portuguese Grand Prix in Oporto

Left Hawthorn shared a Ferrari 625 LM with Peter Collins (*right*) to beat the Maserati of Stirling Moss (*left*) in the 1956 Supercortemaggorie sports-car race at Monza

Opposite top Rounding the cobbled Nouveau Monde hairpin at Rouen-Les-Essarts, Hawthorn struggled to be competitive with the Lancia-Ferrari V8, finishing the 1957 French Grand Prix one lap down in fourth place

Opposite bottom Hawthorn set fastest lap and was leading the 1958 Monaco Grand Prix by half a minute when his Ferrari's fuel pump failed

would go on to affect the rest of his career and prompt thoughts of retirement from motor-racing.

After a desultory season with BRM, Hawthorn's effervescent character was boosted in 1957 when he returned to Ferrari and strengthened a close friendship with Peter Collins. The Englishmen had to work hard against Vanwall and the Maserati of Fangio but, in 1958, consistent finishes plus a single victory – only his third in total – meant Hawthorn would become the first Englishman to win the World Championship. Then he decided to retire.

Motor racing had lost some of its appeal for a man whose enjoyment of life had always been a top priority. Hawthorn had seen Collins crash fatally a month after their Ferrari team-mate, Luigi Musso, had lost his life at Reims. Then, in Hawthorn's championship-winning race in Morocco, Stuart Lewis-Evans had suffered severe

burns. Hawthorn flew back to England on the same chartered aircraft with the young Englishman and was deeply distressed when Lewis-Evans succumbed to his injuries a few days later.

In many ways, Hawthorn's brief but eventful career was in keeping with the dashing image of the young man with flaxen hair and jutting good looks. He usually wore a spotted bow tie, even when racing, and enjoyed a pipe and a few pints with the lads in the pub.

At twenty-nine, his future lay in running the family garage in Farnham, Surrey, and playing an ambassadorial role in the motor industry. Hawthorn was heading towards London on just such a mission on 22 January 1959 when his Jaguar 3.4 saloon left the wet road near Guildford and spun backwards into a tree, killing him instantly. This time, John Michael Hawthorn was front-page news, but for the worst possible reasons.

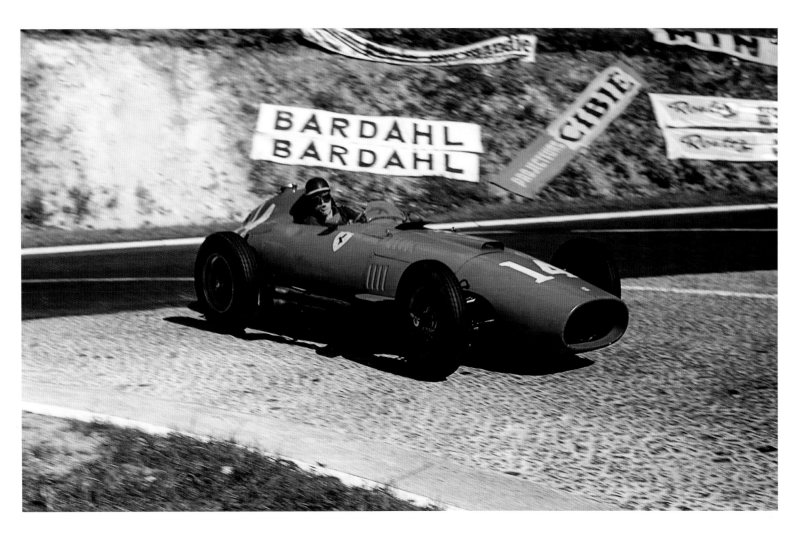

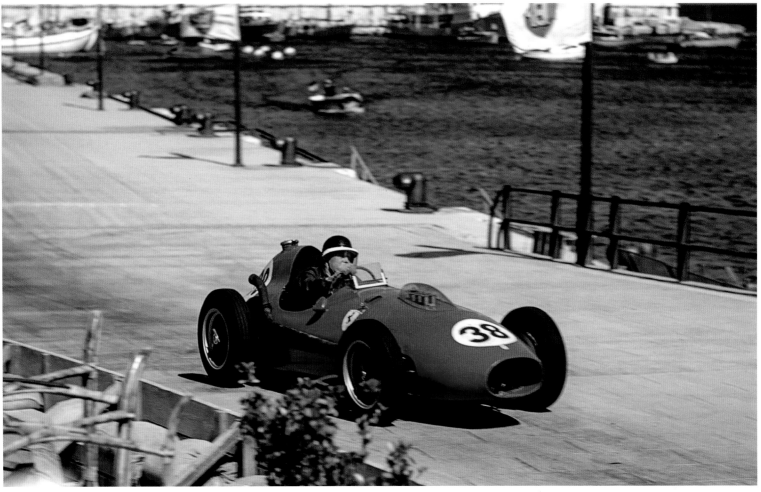

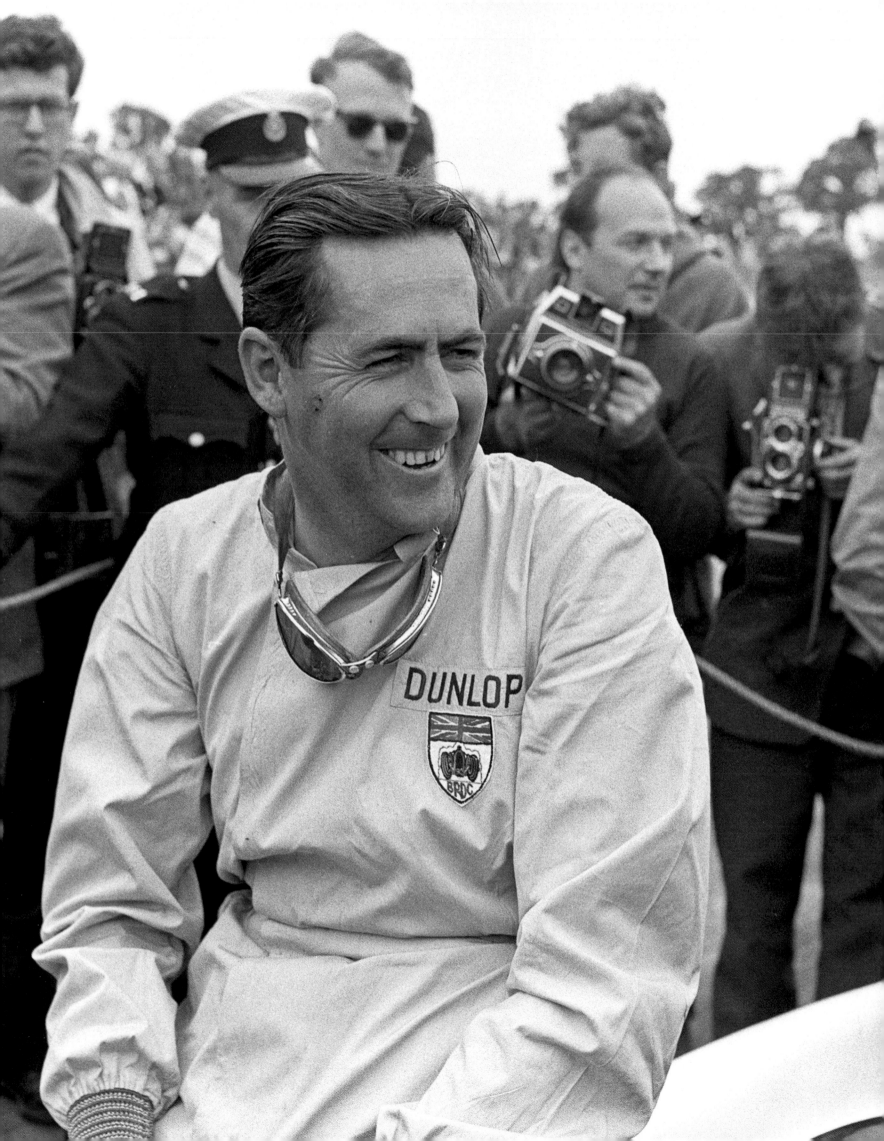

Every reason to smile. Better known for a taciturn manner, Jack Brabham was happy to make the most of a rear-engine revolution started by Cooper and score a second successive world title thanks to five wins from the nine Grands Prix in 1960, including Britain (*opposite*) and Holland (*right*)

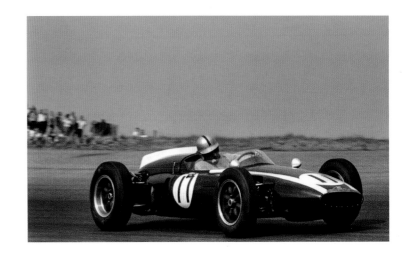

Sir Jack Brabham

1959, 1960, 1966

Jack Brabham won his first of three World Championships at the final race of the 1959 season. His car having run out of fuel, he had to push it 400 metres up a slope to take the chequered flag and earn the points he needed by being classified fourth in the United States Grand Prix.

Exhausted by this effort after more than two hours of racing in the heat of Florida, Brabham collapsed as the Cooper-Climax gently rolled across the line. It was, he said, 'bloody tough'; a concise summary that perfectly defined a laconic no-nonsense Australian accustomed to graft and grit.

Brabham was an engineer who went motor racing – eventually. The first race he ever saw was almost as an aside, the adjunct to working as a mechanic on a friend's midget racer on rough oval tracks in and around his native Sydney. Brabham was not

particularly impressed by the wild, wheel-banging, sideways competition as dirt and cinders flew in all directions. It was almost with reluctance that he later accepted the offer of a race when his friend chose to reduce his competition driving. After a hesitant couple of races, Brabham won his third – and went on to become 1946 New South Wales Champion before winning the national championship twice.

Progress on more solid ground brought the Australian a national hill-climb title with a midget in 1951 before stepping into a full-size racing car on proper circuits and winning the local championship with a Cooper-Bristol. The first association with the British manufacturer would have far-reaching consequences, particularly in 1955 when Brabham arrived in England to chase any opportunity to take part in Grand Prix racing.

Below Head down, shoulders hunched, Brabham in his Cooper-Climax T51 leads the field into the first corner at Monaco in 1959 and onward to his first Grand Prix victory

Opposite top Reims in France was a happy hunting ground for Brabham as he takes the chequered flag with the Cooper-Climax T53 in 1960

Opposite bottom Another win for Brabham and the Cooper-Climax T53 in 1960, this time on the streets of Oporto in Portugal

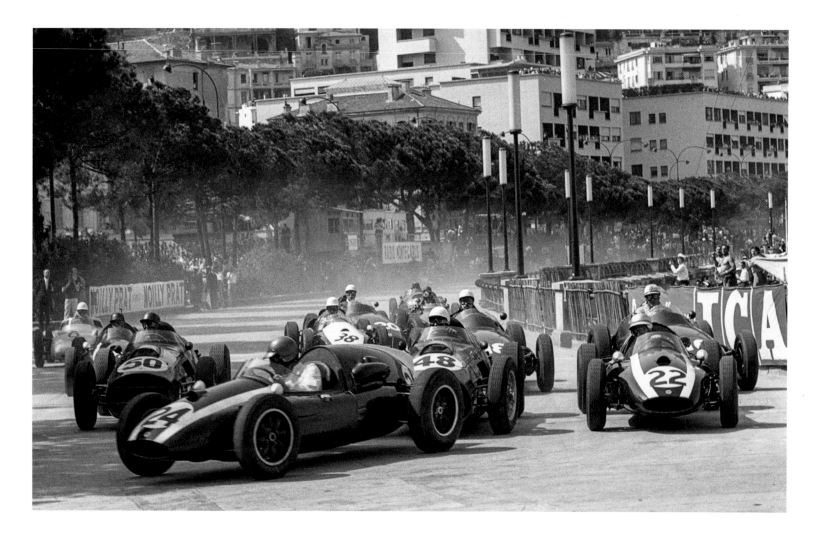

This coincided with a massive step-change in F1 thinking, Cooper being the first to move the engine from the front to the rear, creating a car that was smaller, lighter and more nimble. Brabham embraced the engineering innovation and used the Cooper to good effect, winning his first Grand Prix at Monaco in 1959 and going on to take the championship with, almost literally, his last gasp at Sebring in Florida. With the momentum well and truly rolling and the opposition struggling to catch up, Cooper and Brabham made it two titles in a row with five wins from the nine Grands Prix in 1960.

Forever searching for technical challenges, Jack decided to move on and manufacture his own cars, the first Brabham appearing at the German Grand Prix in 1962. Brabham continued to race but was content to be number two in his own team while establishing a company that would grow to an annual production of eighty racing cars across the junior categories.

A change in engine formula in F1 would establish the beginning of an Indian summer as Jack turned forty in April 1966. Cleverly using a production-based Repco V8, while rivals struggled with purer and more sophisticated engines, Brabham became the first man to win a Grand Prix in a car bearing his own name. He followed up that victory in France with three more, his win in the rain at the daunting fourteen-mile Nürburgring bringing as much personal satisfaction as becoming World Champion for a third time.

Almost embarrassed by the accolades, Brabham focused on the job in hand and continued to contradict a shy personality out of the car by his elbows-out method when in the cockpit.

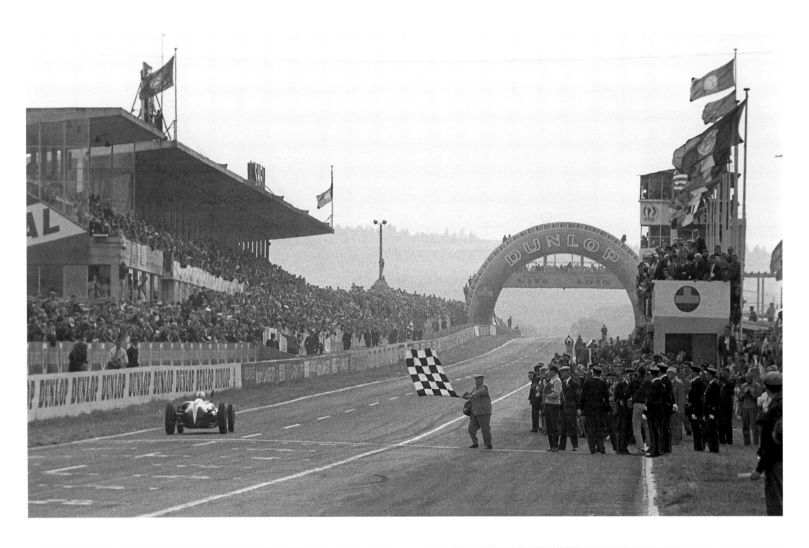

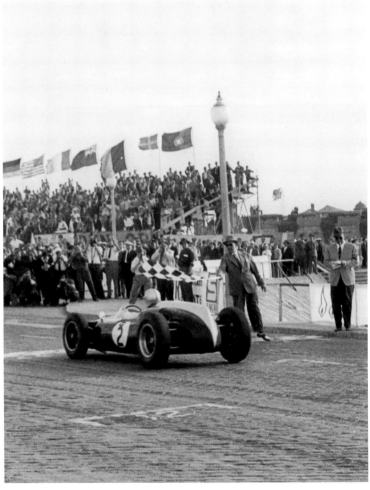

'I was more pleased with the different championships coming together in 1966 than I had been with my previous two. I felt that the Constructors' is just as important as the Drivers' because the driver tends to overshadow the publicity which really ought to go to the people who make the cars.'

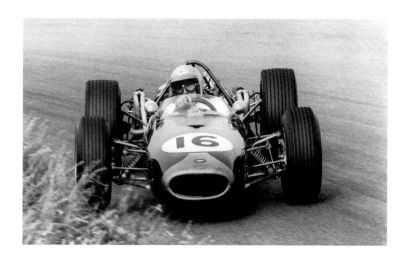

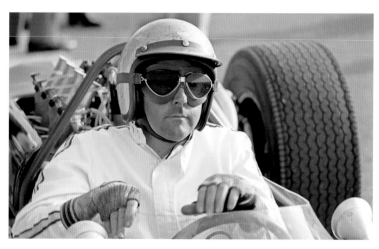

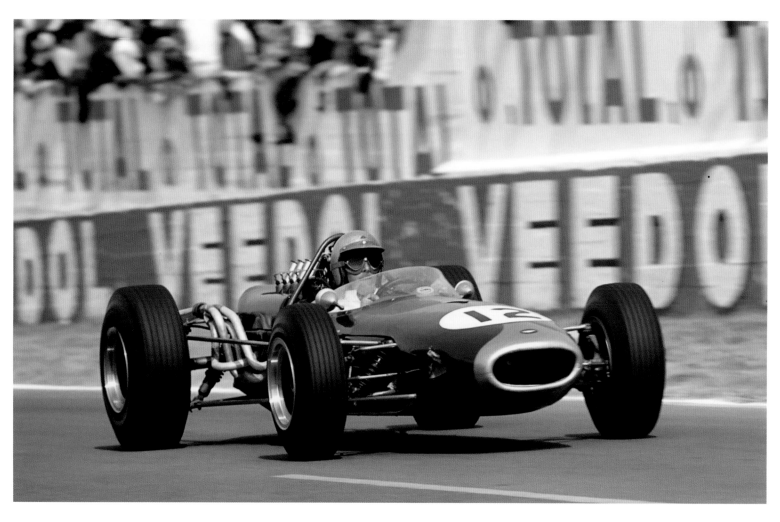

Opposite top Classic Brabham pose as Jack power-slides his Brabham-Repco BT19 on the way to victory in Holland and his third World Championship in 1966

Opposite bottom Brabham established a record with the Brabham-Repco BT19 at Reims in 1966 by becoming the first man to win a Grand Prix in a car bearing his own name

Below There was nothing Brabham enjoyed more than getting down to it and working on every aspect of his car. He examines the Repco V8 in the back of his BT24 during the 1967 French Grand Prix weekend

A head-down, shoulders-hunched style may not have been elegant, but it was hugely effective. Jack was not averse to putting a rear wheel over the trackside edge and showering his challengers with dirt in the sideways manner learned during the rough and tumble of his midget-racing days.

He had come a long way since then in every sense, Jack being the first F1 driver to fly his own plane to races in Europe. But despite this elevated status in life, Brabham continued to enjoy being down to earth and getting his hands dirty whenever the occasion demanded – no matter how unexpected.

Officials at Buckingham Palace in June 1966 were somewhat alarmed when they found Brabham in a courtyard, top hat cast aside and still decked out in his morning suit after receiving an OBE, lying beneath his road car and whacking a jammed starter motor. There was no mechanical misfortune thirteen years later when John Arthur Brabham became the first man to receive a knighthood for services to motor racing.

By then he was back in Australia, living in retirement but missing the buzz of competing, if not the media attention. Always a man to keep himself to himself, and taciturn to a fault (earning the sardonic nicknames 'Chatty Jack' and 'Black Jack'), Brabham will forever remain in the record books as the first – and so far only – man to win the Drivers' and Constructors' championships at the same time.

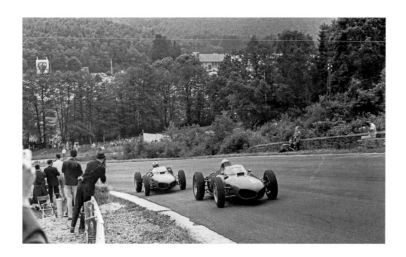

Phil Hill

1961

Stirling Moss always reckoned that if you crept up behind Phil Hill as he stood on the starting grid and shouted 'Boo!' the American would jump three feet in the air. Nervy and anxious he may have been out of the car, but once in the cockpit Hill had a calm and composed style that was good enough to make him World Champion.

Hill took part in forty-eight championship Grands Prix, the vast majority of them for Ferrari. The Californian had come to Enzo Ferrari's attention thanks to consistent success in local amateur sportscar races, first in a Jaguar XK120 and then at the wheel of Ferraris owned by wealthy collectors.

Hill's performances had been so fast and assured that he was offered a seat in the Ferrari works sportscar team, and would go on to justify the choice with some classy and brave

victories. There were few more impressive than the Le Mans 24 Hours in 1958 when Hill drove through the night in teeming rain; conditions in which he excelled for reasons he could never fully explain. His partnership with the Belgian Olivier Gendebien would be one of the most successful and enduring in world sportscar racing.

Unusually for a motor-sport enthusiast from the United States, Hill had a burning desire to reach Formula 1. Ferrari were aware of this and in 1958, with the loss of Luigi Musso and Peter Collins within a month, Hill was the logical replacement. He led from the start of his first Grand Prix for Ferrari at Monza until tyre problems dropped him to a nevertheless very fine third, Hill then handing second place in Morocco to Mike Hawthorn to help the Englishman win the title.

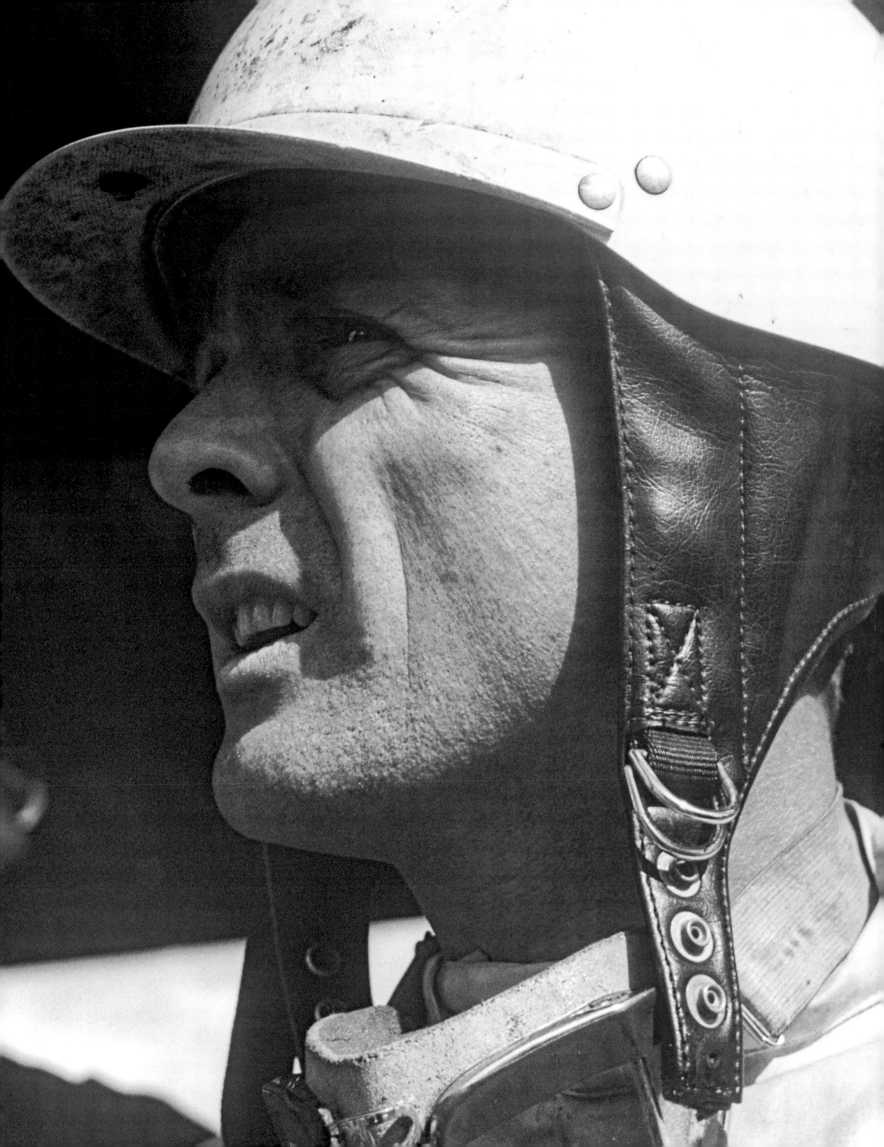

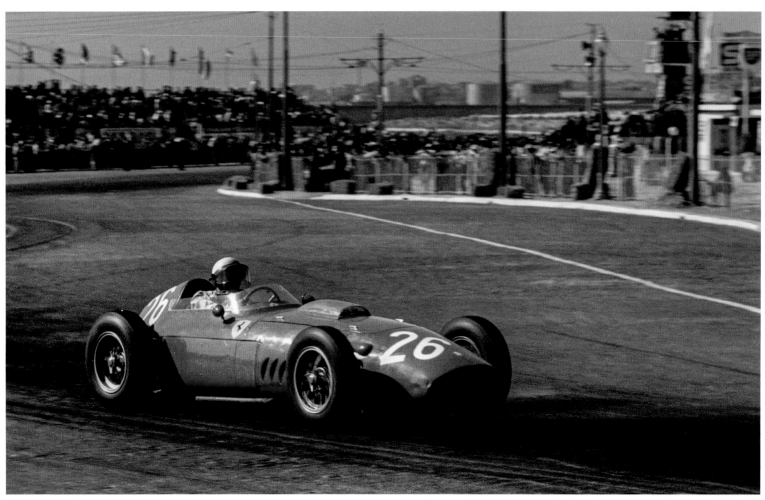

The timing of Hill's first two full F1 seasons coincided with the Ferraris being outclassed by the smaller and lighter rear-engine Cooper and Lotus, but a boycott of Monza on safety grounds by the British teams in 1960 gave Hill, now the Ferrari team leader, the chance to win his first Grand Prix.

It was a very different story the following year. Ferrari were fully prepared for a change of formula in 1961, the so-called 'Sharknose' winning four of the first six races, leaving Hill and his team-mate Wolfgang von Trips in contention for the title going into the penultimate round at Monza. Hill won the race and clinched the championship – but under the most dreadful circumstances as von Trips was killed.

A sensitive, highly articulate and intellectual man, Hill was deeply affected by events that day. But such was his love of racing, living in Italy and enjoying its classical culture that he chose to continue. It was a serious misjudgement. Complacency and inadequate development led Ferrari into decline. Such were the pernicious internal politics that Hill unfairly took the blame and decided to leave at the end of a season that brought him just two second places.

If 1962 had been disappointing, the next two years with ATS and Cooper would be disastrous, Hill then leaving F1 to return to sportscars, his final international victory coming with the high-winged Chaparral 2F at Brands Hatch in 1967.

Quietly drifting away from racing, Hill got married and began a successful business restoring classic cars in Santa Monica. Along the way, he took up the pen to write erudite features and reflect on a World Championship, three Le Mans

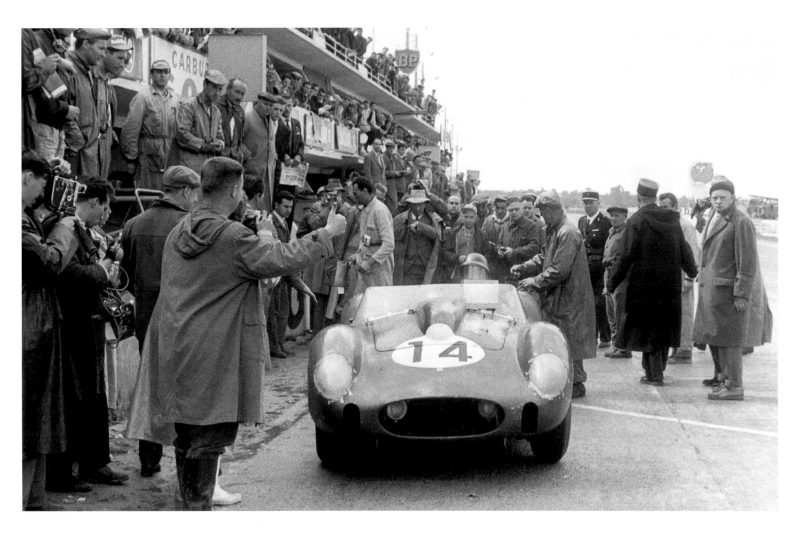

Opposite top Hill cut his teeth racing sports-cars in his native California in the early Fifties

Opposite bottom Hill's first years in F1 were made difficult by the front-engine Ferrari largely becoming obsolete. He worked hard with the Dino 246 in the 1960 Portuguese Grand Prix before retiring after hitting straw bales lining the street circuit in Oporto

Above Hill scored the first of three victories in the Le Mans 24 Hours with an outstanding performance with the Ferrari 250 TR he shared with Olivier Gendebien in 1958

Left Strapped in to deal with the bumpy Monza banking, Hill looks suitably tense in his V12 Ferrari before the start of the 1958 'Race of Two Worlds', a contest between F1 cars and Indianapolis roadsters. Hill came home third, the first F1 finisher

'When I think back on it all, it really does seem crazy to be so obsessed with that occupation. I had a lot of happy times with Ferrari and in racing generally, but I would have liked to have been more mature across the board throughout my career – but then if that had happened I would probably have had more sense than to be a racing driver in the first place!'

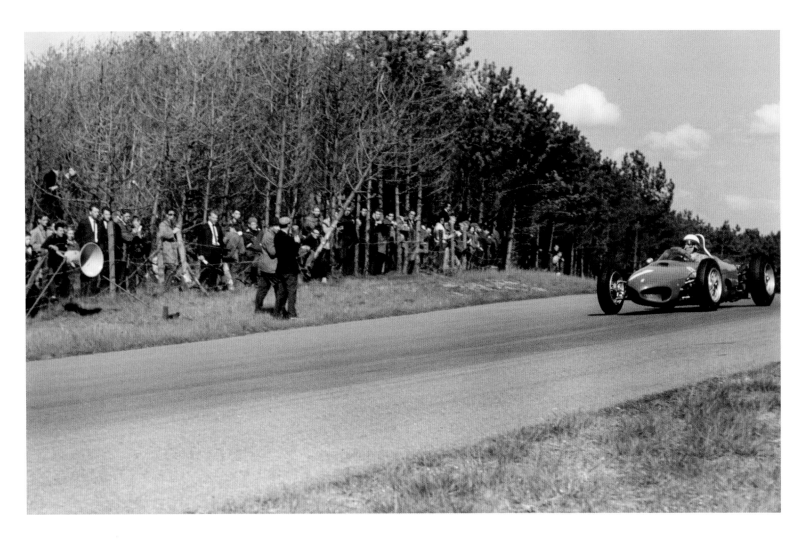

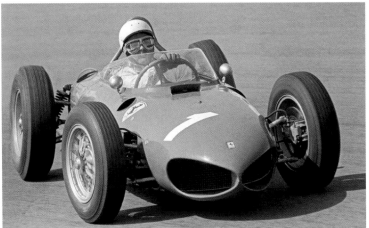

victories and countless others achieved without having hurt
himself during a hazardous era.

Phil Hill would suggest that perhaps his survival was due to him
not trying hard enough, but such a typically wry remark allowed
no credit for the skill of one of the most intelligent of racing
drivers, a mild-mannered man who was World Champion almost
in spite of himself.

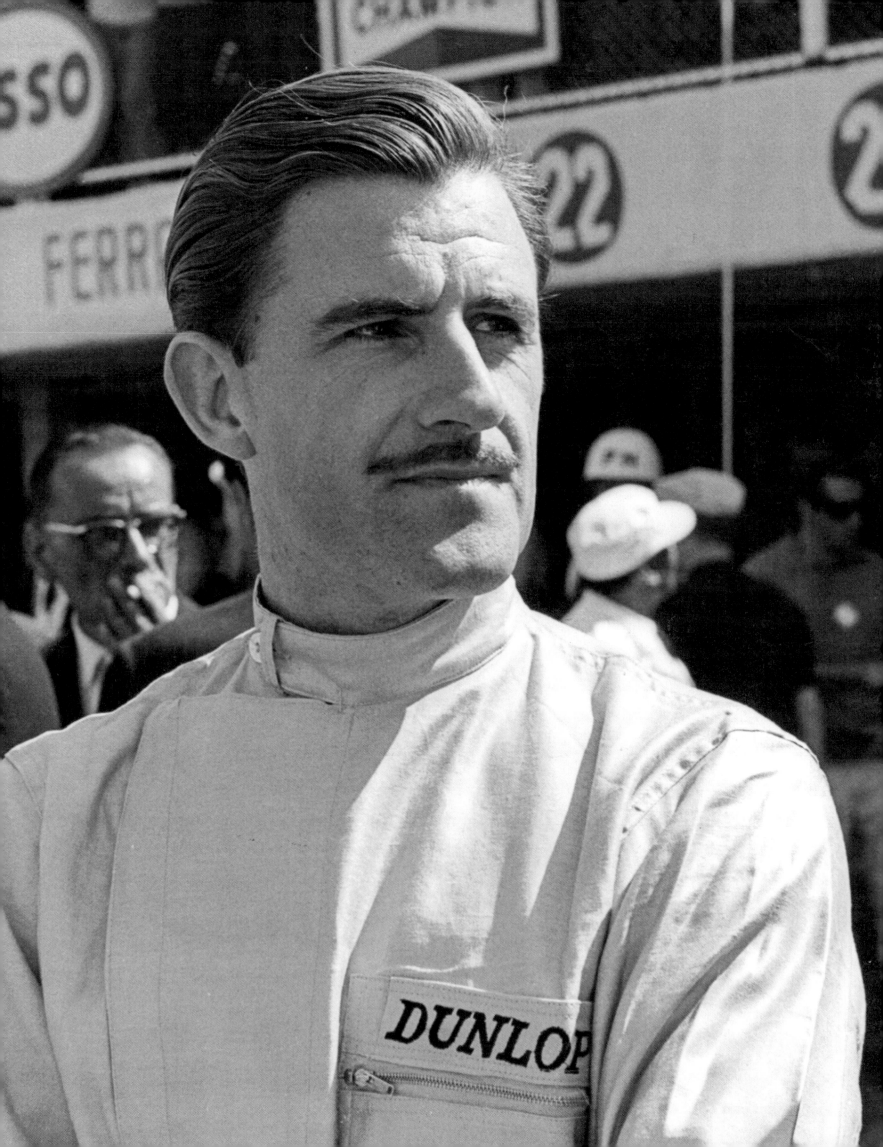

Opposite Graham Hill in typically determined, stiff-upper-lip pose

Right On his way to a maiden F1 victory with the BRM P57 in the 1962 Dutch Grand Prix and his first World Championship

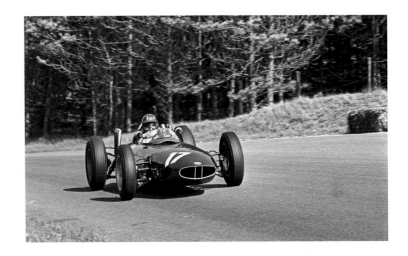

Graham Hill

1962, 1968

Graham Hill bought a humble Morris 8 shortly before his 24th birthday in 1953. He paid £110 for the nineteen-year-old car, climbed on board and headed for home across London. He had never driven a car before. Everything about that improbable story sums up a man who would go on to win two World Championships thanks to a bloody-minded refusal to be defeated, allied to a quick wit and natural charm.

Having been lured by the thrill of a few laps in a car at a racing school, Hill would not rest until he had worked out how to get behind the wheel again – but without having to pay for it. Money was in such short supply one weekend that Hill found himself spectating at a race meeting with no means of getting home. Passing conversation with a team owner got Hill a lift back to London. It was to be one of the most fortuitous moves of his life: Hill had just met Colin Chapman.

Quickly realising that Chapman's fledgling Lotus outfit was a handy place to be, Hill began working as a mechanic. One thing soon led to another, with Hill moving from the driver of a loaned Lotus sportscar to a member of the works team as Lotus made its Grand Prix debut at Monaco in 1958. Having started from the back of the grid and not passed a single car, Hill found himself in fourth place. And then a rear wheel parted company with the car.

Further proof that Formula 1 was not as easy as it seemed would follow as Lotus found its feet but struggled with reliability issues. By the end of 1959, Hill had had enough and signed for BRM to begin a frequently brilliant partnership that was to last for seven years.

It took a while to get going as the British team adapted to a new formula in 1961 but the following year was to be memorable, with Hill winning his first Grand Prix in Holland, then running the

Right Hill held fourth place until a wheel fell off the Lotus-Climax 12 during his F1 debut at Monaco in 1958

Below The 1962 Dutch Grand Prix with the BRM P57 and the first of fourteen Grands Prix wins

Opposite top Every reason to look rather glum at the Nürburgring in 1961 when Hill crashed out of a wet German Grand Prix

Opposite bottom Having won the first heat of the non-championship Brussels Grand Prix in 1962, Hill was disqualified from the second heat for receiving a push start in his BRM P57

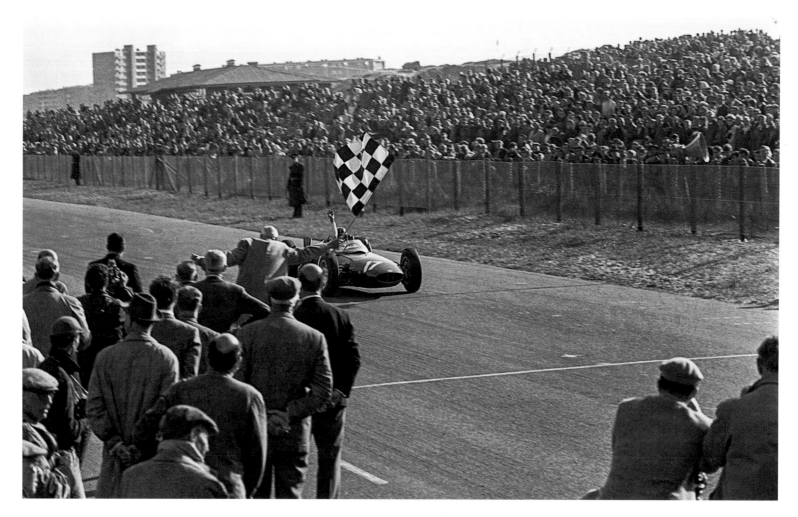

championship to the wire and taking the title after a season-long battle with Jim Clark.

BRM made little progress in 1963 against the domination of Clark and the Lotus 25, but twelve months later it was to be an all-British fight for the title, the Ferrari of John Surtees pipping Hill and Clark, despite Graham having a points advantage going into the final race.

When BRM outfoxed themselves with a heavy and complicated engine for the new 3-litre formula in 1966, Hill felt the time had come to move on. The reason was perfectly understood, but not the decision itself, as Hill elected to rejoin Lotus.

It took a driver of considerable courage and confidence to accept the offer of driving alongside Clark but Hill's strength of character was to be put to a massive test in 1968 when the Scotsman was killed in a Formula 2 race. The team – and Chapman in

particular – was devastated. Hill put the grief behind him by winning the next Grand Prix in Spain and lifted spirits even more with an imperious victory at Monaco. When Hill once again found himself in a three-way fight for the title, he made sure of his second World Championship thanks to a gutsy drive in Mexico.

Flying a private plane (bought with the substantial prize money that had come with staying out of trouble and winning an eventful Indianapolis 500 in 1966), Hill travelled the length and breadth of the country. In huge demand, he regularly took part in television panel games in between making public appearances. The nation took him to its heart as 'Mr Motor Racing' and 'Mr Monaco' (following a record five victories in the principality, a clear sign of the relentless precision Hill brought to everything he did).

Behind the public persona of natural charm and sparkling wit

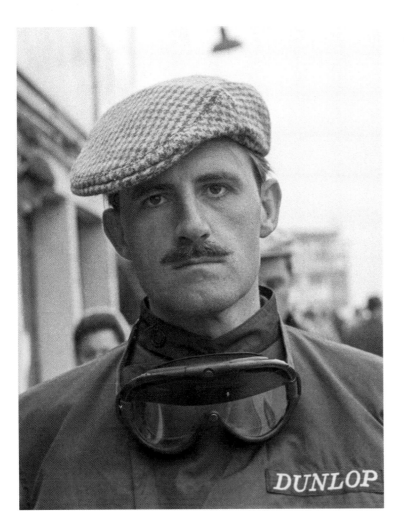

'When I won the last race of 1962 with the BRM in South Africa and emerged as World Champion, it made me the first British driver ever to win the World Championship in an all-English car. The Championship Cup itself wasn't all that imposing to look at – but it meant so much, it didn't have to be.'

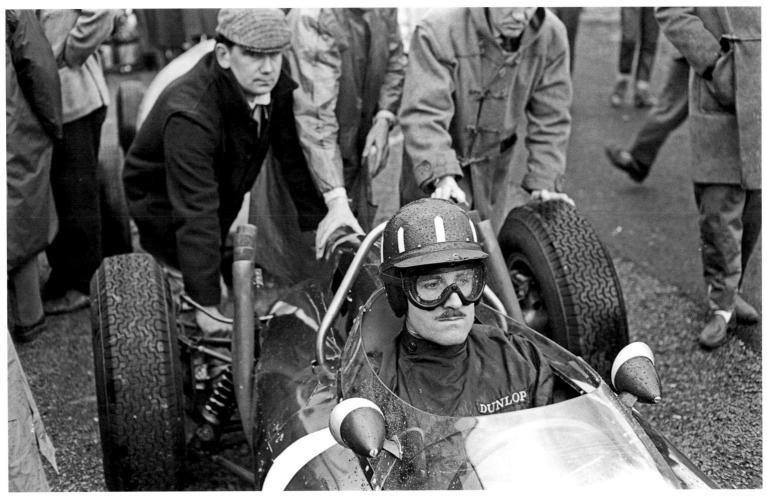

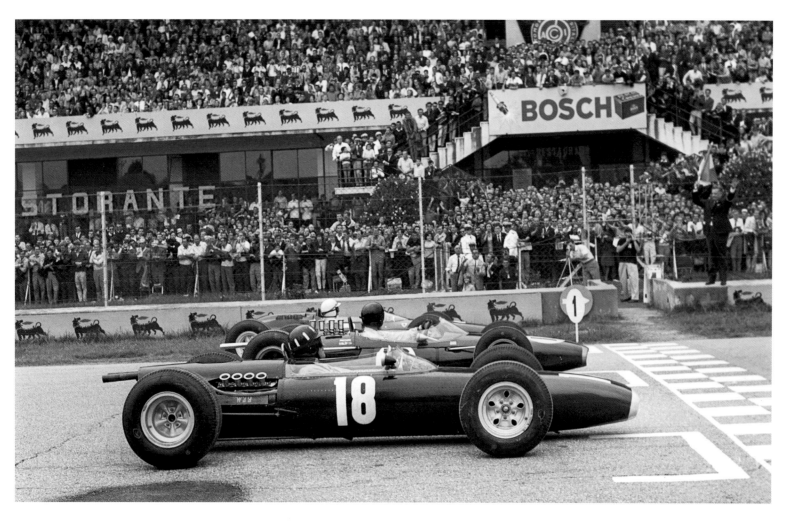

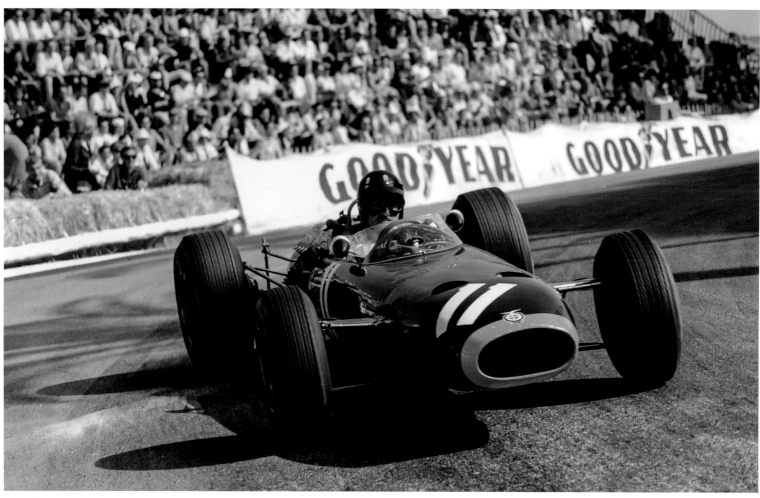

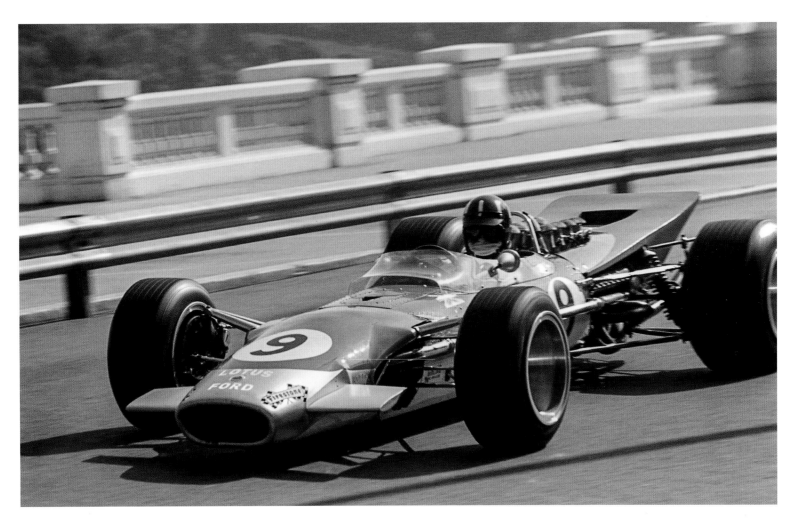

Opposite top The clutch on Hill's BRM P261 (18) is about to fail at the start of the 1964 Italian Grand Prix, severely denting his chance of winning the championship

Opposite bottom The Master of Monaco. Hill won the classic street race five times

Above Following the shock of Jim Clark's death in April 1968, Hill gave the beleaguered Lotus team an enormous boost by immediately winning in Spain and Monaco (*above*) with the Lotus-Ford 49 and going on to take his second World Championship

Right Hill made a brave decision to join Jim Clark at Lotus in 1967

lurked a sometimes gruff and occasionally uncivil character. That would become evident to those working with him as his rate of success went into decline, not helped by a terrible accident near the end of the 1969 season when he broke both legs.

Typically, Hill refused to let go, finishing a resolute sixth in a privately entered Lotus at the end of his comeback race in South Africa just five months later. There would be ignominious moments, such as failing to qualify for Monaco, and an outstanding high when he shared the winning Matra at Le Mans in 1972 to claim the Triple Crown (the World Championship, Indianapolis and Le Mans). But, there was a mix of respect and not a little relief when Hill's retirement from the cockpit was announced at the 1975 British Grand Prix.

Now he could concentrate fully on running his own F1 team, Hill being genuinely excited about nurturing the burgeoning talent of his young British driver, Tony Brise. It was a stimulating new beginning that was to have an abrupt and terrible end.

Returning from a test session in the south of France on 29 November 1975, Hill's twin-engine aircraft crashed while trying to land at Elstree in freezing fog. Graham, Tony Brise and four members of the team perished. Radio and television programmes were interrupted that night to give the devastating news.

Tributes flowed from around the world, recalling the endeavour, guts and good humour behind two world titles and fourteen Grand Prix victories. More than that, there were affectionate messages from members of the public who neither knew nor cared particularly about motor racing but for whom Norman Graham Hill OBE was the epitome of a gritty, stylish and very British sportsman.

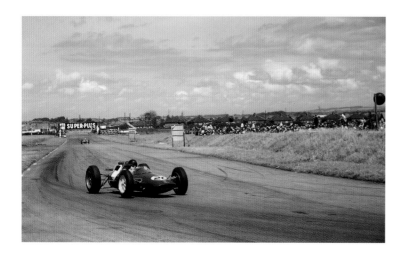

Jim Clark and the Lotus-Climax 25 proved to be an unbeatable combination: the Scotsman on his way to victory (*left*) in the 1962 British Grand Prix at Aintree

Jim Clark

1963, 1965

The inscription on the headstone in Chirnside parish churchyard describes Jim Clark as 'Farmer'. Beneath, it says he was 'World Champion Motor Racing Driver'. The sequence perfectly sums up this quiet genius from the Scottish Borders just as the detail of his life span – 4 March 1936 to 7 April 1968 – serves as a reminder of how the driver recognised by peers as the greatest of his generation was cut down in his prime.

That April day is seared into the minds of anyone who followed motor racing in the 1960s. Clark's death during a relatively minor Formula 2 race not only came as a shock but also underlined the reality that such a dangerous era could ambush a driver for whom driving fast came easily. Naive as it may sound today, it is not an exaggeration to say that Clark seemed indestructible.

Clark would never have seen himself in that light. Modest to

a fault, he was reluctant in the early days to accept an offer to drive a neighbouring farmer's DKW in a club race before lapping the two-stroke saloon three seconds faster than it had ever gone before. Keen to channel this obvious talent, Clark's friends formed a team and purchased a Lotus Elite. The new car from Colin Chapman's latest production line was delivered just in time for the 1958 Boxing Day meeting at Brands Hatch.

Chapman, no mean driver himself, had also entered his own Elite and was fully expected to win. Despite never having been to the Kent circuit before, nor having any experience of this sportscar, Clark took the lead on a Club Circuit made greasy by rain. Had it not been for a wayward backmarker, he would have won. Chapman, mightily impressed, would go on to help mould this raw talent into something very special.

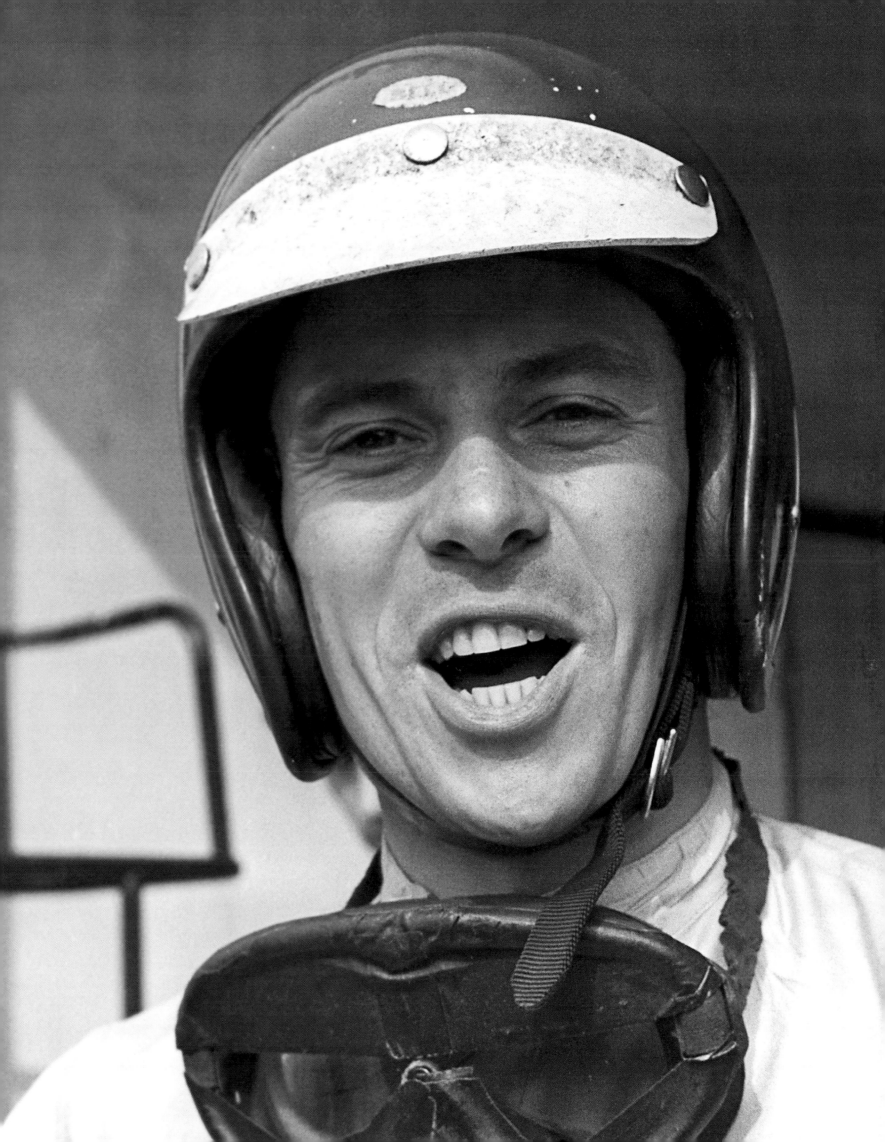

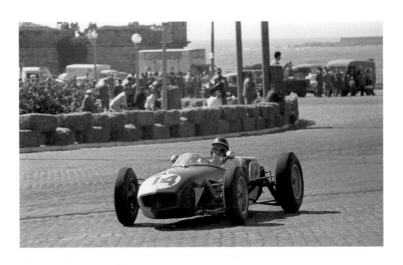

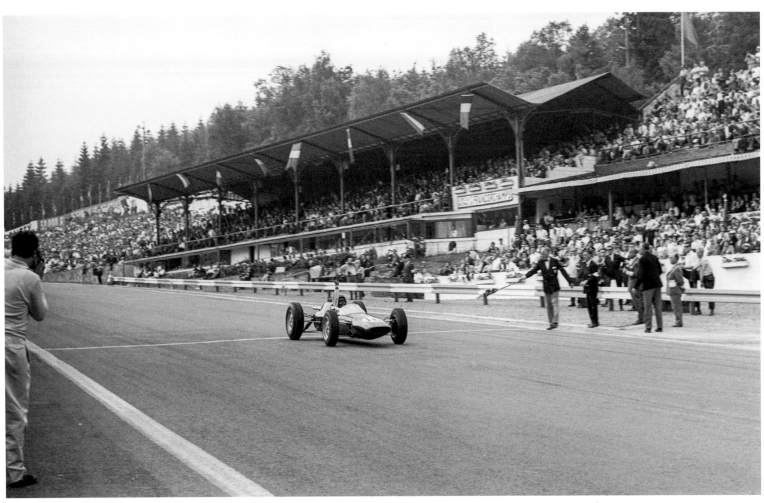

The partnership began in 1960 when Clark agreed to race with Lotus in the junior formulae. When Lotus F1 driver John Surtees had a clashing motorcycle commitment, Clark was asked to take his place in the Dutch Grand Prix at Zandvoort. He worked his way into fourth place before retiring; a debut impressive enough to have Clark entered for the next Grand Prix in Belgium.

Clark knew all about Spa-Francorchamps. When racing a Jaguar D-Type for his Scottish mates two years previously, he had witnessed the loss of fellow countryman Archie Scott Brown. This sense of foreboding would be exacerbated for Clark in the Grand Prix when Chris Bristow and Alan Stacey, a good friend of his, were killed on the same weekend.

Clark came to detest Spa-Francorchamps and yet the Belgian circuit, along with Zandvoort, would give him more success than any other F1 track. He won his first Grand Prix (and the first of four at Spa) in 1962, not long after the introduction of the Lotus 25. Chapman's creation would not only rewrite the record books, it would also set new design standards with its light and strong monocoque chassis. Clark would have won the championship but for the Coventry Climax V8 losing its oil in the final race.

In 1963, there was to be no doubt about his supremacy as Clark won seven Grands Prix, but settlement of the title at Monza would be tainted by an ongoing investigation into a collision two years before. (Wolfgang von Trips had failed to see Clark slipstreaming the German's Ferrari during the Italian Grand Prix. The two cars touched and von Trips crashed into a fence, killing the driver and fourteen spectators.)

There were no such repercussions two years later when Clark

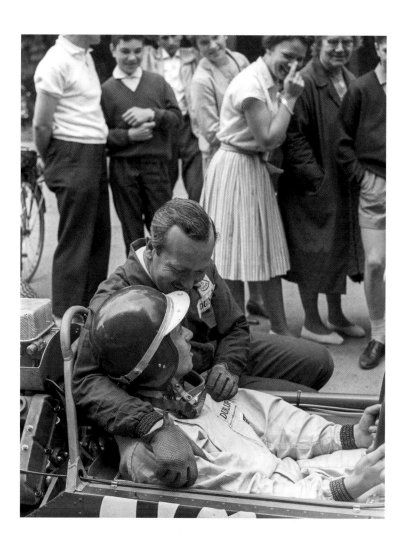

Opposite top With the nose of his Lotus-Climax 18 showing repair work following a rare mistake during practice on the streets of Oporto, Clark speeds towards third place in the 1960 Portuguese Grand Prix

Opposite bottom Clark detested Spa-Francorchamps but won the Belgian Grand Prix four times. This is the first, with the Lotus 25, in 1962

Left Colin Chapman congratulates Clark after his first-ever Grand Prix win in the 1962 Belgian Grand Prix

Below Clark with the Lotus 25 at Reims, on his way to the third of seven wins in 1963, his first championship year

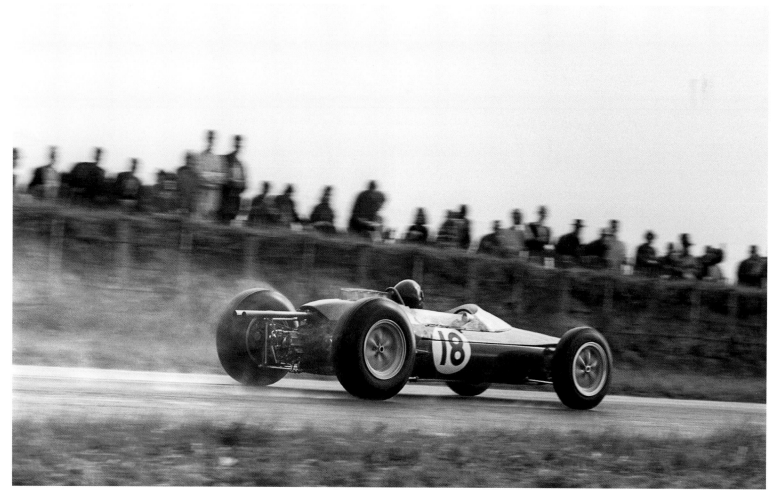

Clark streaks into the lead of the 1963
German Grand Prix at the Nürburgring
Nordschleife but an engine misfire
would relegate the Lotus 25 to an
eventual second place

Clark streaks into the lead of the 1963
German Grand Prix at the Nürburgring
Nordschleife but an engine misfire
would relegate the Lotus 25 to an
eventual second place

arrived at Monza as champion for a second time. Having also
reached new heights by upsetting the American establishment
and winning the Indianapolis 500 – in a Lotus, of course – there
were thoughts that Clark might retire, marry his long-time girlfriend
and return to farming in the Borders.

In fact, he would be more committed to racing than ever with
F2, F1 and a return to Indianapolis, in between adapting to a more
cosmopolitan lifestyle while living in Paris. His visits to the UK (and
his beloved Scotland) may have been limited for tax reasons, but
the British Grand Prix was always marked as essential.

After a difficult season in 1966, Lotus became competitive again
with the launch of the Lotus 49 and the Ford-Cosworth DFV, a
combination Clark used to great effect by winning at Silverstone in
July 1967. Little did his many fans know, this would be the last they
would see of him on home soil.

Following an easy win in the South African Grand Prix at the start
of 1968 and a race series in Australia and New Zealand, Clark's
European schedule took him to Hockenheim for a Formula 2 race
on 7 April. The overcast conditions that day seemed to match his
uncharacteristically introspective mood as he held eighth place,
neither challenging nor being challenged. For reasons that were
never satisfactorily explained, the Lotus 48 left the wet track on a
gentle right-hand curve and smashed into trees (unprotected by a
guard rail of any description). Clark was killed instantly.

The accident was front-page news, reports recounting a record
25 Grand Prix wins from 72 starts, 33 pole positions, 6,331 miles in the
lead and 28 fastest laps along the way.

But race fans remembered much more than that. They fondly
recalled the shy man who would become relaxed at the wheel

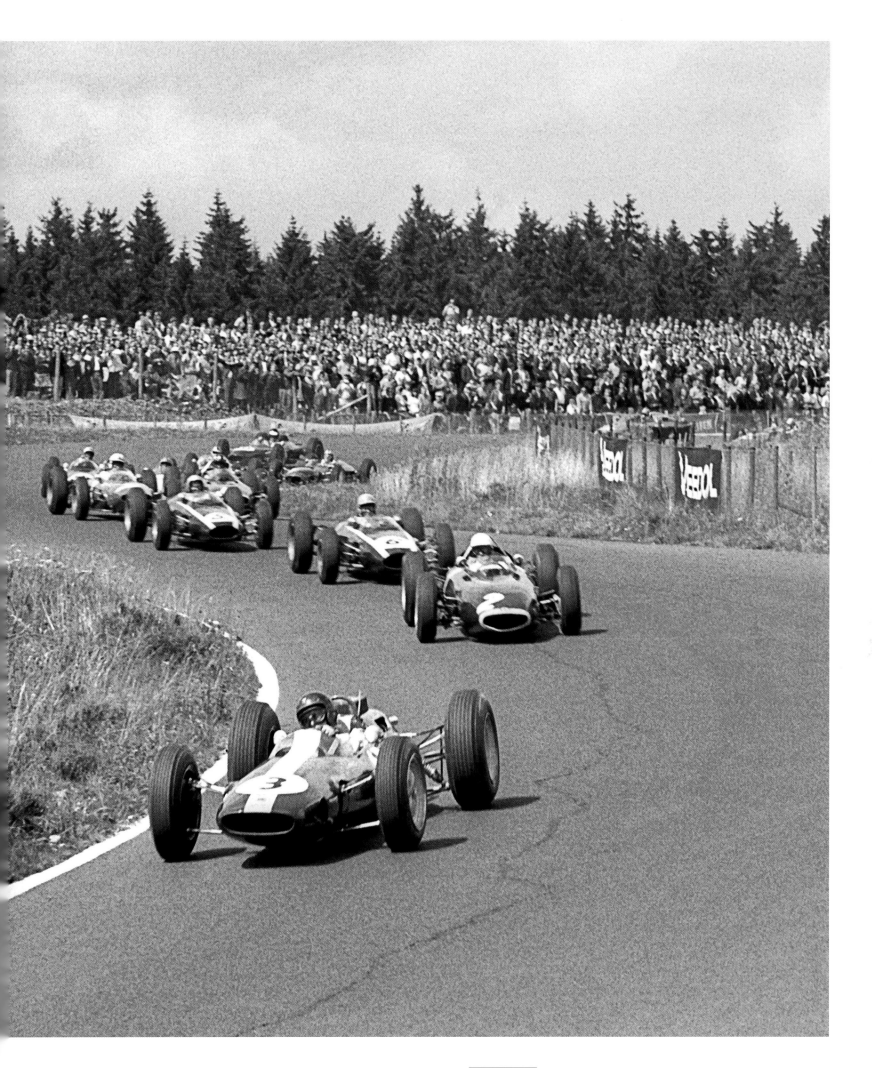

'It was never a matter of feeling
I had to prove anything to myself
or anyone. I was curious to find
out what it was like to drive a car
fast, to drive on a certain circuit,
to drive a certain type of car.
I found I enjoyed motor racing.
I started as an amateur, as a
hobby, with no idea or intention
of becoming World Champion.'

Opposite top Clark gets his Lotus 25 uncharacteristically out of shape while leading the 1964 Belgian Grand Prix

Opposite bottom Colin Chapman shares Clark's victory in the 1964 Dutch Grand Prix at Zandvoort

Below top Clark and the Lotus-Climax 33 heading for victory in the German Grand Prix, the sixth in 1965, his second championship year

Below bottom The arrival of the Lotus-Ford 49 mid-way through 1967 put Clark on another potential winning streak. Victory in the season-ending race at Mexico hinted at another championship that would ultimately be denied by a fatal accident in April 1968

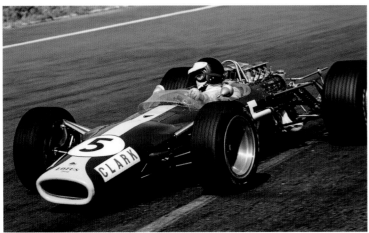

and produce graceful performances that were stunning in their speed and apparent simplicity. They would recall the way he had fun by throwing a Ford Lotus Cortina into absurd angles; recollect the day at Oulton Park in 1964 when he stepped into a GT car, a sportscar and a saloon car – and won all three races, almost because he could; because of the sheer joy of driving quickly.

The loss of Jim Clark at the age of thirty-two was so profound that motor sport, in deep shock, found itself without a leader – and suddenly seemed terribly vulnerable.

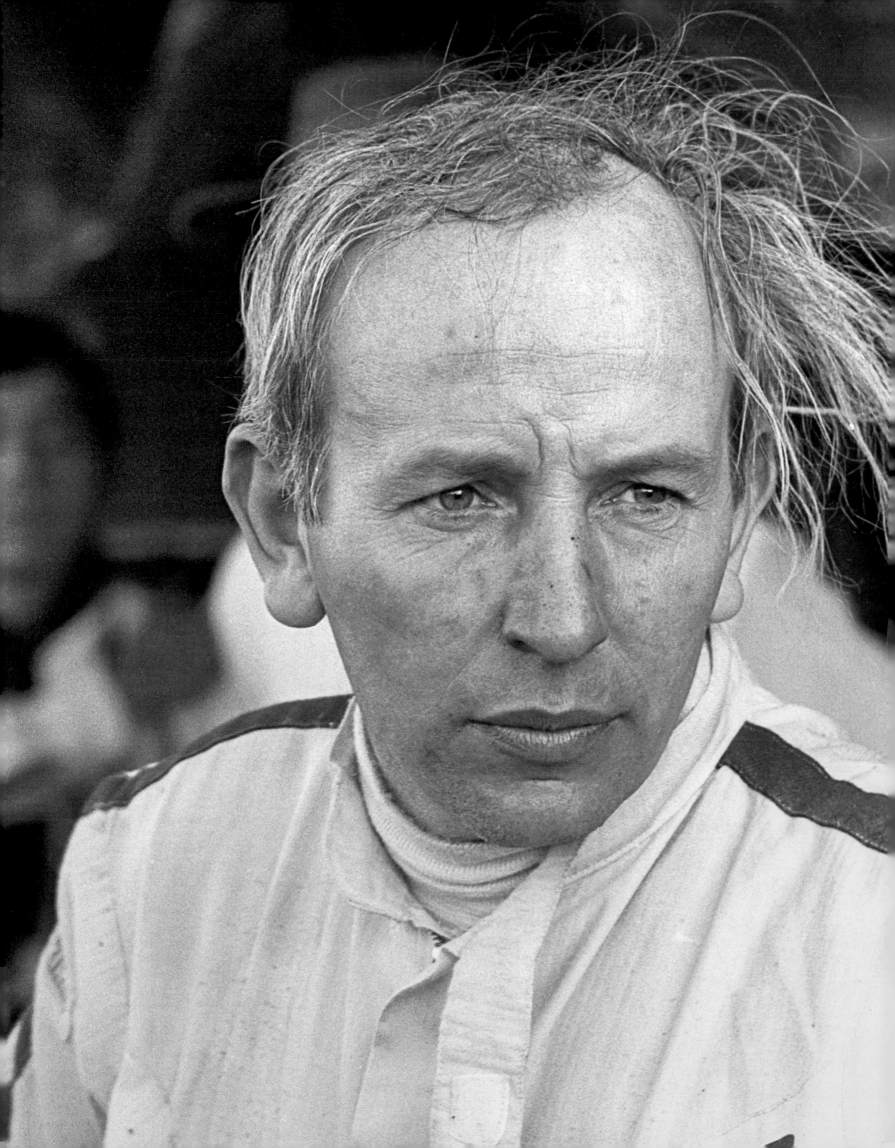

John Surtees won World
Championships on two wheels and
four, with Ferrari taking the Englishman
to the title in 1964 (*right*)

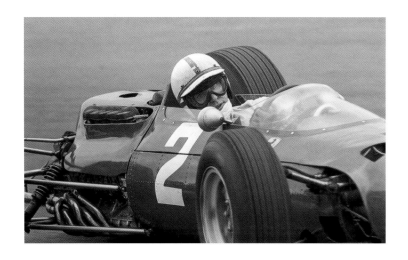

John Surtees

1964

John Surtees was World Champion on two wheels and four; an unequalled achievement that only begins to scratch the surface of a career as remarkable as it was varied – and, at times, outspoken. It's probably true to say that a willingness to express forthright views denied the Englishman even more success than the records show.

A family background in motorcycle racing and extensive success on two wheels led to a works ride with MV Agusta, for whom he won seven World Championships. Such natural ability would take on a new dimension in 1960 when he switched to cars and was immediately competitive. Despite having no knowledge of either Goodwood or the intricacies of motor racing, Surtees qualified on the front row for a Formula Junior race and finished second to Jim Clark.

A couple of months later, he took part in the Monaco Grand Prix and, two months after that, Surtees stood on the British Grand Prix podium after finishing second in his works Lotus. He might have won in Portugal but for an incident caused by a fuel leak and his soaked shoe slipping off the brake pedal. It was a remarkable start by any standard and enough to eventually prompt a decision to focus on four wheels at the expense of racing on two. His bike record – 255 victories from 348 races – requires no further tribute.

When Enzo Ferrari showed interest, Surtees had the temerity to turn down an offer for 1962 because he sensed the Scuderia was top-heavy with drivers and politics. It was a measure of John's standing that Ferrari made a rare second attempt to sign him for 1963, Surtees winning in sportscars and scoring his first Grand Prix victory in Germany. Having helped Ferrari regain competitiveness,

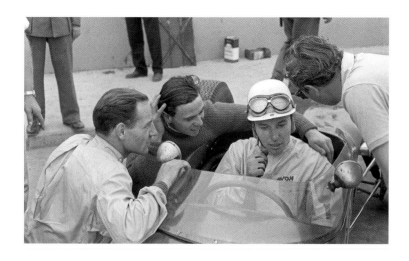

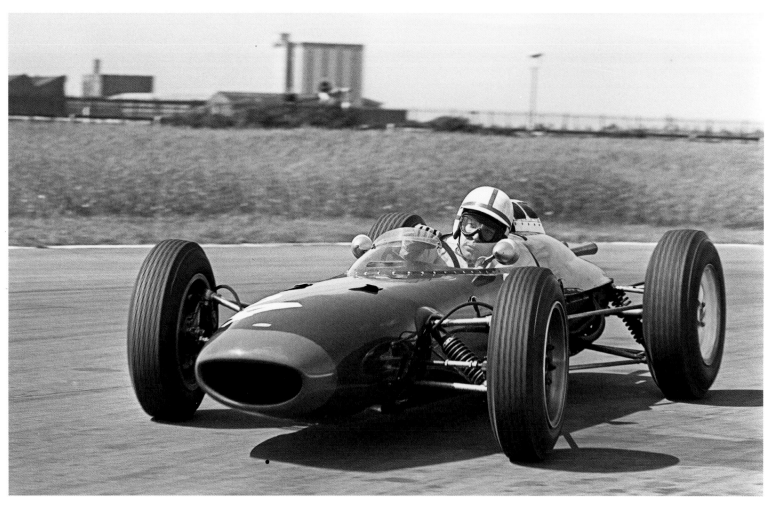

Surtees capitalised on his technical input with two more wins in 1964 and got himself in the running for the title going into the last round in Mexico. He finished second and became World Champion at the eleventh hour when Jim Clark's Lotus failed on the final lap.

A solid streak of stubbornness made him the man he was and undoubtedly helped him return to the cockpit after suffering extensive injuries in 1965 when the front upright broke on a sportscar he was testing for Lola.

Following a long and painful rehabilitation, he won the 1966 Belgian Grand Prix. But life at Ferrari was never smooth, particularly for Surtees who abhorred the inevitable politics. Halfway through the season, Surtees walked out following a row with Eugenio Dragoni, the politically devious team manager. An immediate

move to the uncompetitive Cooper team brought a surprise victory in Mexico.

Honda called upon Surtees to help sort their F1 effort in 1967, part of his cure being a marriage of the Japanese V12 with a Lola chassis. A win in the Italian Grand Prix would be his last in F1, Surtees enduring even more of a struggle with BRM in 1969.

It was almost inevitable that he should design and build his own F1 car, prompted by championship success with an F2 Surtees in the hands of Mike Hailwood. The Grand Prix effort lasted for nine seasons, before financial difficulties and illness eventually forced John to close the doors.

It was while running successful businesses in factory rental and building restoration that Surtees found himself drawn back to the sport in accompaniment with the very promising progress of his

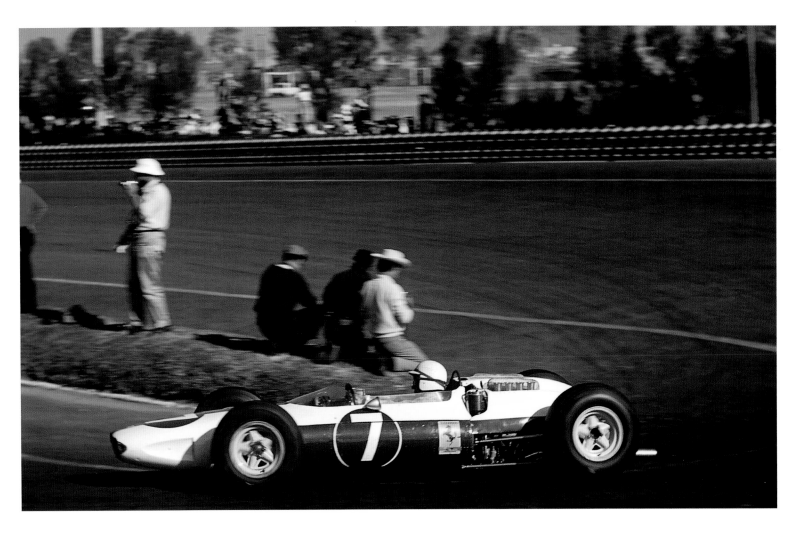

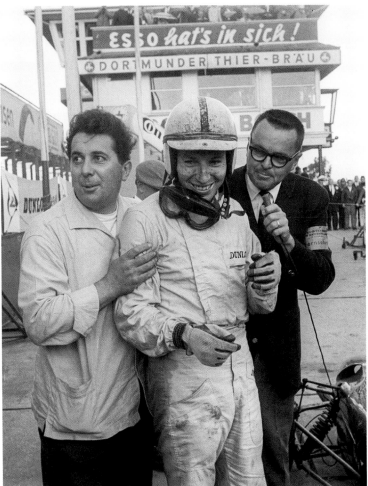

Opposite top Fellow British drivers Innes Ireland (*left*) and Jim Clark gather round the Lotus-Climax 18 with which Surtees came close to winning his third Grand Prix in Portugal 1960

Opposite bottom Concentrating hard on his way to a fine second place with the Lola-Climax 4 in the 1962 British Grand Prix at Aintree

Above Surtees takes his works Ferrari 158 (entered in the colours of the North American Racing Team for political reasons) around the hairpin in Mexico, where second place in 1964 was good enough to win the World Championship

Left Problems for Jim Clark's Lotus-Climax did not detract from a hard-fought maiden F1 win for Surtees and his Ferrari in the 1963 German Grand Prix on the demanding Nürburgring

'I think I was a lot better than my results on paper seem to show. I made some stupid mistakes. I was too emotionally involved and too enthusiastic and enthusiasm is unsuited to the motor racing scene. I was carried away by my little dreams. Looking back, if only I'd chosen the right car at the right time, I'd have had a lot more success. But not so much personal satisfaction, perhaps.'

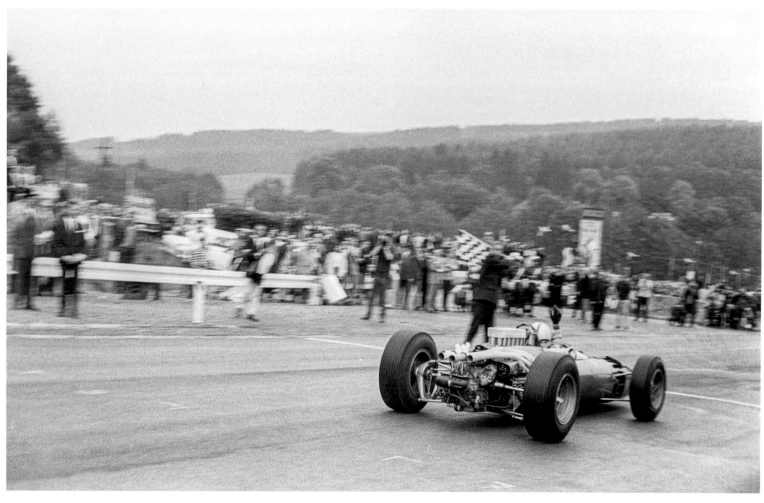

Opposite An imperious victory in the wet 1966 Belgian Grand Prix at Spa-Francorchamps would be his last with Ferrari, Surtees leaving the team a few days later following a disagreement

Below top Surtees raced the Honda V12 for two seasons, winning the 1967 Italian Grand Prix, his last victory in F1

Below bottom Surtees entered a McLaren-Ford M7C for four Grands Prix (pictured at Jarama in Spain) in 1970 before racing his own car

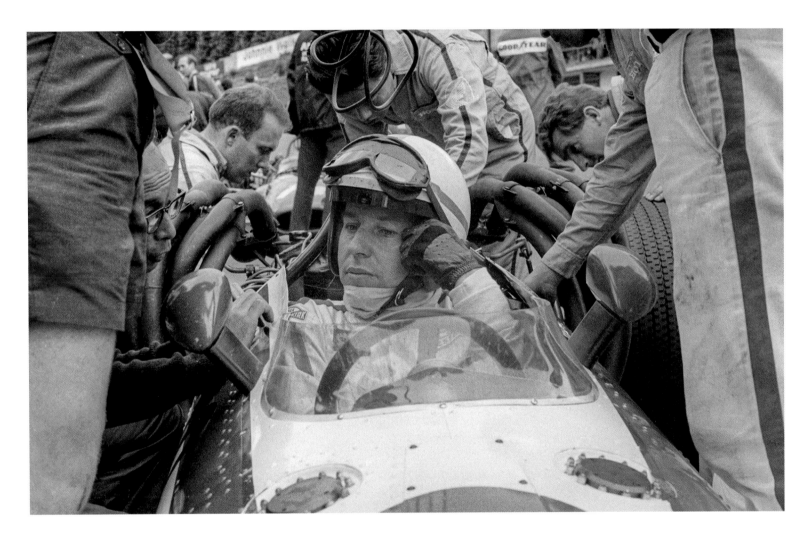

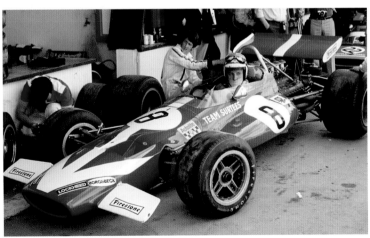

son. Despite the desperate heartache when Henry, at the age of eighteen, was fatally struck on the head by an errant wheel during a Formula 2 race in 2009, John applied his extraordinary tenacity and quiet charm to forming charities for recovery from head injuries and the training of young people.

His passing in March 2017 at the age of eighty-three was mourned by the wide motor-sport world, especially in Italy where he will be forever known as 'Il Grande John'.

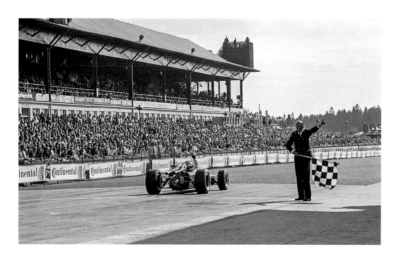

Denny Hulme did not suffer fools gladly. When in the car, he got on with the business, victory with the Brabham-Repco BT24 in the 1967 German Grand Prix (*left*) helping cement the championship

Denis 'Denny' Hulme

1967

The burns were so severe, a nurse had to put the correct change in Denny Hulme's bandaged hands so that he could buy a train ticket home. Upon reaching his destination, he had to wait for someone to open the carriage door. And then he heard that his very best pal, Bruce McLaren, had been killed that morning while testing the CanAm sportscar Hulme had been scheduled to drive. Life for Denis Clive Hulme reached rock bottom at that particular moment.

We are talking here about arguably the toughest and quietest World Champion there has ever been. Realising the McLaren team would have been as devastated as he was, Denny forced himself to drive the brutish CanAm McLaren M8D on its debut in Canada two weeks later. He had to do it for the team. And for Bruce.

Hulme finished third at Mosport that day and sat in the cockpit

for some time afterwards, unable to prise one of his hands from the steering wheel because of unhealed damage from the fire four weeks before.

During practice for the Indianapolis 500, a refuelling vent cap just ahead of the cockpit had popped open and droplets of methanol coursed along the windscreen before making contact with the red-hot turbocharger at the rear. The McLaren, travelling at more than 180mph, burst into a haze of heat. Hulme's leather gloves were already saturated by fuel that burns with an invisible flame. When he eventually hurled himself from the still-moving car, the fire crew rushed past, unaware that the driver was on fire. In one way, he was fortunate that the excruciatingly painful burns were largely confined to his hands.

This was in May 1970, a decade after he had arrived in England

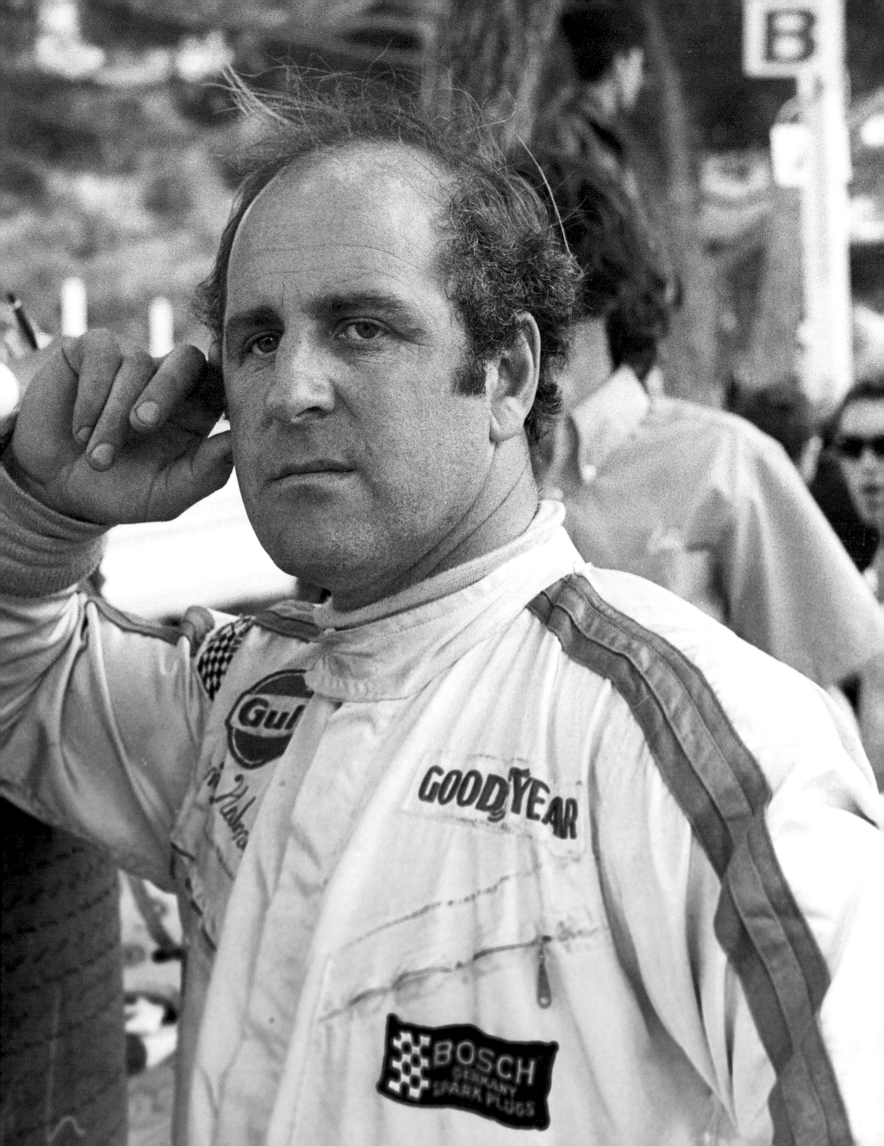

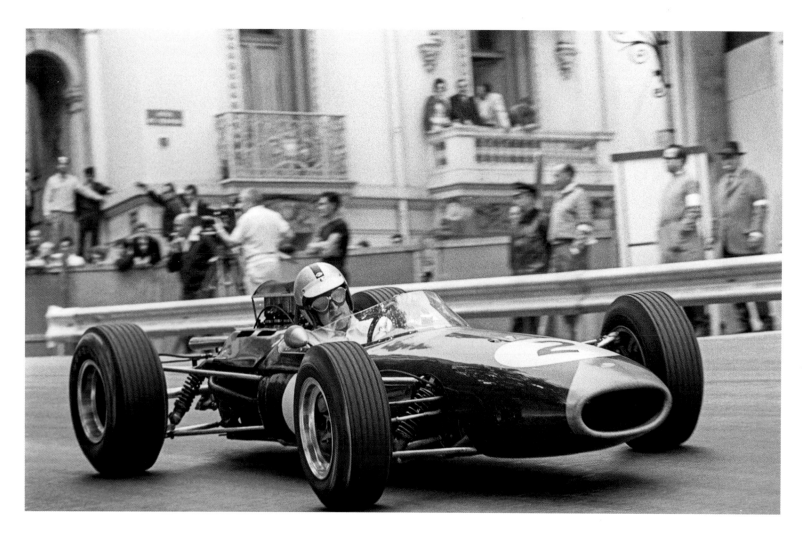

Above Hulme made his Grand Prix debut at Monaco with the Brabham-Climax BT7 in 1965

Opposite top Hulme (pictured at Monza), used his Brabham-Repco BT20 to ably support Jack Brabham's championship challenge in 1966

Opposite bottom Hulme's Brabham-Repco BT20 fends off Lorenzo Bandini's Ferrari and the BRM of Jackie Stewart on the way to winning his first Grand Prix at Monaco in 1967

courtesy of New Zealand's Driver to Europe scholarship. Never one to use chat and diplomacy as a means of advancing his career, the reticent Kiwi spent 1961 towing a Cooper behind his tired Ford saloon as the Formula Junior circus criss-crossed Europe.

Progress seemed even slower the following season as he worked in Jack Brabham's garage as a mechanic, but the lucky break – for Denny if not Brabham's injured Formula Junior driver – came at the end of the season. The outing in the works Brabham was enough to warrant a full season for 1963, with Hulme winning seven times. F2 then led to occasional F1 drives, with Denny and Jack becoming the Brabham F1 entries for 1966. In that year, Hulme also raced Brabham-Hondas in F2, finished second at Le Mans in a works Ford, fourth in the Indianapolis 500 (Rookie of the Year) and was runner-up to Bruce McLaren in the CanAm Championship.

Brabham, meanwhile, won the World Championship, ably backed up by his taciturn team-mate. It would be Denny's turn in 1967 to make very good use of the relatively simple but reliable Brabham-Repco to become the first – and, so far, only – New Zealander to win the title.

Victories at circuits as diverse as Monaco and the Nürburgring Nordschleife were a tribute to Hulme's all-round talent. Six more wins would follow as Denny went home, in a manner of speaking, by joining his Kiwi mates at McLaren for seven seasons. And then, without fuss or fanfare, he walked away at the end of 1974.

Hulme was known as 'The Bear' for good reason. He went racing for the fun of it, rather than talking and thinking about cars for hours afterwards. Journalists would receive short shrift if their questions were not to the point and yet, despite the gruff

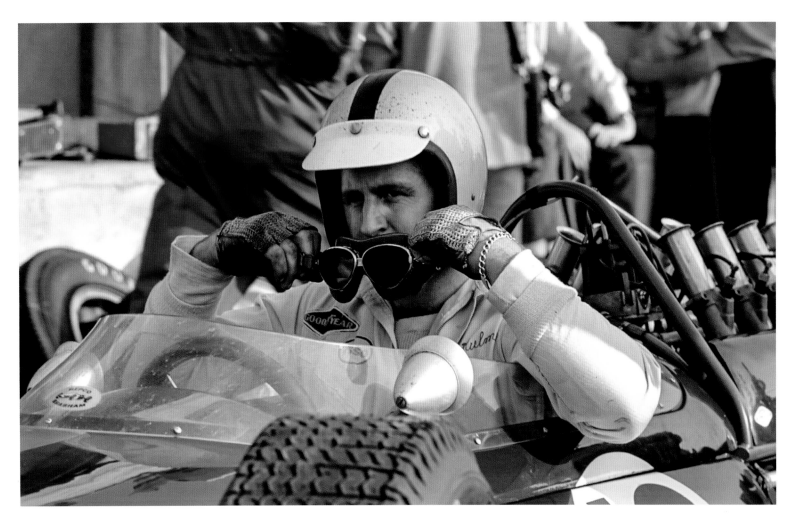

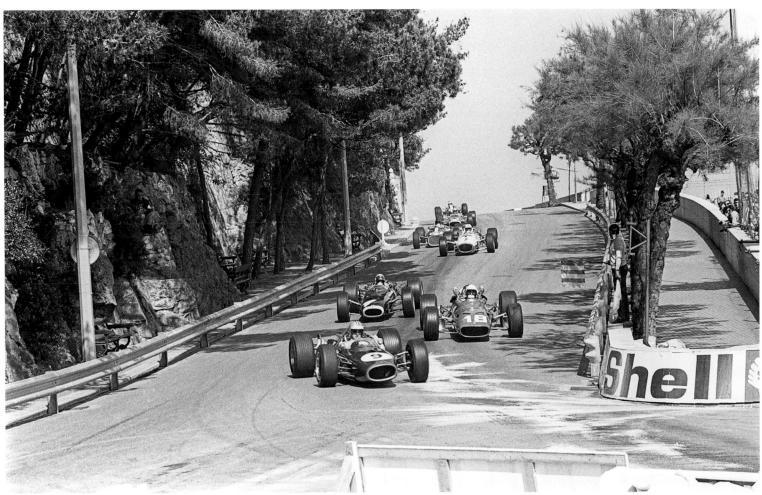

'From the start, I only ever wanted to race cars quicker than anybody else. It was just a day at the races; have a good time; bring it home in one piece. But once you find the championship is within your grasp, you become a bit desperate. Not desperate on the track, but you don't let too much slip you by.'

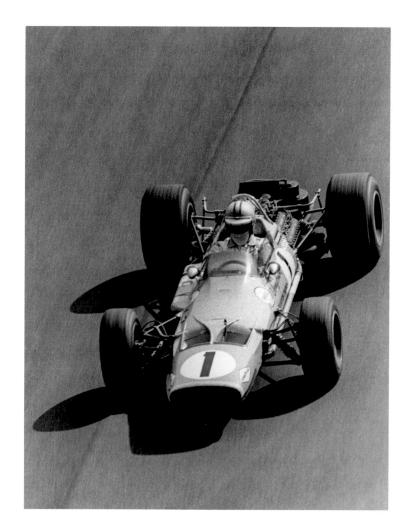

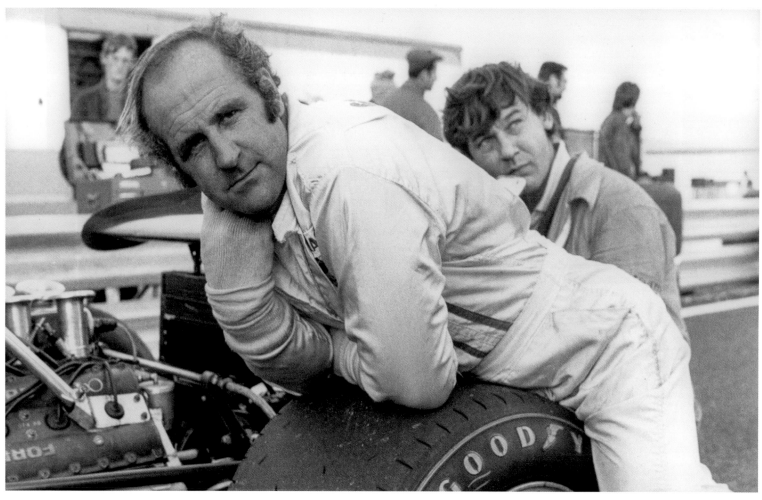

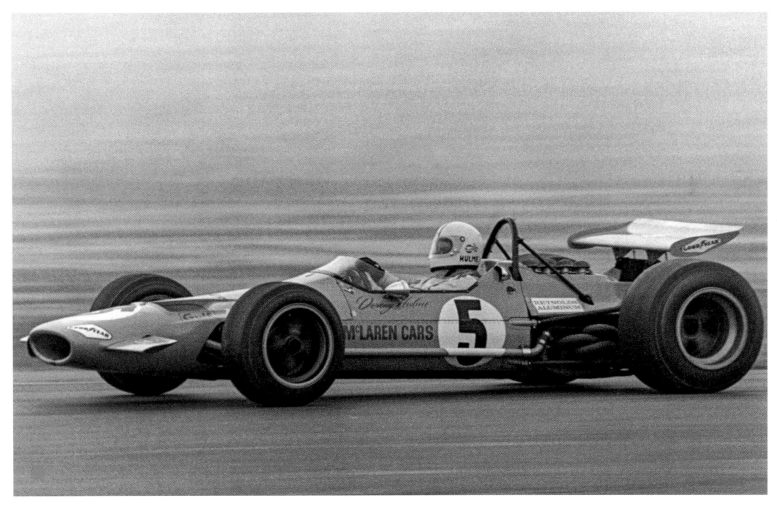

Opposite top On his way to victory with the McLaren-Ford M7A at Monza in 1968

Opposite bottom A languid and gruff exterior hid a warm and decent man inside

Above top Typically unorthodox celebration of a penultimate-lap victory in the 1973 Swedish Grand Prix

Above bottom Hulme uses his relaxed driving style to win in Mexico 1969 with the McLaren-Ford M7A

exterior, he was a warm and decent man inside. There would be a further contradiction through his hobby of fettling and watching stationary steam engines chuffing gently and slowly.

But the need to compete remained, and Hulme returned to race touring cars. It was while taking part in one of his favourite events, the Bathurst 1000 in New South Wales, that Denny suffered a fatal heart attack in 1992 at the age of fifty-six. He managed to bring the car gently to rest without drama. That had ever been his way.

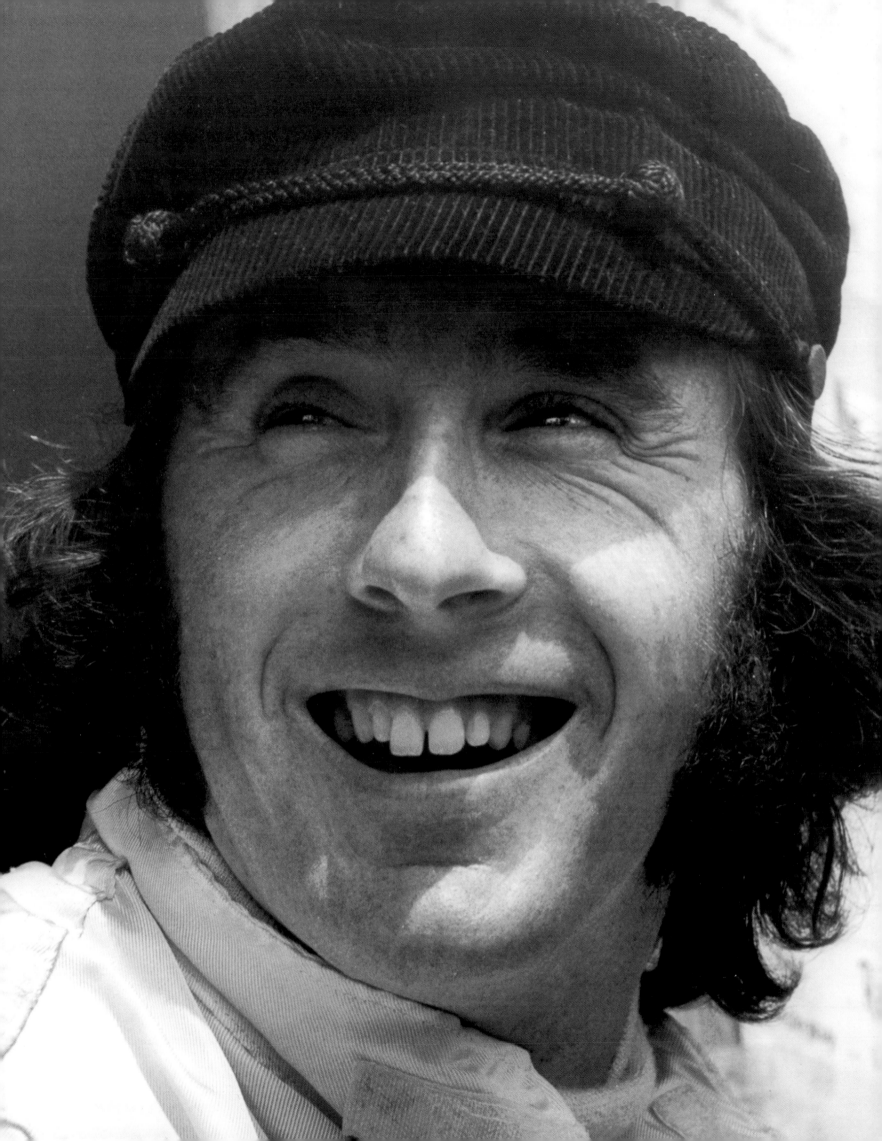

With his trademark corduroy cap, long hair and cheeky grin, Jackie Stewart stamped his personality on and off the track, particularly with an outstanding victory (*right*) in mist and rain during the 1968 German Grand Prix at the Nürburgring Nordschleife

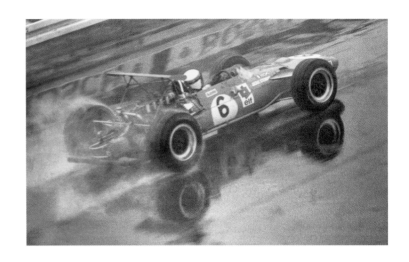

Sir Jackie Stewart

1969, 1971, 1973

Sir Jackie Stewart's influence on international motor sport was generated not only by three World Championships but also when he was sitting still, trapped in a racing car leaking fuel.

The terrifying accident during the 1966 Belgian Grand Prix would have a profound effect on the Scotsman's thinking about safety. By today's standards, driver protection and security were almost non-existent. The prevailing attitude was: 'It's a dangerous sport; if you don't like it, then don't do it.'

Stewart's experience at Spa-Francorchamps highlighted the woeful lack of support when something went wrong. It took two other drivers to come to his rescue, borrow a spanner from a spectator's car and remove the steering wheel trapping their rival in a BRM badly bent after spinning off the wet road and into a ditch. That was just the beginning of the shocking shortcomings as Stewart

and his rescuers found a complete absence of medical backup to deal with petrol burns, a broken shoulder and a cracked rib.

Stewart disregarded widespread criticism from the sport's 'old guard' as he initiated a relentless campaign that would form the nucleus of the rigorous safety values in evidence today. He destroyed cynical suggestions that he was 'scared' by producing one of the greatest drives in F1 history, winning the German Grand Prix by more than four minutes at the Nürburgring Nordschleife, a fourteen-mile track that was fearsome in the dry, never mind the mist and rain making more than a hundred corners and curves a potentially lethal trap that afternoon in August 1968.

Stewart's self-assurance may never have been in short supply but it had received a handy rebuke when he narrowly missed what had seemed a certain place on the 1960 British Olympic

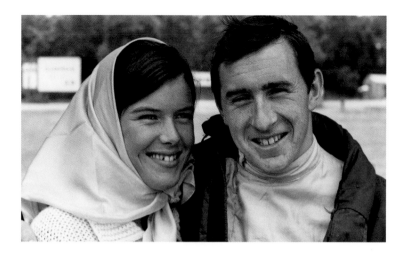

Childhood sweethearts, Helen and Jackie (*right*) travelled the journey together, starting with the early days of Formula 3 in 1964 as Stewart dominated the championship, including this win with his Cooper-BMC T72 at Rouen (*below*)

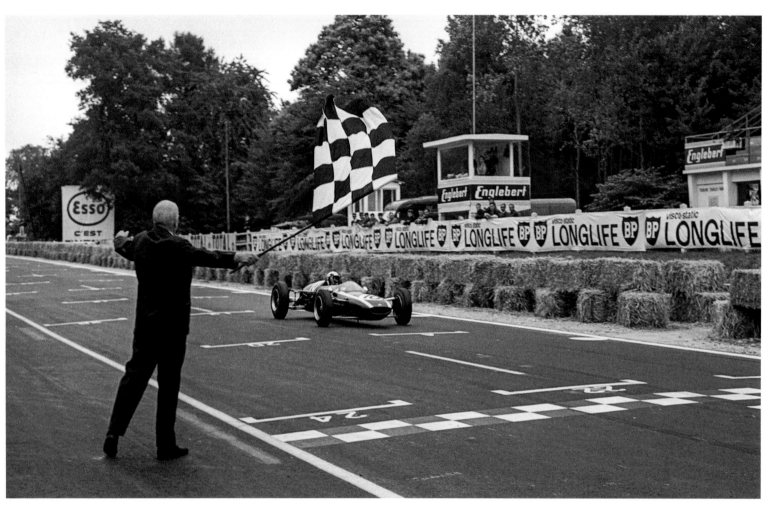

clay-pigeon team. Shooting's loss was to be motor sport's gain as the cocky little Scot made a name for himself in club racing and earned a drive with Ken Tyrrell's Formula 3 team.

The combination won all but two of the races in the 1964 championship and put Stewart in the frame for an F1 drive with Lotus. Showing a canny reasoning that would become his hallmark, Stewart sidestepped the pressure of direct comparison with Jim Clark (much admired by Stewart), turned down an offer that had been doubled by Lotus and chose instead to learn from working alongside Graham Hill in the seasoned BRM team.

Stewart applied similar shrewd thinking at the end of 1967. Rather than accept an offer from Ferrari, he elected to join Tyrrell as the former timber merchant took his small team into F1. Apart from trusting Ken implicitly (the deal was done on a handshake without

the need for a written contract), Stewart's decision had also been swayed by Tyrrell's choice of a Matra chassis, Jackie's experience with the French aerospace company in F2 being nothing but favourable. In the running until the last race of 1968, Stewart and Tyrrell would win their first championship the following year with the Matra MS80, the light-blue car remaining one of Stewart's favourites.

Affection for such a sure-footed machine would not be enough to overcome the effect of politics as Matra were obliged to ditch the Ford-Cosworth V8 engine for their own V12. Stewart and Tyrrell's prediction of an uncompetitive all-French combination would be proved correct but, in the meantime, the reigning champions found themselves in the absurd position of being without a car for 1970.

The purchase of a March-Ford might have been the only alternative (Stewart actually managing to win a Grand Prix with the

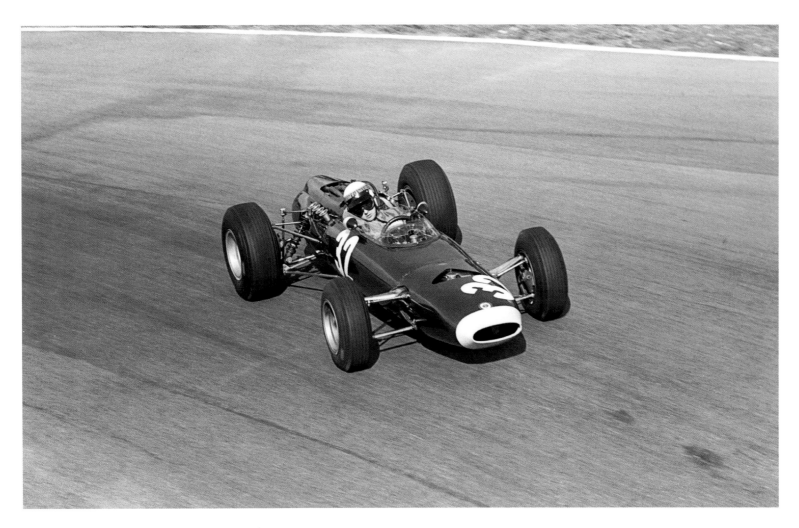

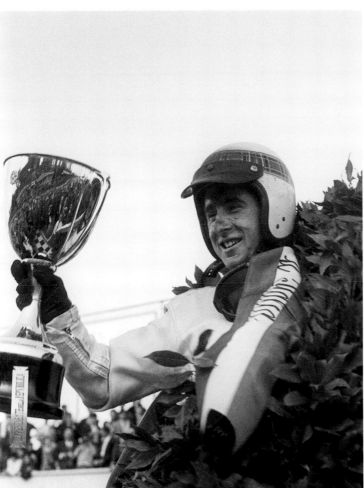

Above and left Stewart scored his first
Grand Prix win with the BRM P261 at
Monza in 1965, his first season of F1

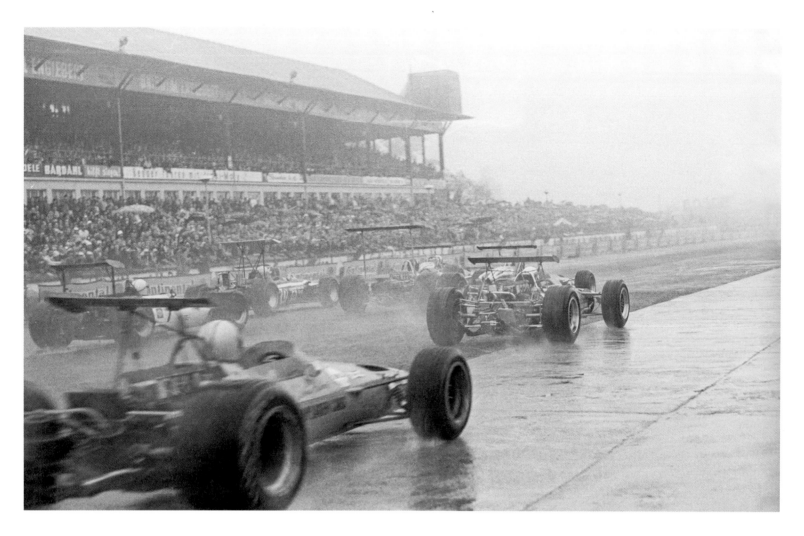

'When I was a driver it would have been far easier to have kept quiet about safety. I'd have been a much more popular World Champion if I'd said what people wanted to hear me say. I might not have been alive, mind you, but more popular...'

Opposite top Stewart, starting the
infamous 1968 German Grand Prix
from sixth on the grid, is already
aiming his Matra-Ford MS10 for the
gap created by the concrete pit lane
on the right of the picture and about
to pass the pole position Ferrari of
Jacky Ickx. The high-wing Lotus-Ford
of Graham Hill squeezes through on
the left of the Ferrari. Stewart would
emerge from the first corner in third
place and quickly assume a lead he
would never lose

Opposite bottom Stewart mastered
the tricky road circuit at Clermont
Ferrand more than once, this time in
1969 with his Tyrrell-entered Matra-
Ford MS80

Below Savouring the 1969 French
Grand Prix win with Helen

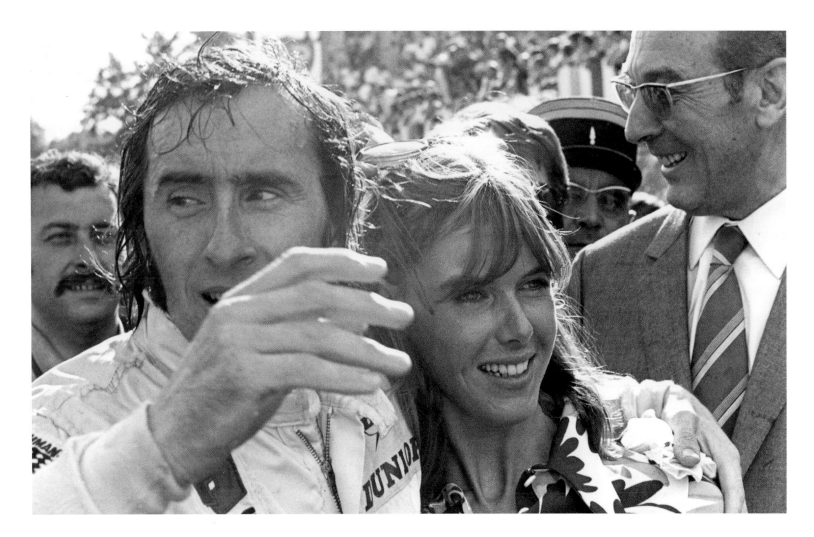

recalcitrant machine) but necessity would prove to be the mother
of invention. Feeling he had no choice, Ken Tyrrell decided to
design and build his own car in a shed in the former woodyard.
With continuing acuity, Stewart chose to stick with a team owner
who had become a father figure.

Together, they dominated the 1971 season, although a repeat
would be ruled out in the following months when Jackie suffered
an ulcer caused by exhaustion – and yet he still managed to win
four times. The records show that, once recovered, Stewart took his
third title in 1973, but five victories that season do not indicate how
hard he had to work.

Stewart's 27th win – a record at the time – would be his last.
Appropriately it came at the Nürburgring, perfect conditions on
this occasion allowing Jackie to demonstrate an effortless style
that camouflaged the inherently nervous nature of his short-
wheelbase car.

Having mastered the apparent contradiction of winning as
slowly as possible, there was to be a pleasing paradox during what
was, for Jackie, one of his greatest races.

Stewart held fifth place in the early laps of 1973 Italian Grand
Prix but a pit stop to replace a punctured tyre meant the loss of an
entire lap. On a super-fast track with very few corners in which to
eke out an advantage, Stewart applied his clinical precision and
gift of speed to unlap himself and finish a very fine fourth. One
month later, he announced his retirement at the age of thirty-four.

Never one to shun the limelight, Stewart threw himself into a
whirlwind of consultancy, commentary and public appearances.
His potentially crippling dyslexia was subjugated completely by a

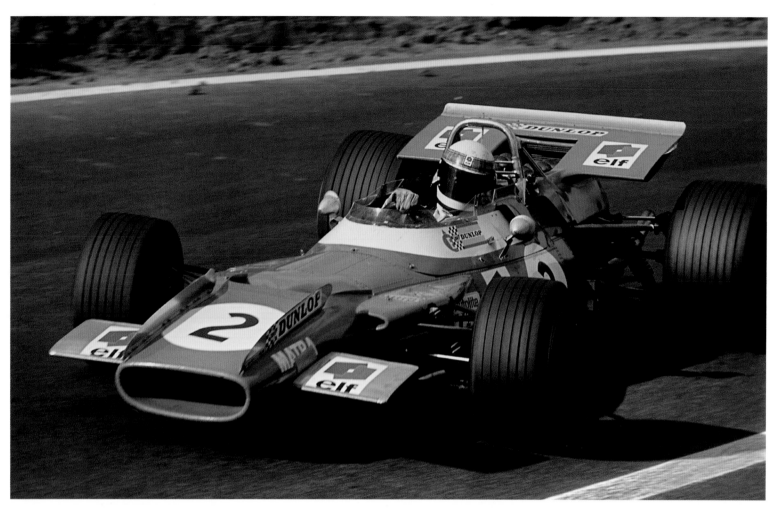

Opposite top The Matra-Ford MS80: Stewart's favourite F1 car that took the Scotsman to his first World Championship in 1969 thanks to six victories, including this one in the French Grand Prix

Opposite bottom In the days before acute awareness of sponsor logo exposure, Stewart is dwarfed by the winner's laurels at Paul Ricard in France in 1971

Below top Never losing focus. Jackie proudly carried the Royal Stewart tartan throughout a Grand Prix career spanning twenty-seven wins from ninety-nine starts

Below bottom Stewart began a difficult season in 1972 with a win with Tyrrell 003 in Argentina

self-taught eloquence and self-deprecating humour that made him much in demand and appreciated by blue-chip companies with whom he had been associated for decades. Jackie used his contacts and experience to establish, along with his son Paul, an F1 team in 1997 and win a Grand Prix before selling on; another substantial box ticked.

In 2001, he received a knighthood to add to the OBE awarded thirty years before. Such a significant passage of time and activity was a telling summary of a champion who continued to be regarded with respect and affection.

Stewart never spilt a drop of blood when racing. But having lost fifty-seven fellow drivers during that time, his brave and resolute campaign for safety would indirectly save many more from serious injury – or worse – over the decades to follow.

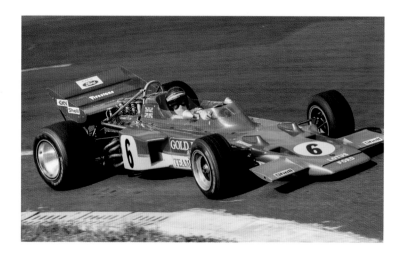

Jochen Rindt: charismatic and fast. The Austrian refined his spectacular technique in 1970 to become World Champion with the Lotus 72 (*left*)

Jochen Rindt

1970

A mere six Grand Prix wins do not begin to tell the story. With Jochen Rindt, it was about the way the Austrian did it rather than the final result. Rarely has a World Champion brought such raw excitement to watching a driver at work.

Rindt knew he was good and had no compunction about shunning textbook technique as he displayed his version of form over function. The application of opposite lock appeared to be as essential and easy as putting one foot in front of the other.

Such insouciance was abetted by a wealthy background, Rindt wanting for little and treating a car as either functional transport or as a tool to satiate a hugely competitive free spirit. Added to which, Jochen looked like a racing driver should, thanks to his distinctive features, unruly blond hair and cool clothes before clothes became commonly fashionable.

Orphaned (his parents had been killed in a wartime bombing raid) in 1943 and cared for by his grandparents, Jochen inherited the family's prosperous spice-importing business when he was twenty-one. He promptly bought a Formula Junior Cooper and won his second-ever race.

A step-up to Formula 2 in 1964 led to a race that would generate headlines for all the right reasons. Rindt flung his dark-blue Brabham around the narrow Crystal Palace track in south London to beat established Grand Prix stars and prompt the offer of a drive in a privately entered Brabham in the Austrian Grand Prix. Retirement with mechanical trouble from his home race would be indicative of what was to follow over the next four seasons as Rindt raced for Cooper and then Brabham in cars that were largely uncompetitive despite the driver's energetic efforts.

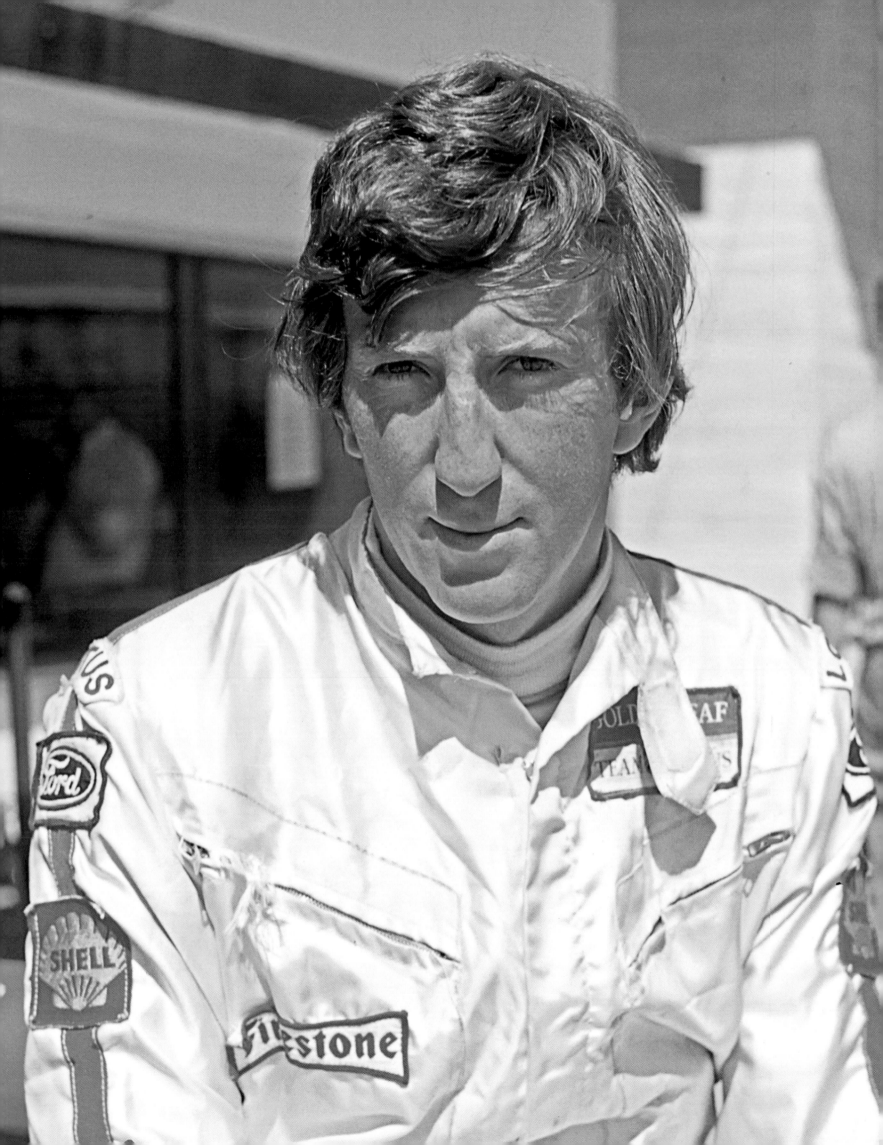

Right Rindt's best result in his first full F1 season was fourth with the Cooper-Climax T77 in the 1965 German Grand Prix

Below Woeful unreliability with the Brabham-Repco BT26 brought ten retirements in 1968, including the Belgian Grand Prix at Spa-Francorchamps

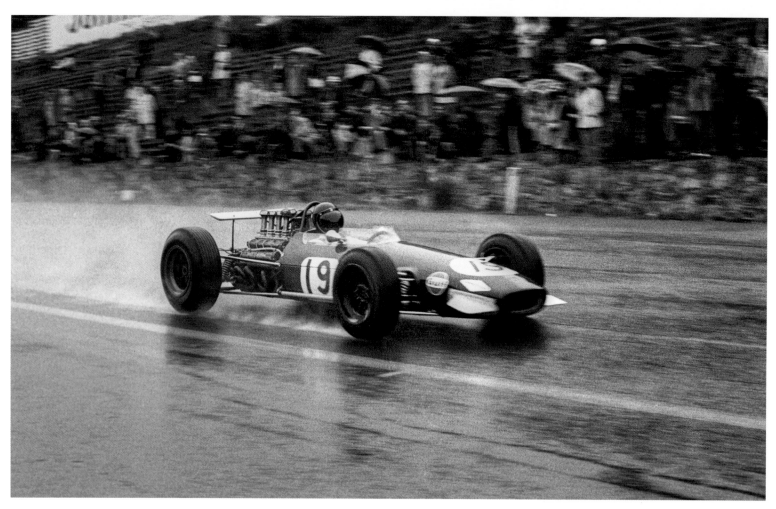

His time seemed to have arrived in 1969 with a switch to Lotus, the reigning World Champions. It would be a tetchy relationship, with Rindt suffering a rear-wing failure during the Spanish Grand Prix. The resulting crash prompted a frank letter from Rindt as he recovered from a broken nose and fractured jaw, and the criticism of F1's dangers did not endear him to Lotus boss Colin Chapman.

There was to be one outstanding highlight when Rindt engaged in an epic battle with Jackie Stewart that lasted for most of the British Grand Prix. Once again, the Lotus failed. It held together in the United States Grand Prix to give Jochen a maiden win; a seriously overdue victory that did little to assuage his doubts about staying with Lotus for another season. Chapman persuaded Rindt by revealing plans for his 1970 car, the striking Lotus 72.

Initially, the new car did not work. Rindt's dissatisfaction in having to resort to the Lotus 49, now in its fourth season, was particularly evident during the Monaco Grand Prix when he tooled around in the midfield. But as those ahead began to drop out, Rindt realised there was a slim chance, despite the leader, Jack Brabham, being fifteen seconds ahead.

Relishing the unexpected challenge, Rindt set the streets alight, lapping 2.6 seconds under his qualifying time and slashing Brabham's advantage. Going into the final lap, they were 1.3 seconds apart. Rindt broke the lap record once more, the advancing Lotus unnerving Brabham to such an extent that he made a mistake at the final corner – and his rival was through to a sensational finish in keeping with the surroundings.

When the Lotus 72 was finally sorted, Rindt altered his game to suit. The sideways exuberance was replaced by a calm control

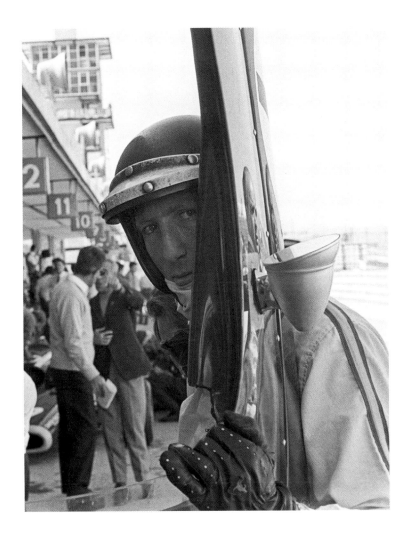

Left Rindt assists his mechanics during more trouble with the Brabham in Spain in 1968

Below Graham Hill comes to the aid of his team-mate at Montjuich Park in 1969. Having already crashed out of the Spanish Grand Prix when his rear wing collapsed, Hill saw Rindt suffer an identical failure and canon into the abandoned Lotus 49. Rindt suffered a broken nose and fractured jaw

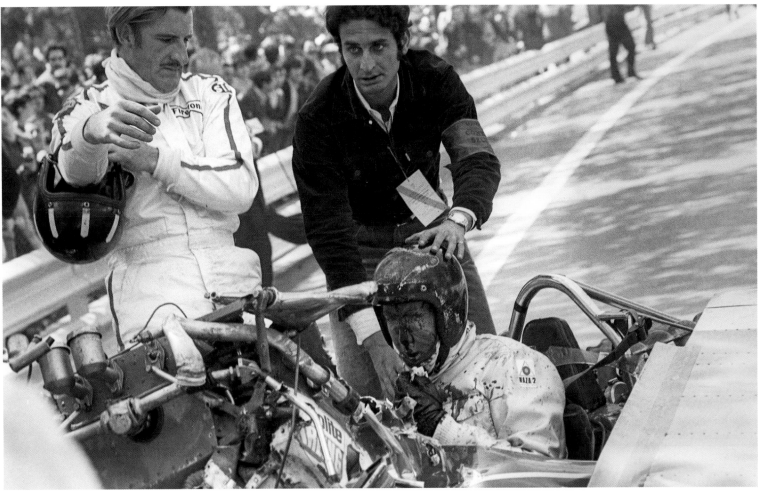

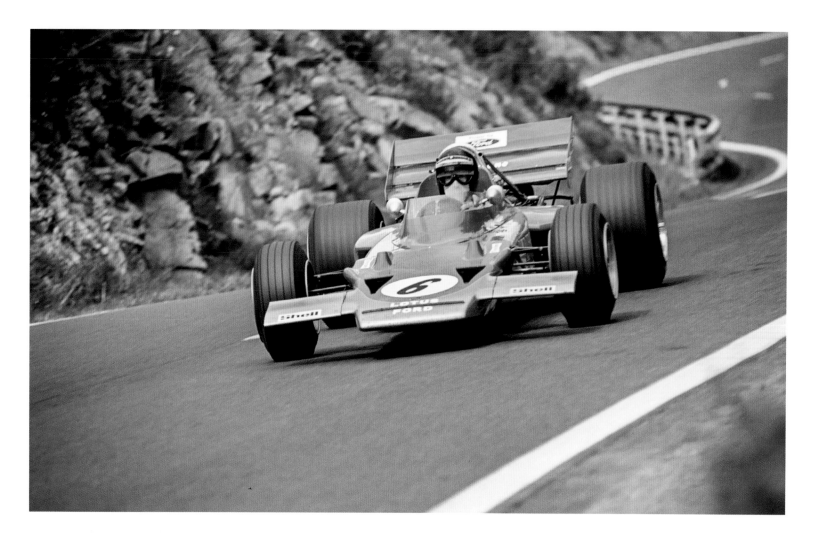

'Jochen and I had grown up together in F1 racing, and he was one of the most sincere men I ever knew, who said what he thought and, as a result, upset as many people as he befriended. I admired him tremendously as a driver. We trusted each other completely on the track, developing a kind of mutual understanding that I had not known since the Jimmy Clark days.'
Sir Jackie Stewart

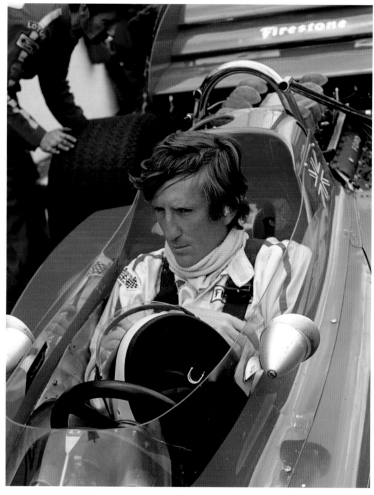

Opposite top and bottom Rindt
scored another imperious win with the
Lotus-Ford 72 in the 1970 French Grand
Prix at Clermont Ferrand

Below Unhappy initially with the
Lotus 72 in 1970, Rindt resorted to the
Lotus 49 and produced a stunning
performance to snatch the lead of the
Monaco Grand Prix at the final corner

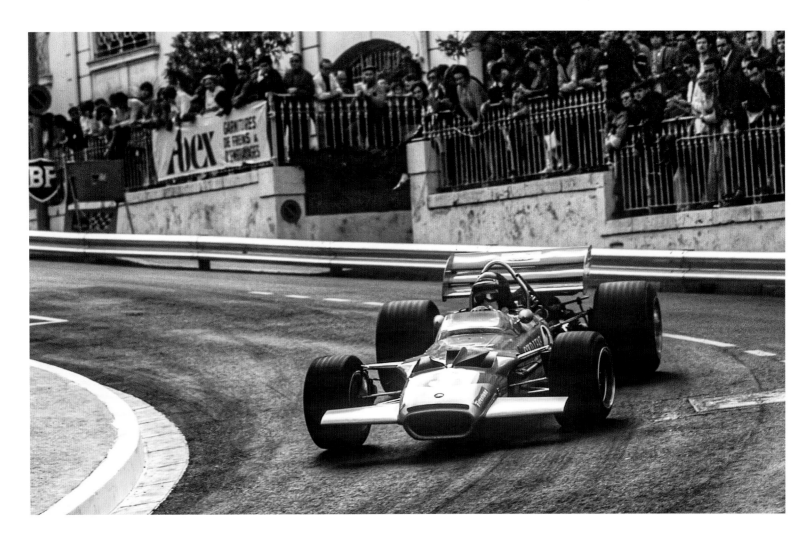

that earned four wins that summer and brought Jochen to the
head of the championship as the season edged into September
and the Italian Grand Prix.

By this stage, Rindt had also become circumspect and upset by
the loss of Bruce McLaren, followed a couple of weeks later by his
good friend Piers Courage. There were suggestions that Jochen
might retire once the season was done. First, though, there was the
championship to settle.

Having reached more than 180mph on the back straight
during qualifying at Monza, the Lotus suddenly turned sharp left
under braking for the final corner. Rindt was killed instantly as the
Lotus struck a post supporting the crash barrier and the front was
wrenched off the car.

As the final four races played out, his points total was not

surpassed, so Jochen Rindt became the sport's first, and so far
only, posthumous World Champion. It was a result achieved under
shocking circumstances that his many fans quietly and reluctantly
felt was somehow part of a short but very special career.

According to those who knew him well, Rindt had been a happy
and contented man when he climbed into his car for what would
be the last time on 5 September 1970.

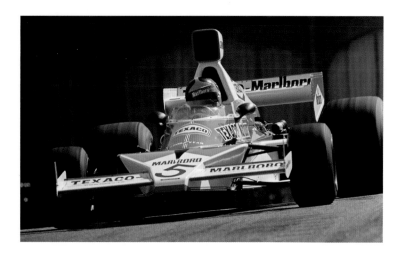

Emerson Fittipaldi became the youngest World Champion in 1972 (*opposite*) when he won his first title with Lotus, following up with a second with McLaren (*left*) in 1974

Emerson Fittipaldi

1972, 1974

Emerson Fittipaldi arrived in Britain as a fresh-faced youngster with little more than a Formula Vee title to his name. Eighteen months later, he made his Formula 1 debut with Lotus. Three months after that, the Brazilian won his first Grand Prix. Such a remarkable and rapid rise was the product of innate ability supported by natural charm and the calm capacity to deal with enormous pressure.

Fittipaldi had been given his F1 chance thanks to immediately dominating Formula Ford and, in equally short order, the British Formula 3 championship. A third works Lotus in the 1970 British Grand Prix was the perfect stress-free environment for a 23-year-old novice but the stakes would rocket two months later as a repercussion of Jochen Rindt's fatal crash in a Lotus at Monza.

Almost before he knew it, Fittipaldi was not only being asked to lead the team into the United States Grand Prix but also to defend Rindt's championship lead from attack by the Ferrari of Jacky Ickx, a comparative veteran of more than thirty Grands Prix who had already won twice in 1970.

Small wonder that Emerson developed a high temperature on the night before the race. A bad start dropped him to eighth. He drove cautiously, kept out of trouble, took advantage of problems for the leaders and was as surprised as anyone when shown the chequered flag nearly two hours later. The boost for the shattered team's morale could not be overstated, and his relationship with Lotus quickly blossomed and matured, even though they would be handicapped by tyre problems the following year.

By 1972, however, the technical difficulty had been solved to such an extent that Fittipaldi became the youngest World Champion up to that point thanks to a string of victories. He was in

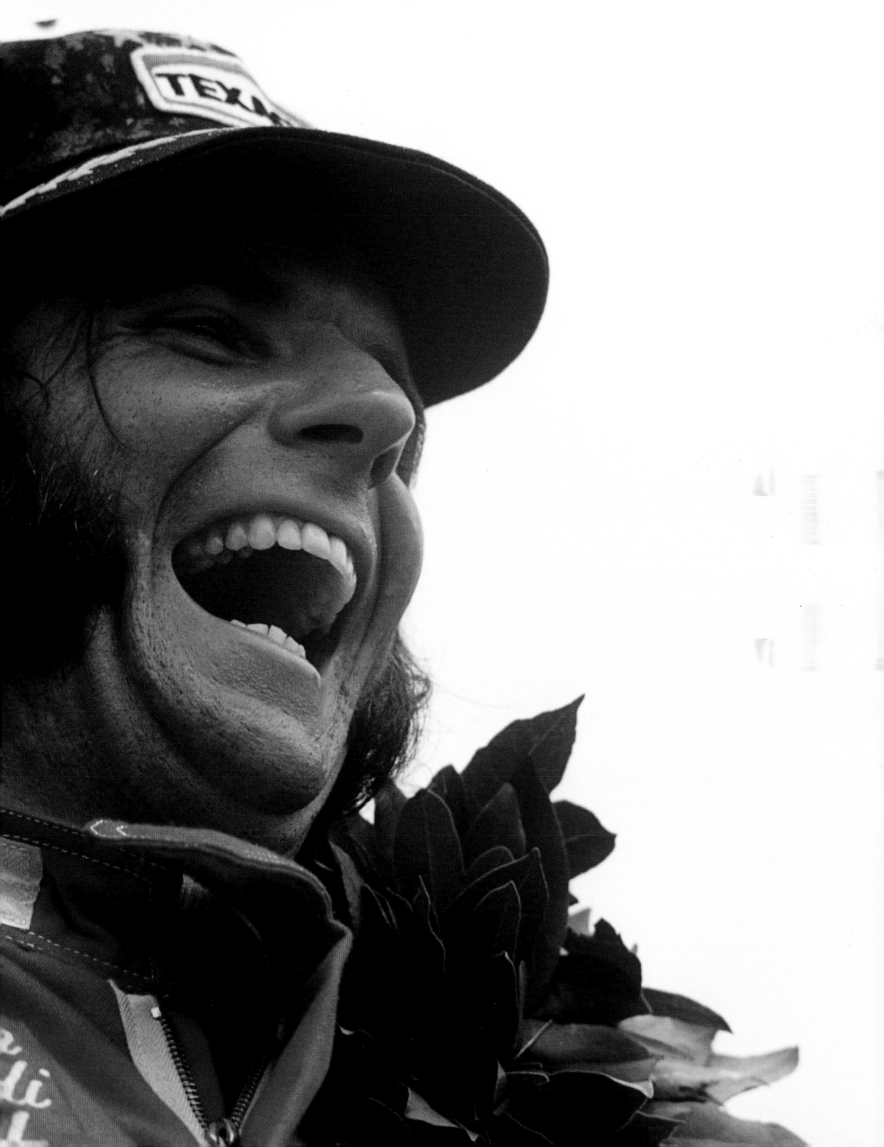

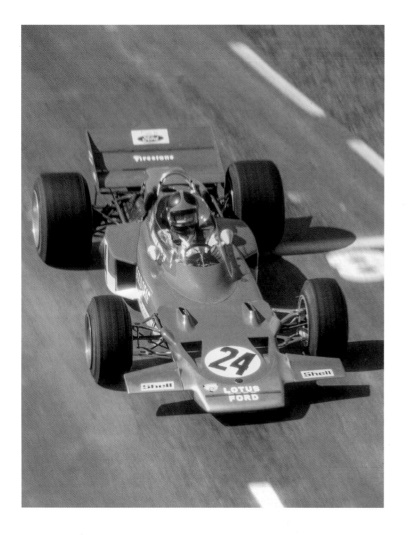

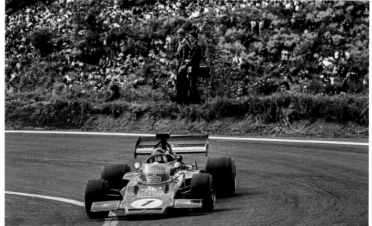

Left Thrown in the deep end at Lotus following the loss of Jochen Rindt, Fittipaldi won the 1970 United States Grand Prix, his fourth F1 race

Below Fittipaldi finished second with the Lotus-Ford 72 in the 1972 French Grand Prix on his way to becoming World Champion for the first time

Opposite An easy win with the Lotus 72 in Austria (*top*) in 1973 was denied by a fuel pipe coming adrift and weakening Fittipaldi's chance of defeating Jackie Stewart in the World Championship following a strong start with a win in his home Grand Prix in Brazil (*bottom*)

the running again twelve months later but a disagreement over team tactics helped prompt a move to McLaren.

Very much a team player, Emerson felt immediately at ease with the young Kiwi mechanics and their determination to make McLaren champions for the first time. The partnership got off to a brilliant start in January 1974 when Fittipaldi took pole and won his home Grand Prix, instantly making him a national hero and inspiring a surge of interest among prospective Brazilian motor-racing champions.

The passion would intensify as the season advanced, with Emerson winning twice more to put himself into the joint lead of the championship with Ferrari's Clay Regazzoni as they went into the final round at Watkins Glen in the United States.

This may have been the scene of his maiden win four years before but experience seemed to count for little as Fittipaldi qualified eighth.

Regazzoni was no better off in ninth but showed his ruthless streak by forcing his rival onto the grass on the first lap. Emerson would have none of it and keep his foot on the throttle, maintaining an advantage that would finally bring the sought-after title to McLaren.

Despite Fittipaldi winning twice in 1975, McLaren would give best to Ferrari, their disappointment plunging to new depths at the end of the season when Emerson unexpectedly announced his decision to leave and start an all-Brazilian F1 team with his brother, Wilson.

Known initially as Copersucar, the project would be hamstrung by a shortage of funds and expertise to deal with rapid technical developments – instigated, ironically, by Colin Chapman, the design genius and Emerson's former boss at Lotus. Fittipaldi's team folded at the end of 1982, two years after Emerson had retired from driving.

The lure of competition proved difficult to resist as Fittipaldi raced

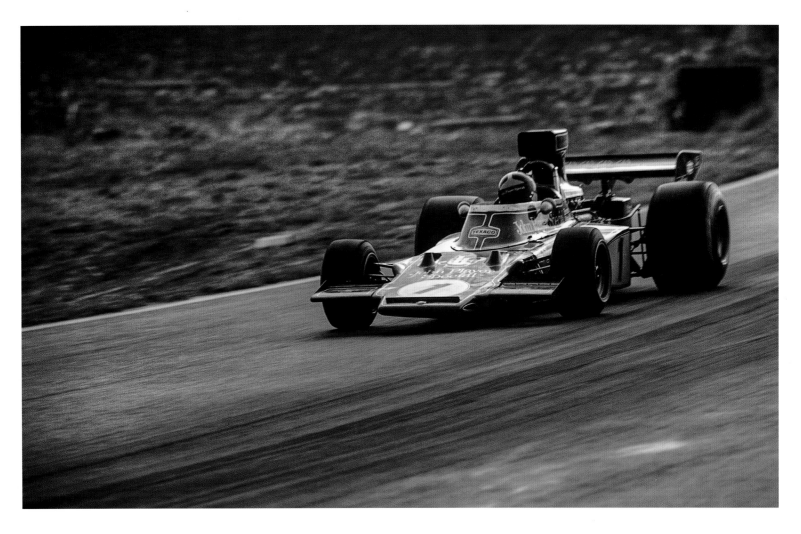

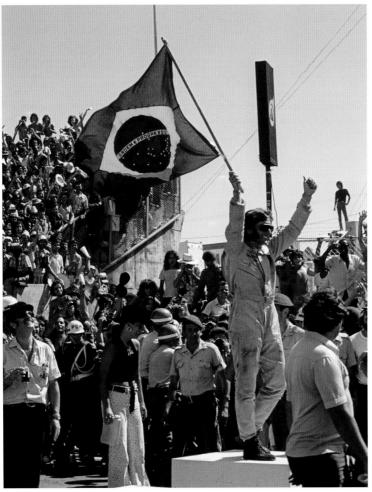

'You need natural talent, of course, and incredible car control. But there is more. Think all the time; think how to improve the car, improve the driving. Ask yourself questions; what do you need to learn to get to the next level? Your mind must be totally focused, to achieve a better sporting performance. Then you are on the way to your dream and winning the championship.'

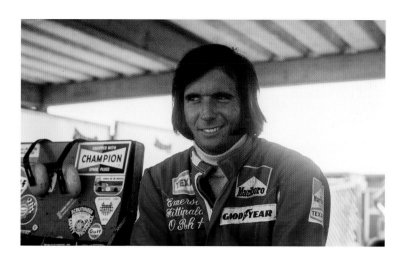

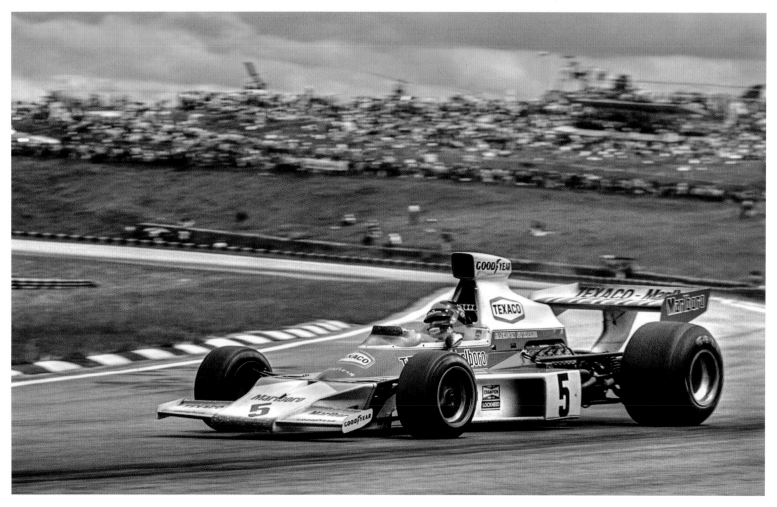

karts in Brazil. But the fun element would become serious again in 1984 when he accepted the offer of a drive in CART (Indycars), the top level of single-seater racing in North America.

Even at thirty-eight, Emerson's racer instincts remained sharp, winning at least one race for eleven straight years, becoming champion in 1989 and triumphing in the famed Indianapolis 500 twice. When he finally retired in 1996, Fittipaldi was heading towards his fiftieth birthday – and looking at least ten years younger.

Permanently trim and fit, Fittipaldi remained an ambassador for the sport and his personal sponsors. Like his fellow South American and former champion Juan Manuel Fangio, Emerson brought a dignified and serene presence to the room; a sporting hero and family man totally comfortable within his own skin and grateful for having survived a dangerous game.

His most serious accident had come in the final year of his career when a 190mph crash on the banked Michigan Speedway put him in hospital with a broken vertebra, collapsed lung and internal bleeding. Having eventually recovered, Fittipaldi was flying with his six-year-old son, Luca, towards his orange farm in Brazil when the microlight aircraft lost power and crash-landed in a swamp. Badly aggravating the previous back injury turned out to be the least of Emerson's problems. It took a few hours for rescuers to arrive, during which time young Luca had to flap his arms to ward off circling vultures, attracted by his father's blood-soaked clothing.

It was to be more terrifying and protracted than the worst moments during an eventful and distinguished career spread across 144 Grands Prix and 195 Indycar races.

Opposite Another win for Fittipaldi at Interlagos in 1974 did much to raise enthusiasm for motor racing to an even higher level in Brazil

Above Fittipaldi maintained a steely focus to see off a championship challenge from Ferrari's Clay Regazzoni at the final race of the 1974 season

Left A move by Fittipaldi from McLaren at the end of 1975 to establish the all-Brazilian Copersucar team with his brother did not work out as planned

Niki Lauda's second of three World Championships in 1977 (*right*) was remarkable because he was there at all following a harrowing and fiery accident the previous year

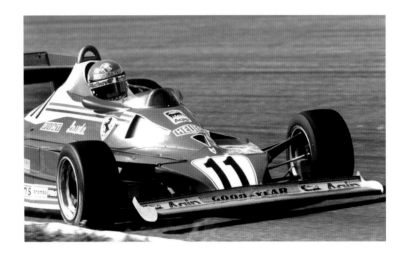

Niki Lauda

1975, 1977, 1984

Reflecting on his twenty-five Grand Prix wins, Niki Lauda considered his victory in South Africa in March 1977 to be the most satisfying. It was not so much that he had to nurse his crippled Ferrari across the line, but more to do with the fact that he was there at all – and winning again.

Seven months before, Lauda had been given the last rites after an accident so severe that no one expected him to survive. Not only had he returned to the cockpit within six weeks, here he was at the beginning of the next season with a victory that would form the foundation of his second World Championship. As comebacks go, Lauda's story is the stuff of legend. And typical of the man himself.

It could hardly be anything else when discussing a 24-year-old Austrian who funded his foray into Formula 1 with a bank loan

secured by an insurance policy on his life – and then discovered that the F1 car with which he hoped to start building a reputation was one of the worst ever produced by March Engineering.

Undaunted by scoring zero points in 1972, Lauda approached the venerated BRM team with the promise of sponsorship he didn't have. Fortuitously, on the weekend the first payment was due, Lauda held third place – ahead of two Ferraris – in the prestigious Monaco Grand Prix. The car may have let him down eventually but Niki had scored a personal point – or two. Not only did BRM decide to continue the relationship at no cost to Lauda, but Enzo Ferrari had also been impressed and made an offer for 1974. Scarcely able to believe this turnaround in fortune, Niki had no hesitating in choosing the latter.

Had it not been for driver errors born of inexperience and

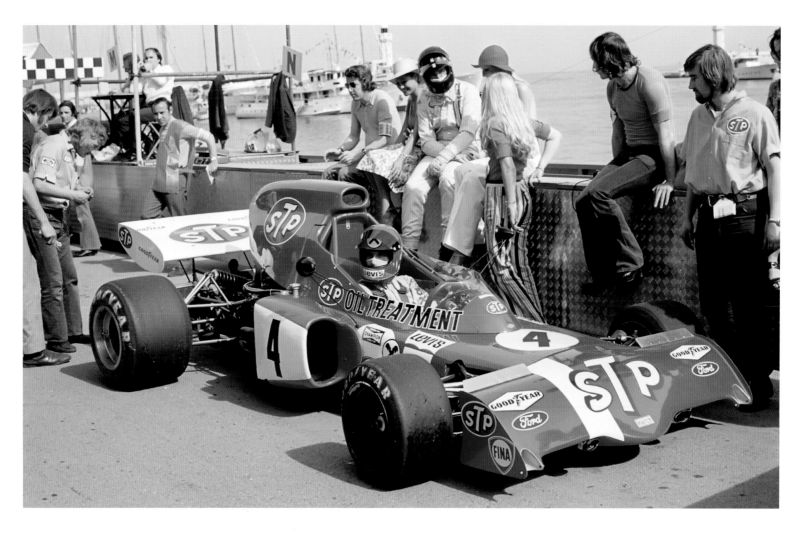

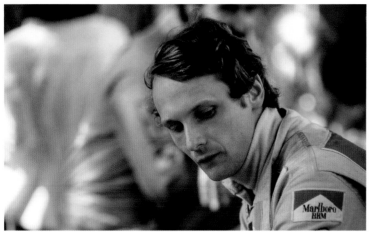

Above Lauda's F1 career was almost wrecked before it had started thanks to finding himself in the complex and slow March-Ford 721X in 1972

Left Holding an impressive third place with BRM during the 1973 Monaco Grand Prix changed everything and led to an offer from Ferrari

Opposite Lauda applied his incisive mind to sorting out the Ferrari 312B3 in 1974 (*top*) but put himself out of championship contention with sometimes impetuous errors, such as in Germany (*bottom*) when he hit another car on the first lap

impatience, Lauda could have won the championship in his first year with a team on the up after a disastrous couple of seasons. Learning from his mistakes and making full use of an even better car in 1975, Lauda took nine pole positions in fourteen races, won five of them and claimed his first World Championship.

The following season would not be so straightforward. James Hunt's arrival at McLaren signalled the start of a contest that touched on every emotion. Hunt and Lauda perfectly fitted the stereotypes of the dashing Englishman taking on the arrogant Austrian, but the story appeared to have reached a sudden and terrible end when Lauda crashed on the Nürburgring Nordschleife during the German Grand Prix. Running wide and hitting the barrier was one thing but the wayward Ferrari catching fire after being struck by another car was a more shocking story.

The location was so remote that the absence of adequate marshalling meant Lauda had to be pulled from the flames by other drivers. His crash helmet had been ripped off during the impact, allowing the barely conscious driver to breathe in fumes and smoke. When reports of the extent of his external and internal burns filtered through, no one expected Lauda to last the night.

But that did not allow for his ferocious determination to overcome the searing pain and defy the ministrations of the hovering priest. Not only did Lauda survive, he confounded even his most optimistic supporters by declaring himself fit enough to race in the Italian Grand Prix less than two months later.

During this time, Hunt had closed down Lauda's championship lead. With four Grands Prix remaining, it was game on as Lauda, his head swathed in bandages, demonstrated the next startling

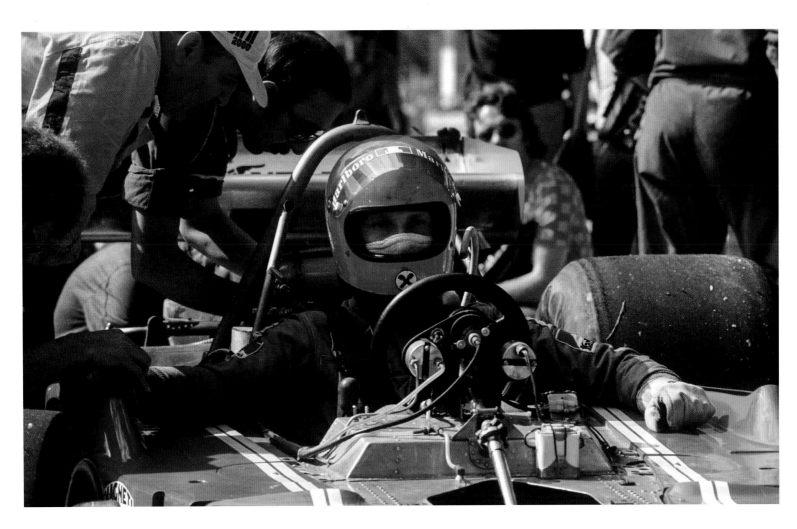

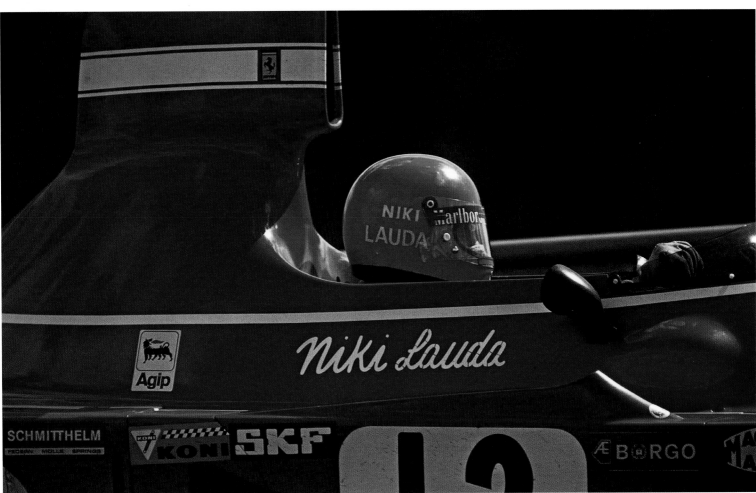

'Bad though the crash (in 1976) was, I was lucky. Another ten seconds in there and I would have been dead. When I was motor racing, I had taken the decision to risk my life. But when you run an airline and more than two hundred people want to go from A to B and they don't arrive – that's a different responsibility. That was the worst time of my life.'

paradigm of mind over matter by finishing a truly remarkable fourth at Monza.

The two rivals slugged it out until the final round in Japan, the championship going to Hunt after Lauda quit the rain-soaked race. When the Ferrari management offered engine trouble as a cover for his voluntary retirement, Lauda would have none of it. He made it clear he considered the risks in the appalling conditions had been too high and this was the value he put on his life. After all he had been through, who could argue?

The satisfaction that came with his second world title in 1977 was tempered by a deterioration in relationships within the political minefield endemic to Ferrari. When a switch to Brabham failed to produce the competitiveness Lauda expected, he suddenly decided enough was enough and stopped halfway through the first day's practice in Canada. Leaving his crash helmet and flameproof overalls on the pit counter, he simply walked away to pursue plans for Lauda Air.

Running his own airline worked well enough to provide a thorn in the side of the national carrier, Austrian Airlines. In the meantime, F1 cars had become faster and sophisticated enough to pique Niki's interest. McLaren boss Ron Dennis successfully tapped into Lauda's enquiring mind and arranged a comeback in 1982 that would have been considered foolish for anyone other than the pragmatic and clinically incisive Austrian.

Lauda won two races that year before the normally aspirated car gradually became uncompetitive. He was ready for a championship onslaught in 1984 when McLaren raised their game with a state-of-the-art turbocharged car. Lauda's only rival was his new team-mate, Alain Prost. The Frenchman was six years younger

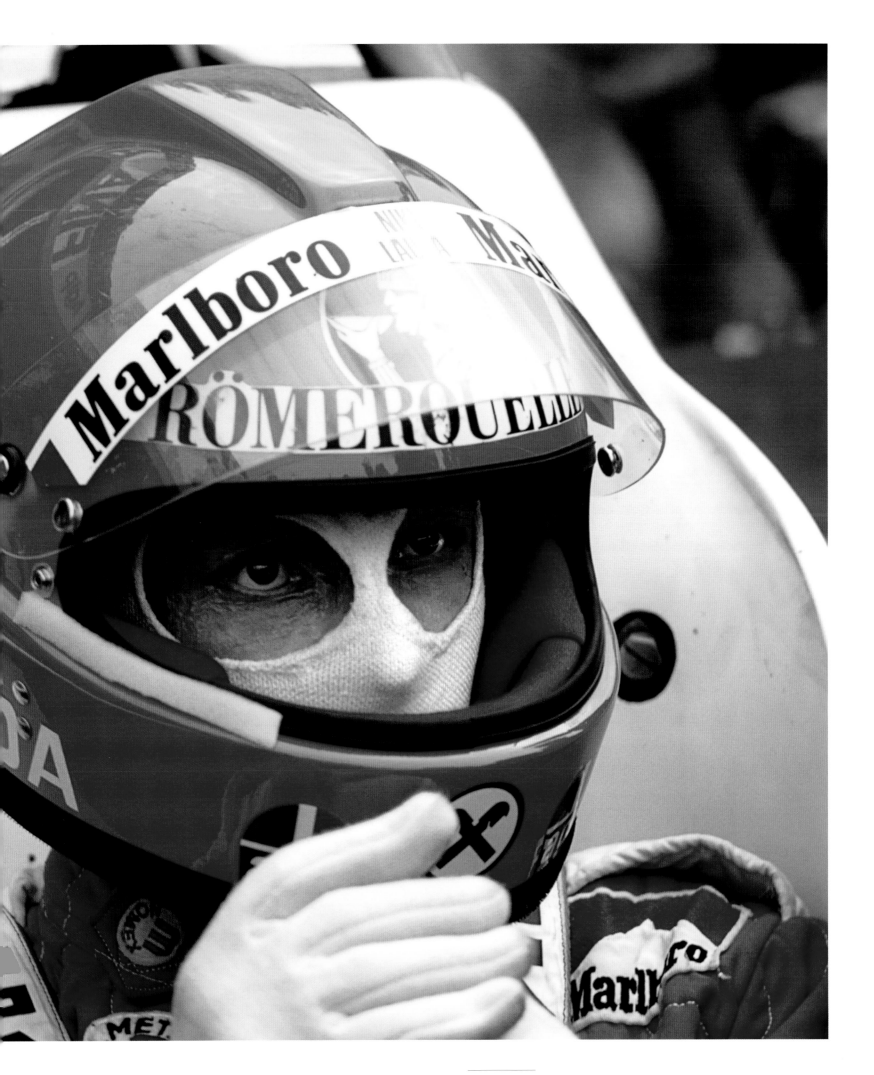

Previous page
Wearing a crash helmet specially
adapted to accommodate his head
bandages, Lauda defied all logic by
racing in the 1976 Italian Grand Prix
just six weeks after his near-fatal crash
in Germany

Right Following retirement at the end
of 1979, Lauda made a comeback
with McLaren in 1982. Ayrton Senna,
having finished third at Brands Hatch,
hoists the winner's arm aloft after
Lauda's victory in the 1984 British
Grand Prix

Below Lauda claimed a third
World Championship after finishing
second with his McLaren-TAG MP4/2
in Portugal, the final race of the
1984 season

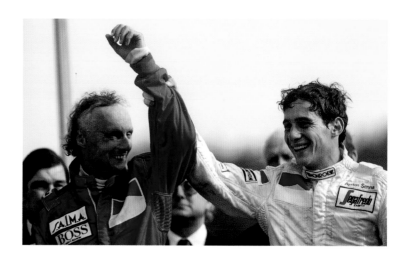

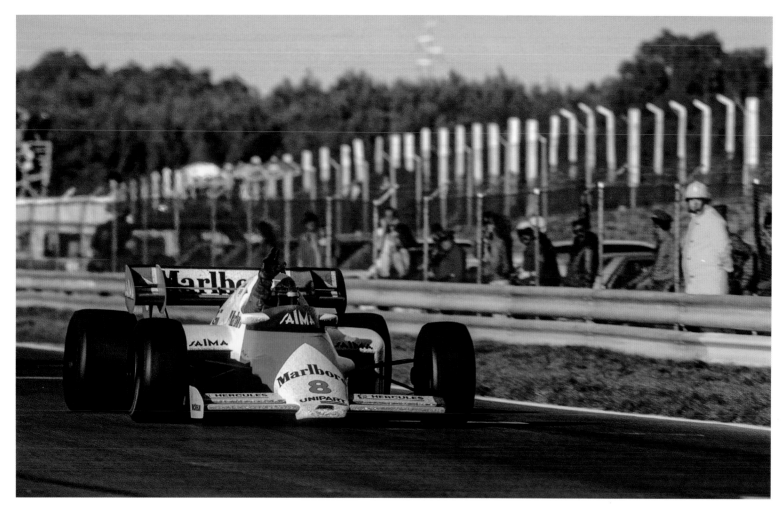

– and faster. Typically, Lauda recognised this, won fewer races but consistently scored through stealth and experience to take his third title by half a point. Then he retired for good at the end of the following season to focus fully once more on his airline.

Lauda may have been through the mill as a racing driver but he was to suffer an altogether different and more distressing experience in 1991 when one of his Boeing 767 aircraft suddenly fell from 28,000 feet shortly after taking off from Bangkok, killing all 223 on board.

Lauda literally waded into the appalling scene of the tragedy in a remote and mountainous forest. The devastation was so severe that the black box could not be found. By slowly piecing clues together, Lauda, an accomplished pilot, became convinced the reverse thrust in one engine had engaged. Boeing

insisted that even if that was the case, the aircraft could have been saved.

Eight months later, Lauda was moved and angered in equal measure while attending a mass burial for twenty-three unidentified victims in Bangkok. He flew straight to Seattle and, railing against Boeing's intransigence, demanded to operate their 767 simulator under the precise conditions at the moment of the catastrophe – and engage reverse thrust in the left-hand engine. When he failed to recover the aircraft several times, Boeing finally accepted that responsibility lay with a failed part in the engine rather than with the airline operator.

It was another victory for Niki Lauda, albeit one that made his extraordinary deeds on the race track seem prosaic.

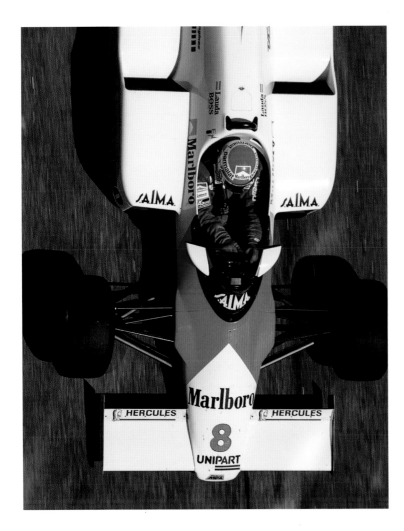

Left Lauda won five times with the McLaren MP4/2 in 1984 – compared with seven for his team-mate Alain Prost – but took the title by half a point through consistency and guile

Below Donning headgear to protect his facial scars, Lauda's ubiquitous red cap became a symbol worthy of lucrative sponsorship

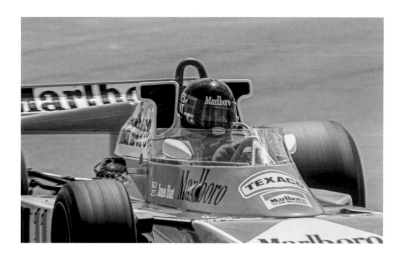

James Hunt

1976

James Hunt was an intriguing contradiction. Here was a World Champion who was physically sick moments before climbing into the cockpit each race day. Nerves and a sense of anticipation would get the better of him and yet, from the moment a Grand Prix started, James Hunt the rebellious, talented and utterly determined race driver would take over.

He would revert to a ruthlessly competitive nature that had informed all of his life beforehand. Once he had established a goal – be it rebuilding a wrecked Mini to go racing even though he had neither mechanical knowhow nor money, or ignoring an early reputation that earned him the sobriquet 'Hunt the Shunt' – the gangling Englishman with the slightly stooped appearance would apply a mental ferocity to everything he did.

Born into a comfortably off and hard-working family in London's stockbroker belt, James was the renegade among his five siblings. Proficient at any sport requiring stamina and good hand-to-eye coordination (he played squash to county standard), Hunt knew nothing about motor sport until he happened across a club event – and was immediately smitten.

Having recently acquired a driving licence, he loved going at breakneck speed on the roads. Here was a means of combining the thrill of driving quickly with a need to compete. Hunt returned home that night, the eve of his eighteenth birthday, and told his parents that not only was he going to be a racing driver, he would also be World Champion.

The realisation of that naive if sincerely held ambition would take eleven years, the first seven of which would be a kaleidoscope of collisions, crashes, heartache and hardship,

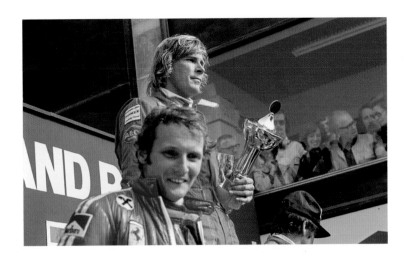

underwritten by a gift of raw speed and a point-blank refusal to give up.

Salvation came in the portly and colourful form of Lord Hesketh, a wealthy entrepreneur who saw in James a like-minded spirit perfect for Alexander Hesketh's wish to go motor racing and have fun. Nonetheless, there was a serious edge to this vibrant group, as indicated by the building of a competitive F1 car that was capable of giving Hunt a first – and well-deserved – Grand Prix victory in Holland in 1975. By the end of the year, however, the champagne and money had run out. The Hesketh team was disbanded and Hunt was out of a drive. But not for long.

By good fortune, former champions McLaren had been left without a driver at the last minute as Emerson Fittipaldi went off to start his own F1 team. Hunt was snapped up, thrown in the deep end – and immediately began swimming strongly in such a competitive environment. But these would be choppy waters in 1976, a season so theatrical and topsy-turvy that a full-length movie would be made about it nearly forty years later.

Hunt's most serious rival would turn out to be Ferrari's Niki Lauda, with each driver suffering setbacks along the way. Hunt would have to cope with a technical disqualification from victory in Spain (later rescinded) and struggle through a period of uncompetitiveness with the McLaren. Lauda would almost lose his life in a fiery accident in Germany and then make a remarkable comeback with four races to go, still leading the championship, as he had done since the start of the season.

Hunt, meanwhile, had been disqualified from an emotional win in the British Grand Prix and sent to the back of the grid in Italy;

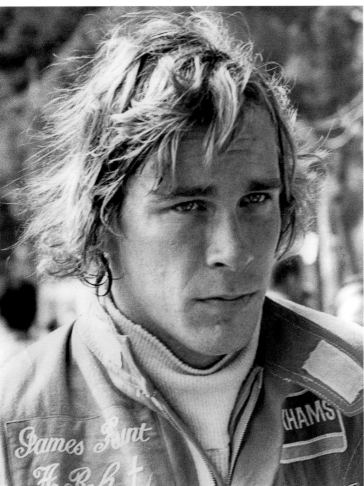

Opposite top Hunt scored his first Grand Prix win the hard way at Zandvoort in 1975 when he held off Niki Lauda's Ferrari during a tense Dutch Grand Prix. It was a sign of things to come during the following season

Opposite bottom Hunt and the Hesketh team gave a good account of themselves during their Grand Prix debut with a privately entered March-Ford 731 at Monaco in 1973

Above and left Despite the team's penchant for partying, the Hesketh-Ford 308B was an indication of serious intent. Three podium finishes would accompany the win in 1975 before Hesketh was forced to close at the end of the season, leaving a worried Hunt in search of a drive – but not for long

'Having won just one Grand Prix, I came from pretty much nowhere in 1976. Being pitched into the deep end, I was operating in the only way I knew, which was not to compromise myself and just get on with it. It was an absolutely frantic year – and the next thing I know, I'm World Champion. Pretty satisfying, I have to say.'

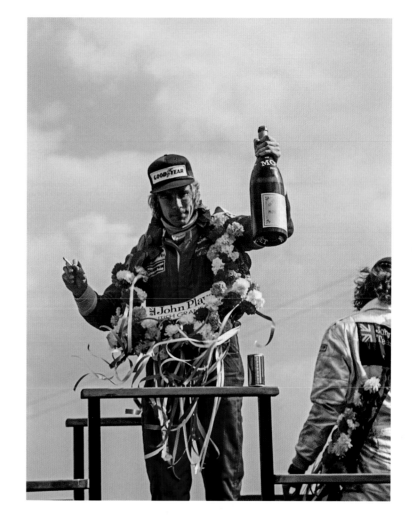

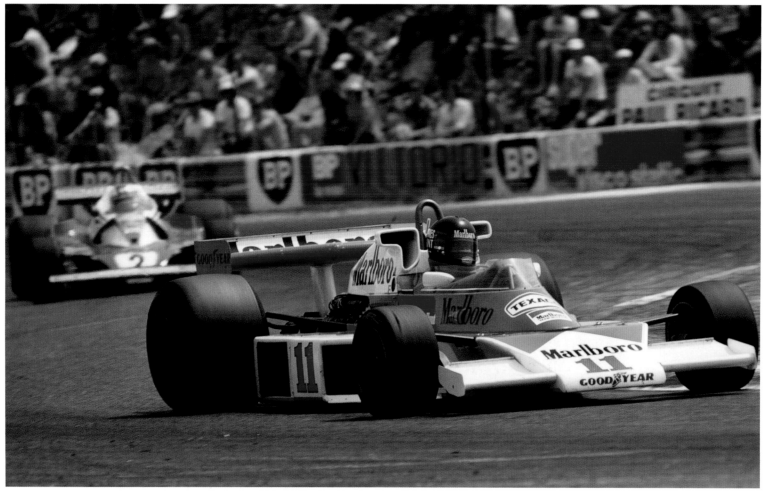

both on technicalities. If anything, this strengthened his resolve, and outstanding victories in Canada and the United States led to a tense finale in a dangerously wet Japanese Grand Prix. Lauda pulled out after just two laps and Hunt finished third, winning the title by a single point.

He had got there through a compelling mix of obstinacy and flair. His fear of the sport's potential hazards was exacerbated by uncompetitive machinery in the following seasons, with James abruptly announcing his retirement in June 1979. He eventually took up commentating with distinctive authority on BBC Television, began breeding budgies and, compared with his rowdy days of partying and womanising, adopted a quieter, more circumspect life. It ended with shocking suddenness when he died of a heart attack at the age of forty-five.

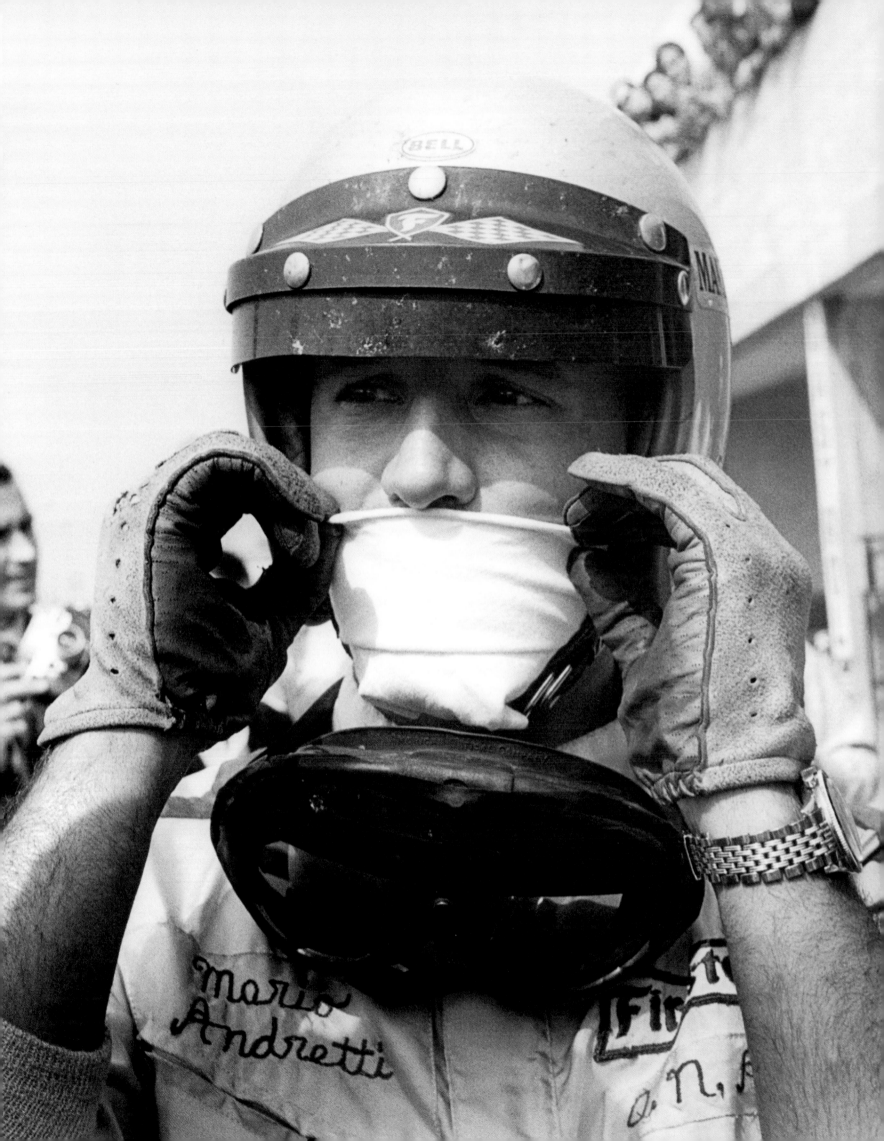

Mario Andretti, vastly experienced in
many disciplines, looked and acted
the part of a champion racing driver.
The tough little American was ready
to make the most of his Lotus 79 (*right*)
to win the F1 title in 1978

Mario Andretti

1978

Few, if any, champions in this book come close to matching Mario
Andretti's extraordinary depth of achievement. The American's
career is not only measured across five decades but also in terms
of results. Formula 1, Indycar, NASCAR, Formula 5000, sports
prototypes, sprint cars, midgets; Andretti has savoured victory in
them all and won titles in many, but none means so much as his F1
World Championship, secured during the Italian Grand Prix in 1978.

In many ways, that moment represented a coming home for
the man born thirty-eight years before in Montona, 500km to the
east of Monza. When that part of Italy was annexed by Yugoslavia
and came under Communist rule at the end of the Second
World War, the Andrettis fled back to Italy and spent seven years
separated only by the blankets ten families had strung up in a
large room in a monastery.

It was a tough beginning but two things would happen to
change young Mario's life: the family emigrated to the United
States in 1955 and, a year before that, fourteen-year-old Andretti
saw his first major motor race, the sight of Alberto Ascari racing a
Ferrari having a profound effect on him.

Embracing the new opportunities presented in Pennsylvania,
Andretti learned his race-craft in midgets and sprint cars on the
rudimentary dirt tracks to be found in almost every American
city. The hard knocks endemic to oval racing made him a tough
competitor, happy to race whatever and wherever he could,
always hungry for success.

Unlike many of his American rivals, Andretti knew all about F1
and jumped at the chance when offered a drive in the 1968 Italian
and United States Grand Prixs after Lotus boss Colin Chapman

An interlude with a March-Ford 701 backed by the American oil and fuel additive, STP, did Andretti no favours as he finished just one Grand Prix during a limited season in 1970

Black Beauty. Andretti takes a tight line at Zandvoort on his way with the Lotus-Ford 79 to one of six wins in 1978

had seen Andretti race in the Indianapolis 500. The race at Monza didn't come off because of an administrative technicality that did not apply to the forthcoming round at Watkins Glen. Despite being unfamiliar with the track in upper New York State, and having completed only a few test laps in the Lotus, Andretti put it on pole and ran strongly until the car broke.

That might have been enough to warrant future drives but Andretti's sporadic Grand Prix programme would be compromised by commitments racing at home. F1 became serious when he signed with Lotus in 1976 and began to help pull the former champions from the doldrums. Fine-tuning Chapman's design genius, Andretti struck gold with the Lotus 79 and won six races in 1978 – and this despite an insistence on maintaining his home and racing links by commuting frequently across the Atlantic.

Andretti was weary by the time the F1 season reached Monza. Sixth place in the Italian Grand Prix would be enough to win the championship. But the high-point of Mario's year – and his career – would be tainted when his team-mate, Ronnie Peterson, later died of injuries received during a multiple pile-up on the first lap. Andretti had experienced more than his fair share of tragedy while engaged in such a hazardous profession, but the unexpected nature of this one hit him hard when a toll-booth attendant told Mario the news as he drove to visit his friend in hospital.

Mario would compete in F1 for three more seasons before returning to fully focus on Indycar racing, winning America's prestige title for the fourth time in 1984. With racing coursing so deeply in his veins, Andretti was reluctant to quit the cockpit after scoring his last win at the age of fifty-three.

'I've been fortunate and dodged so many bullets. Look at how many great champions were never able to finish their career; that was the saddest part about our sport in those days. I was one of those who were spared, which is why I was able to satisfy my career to the fullest. Do I know how fortunate I've been? You're damn right I do.'

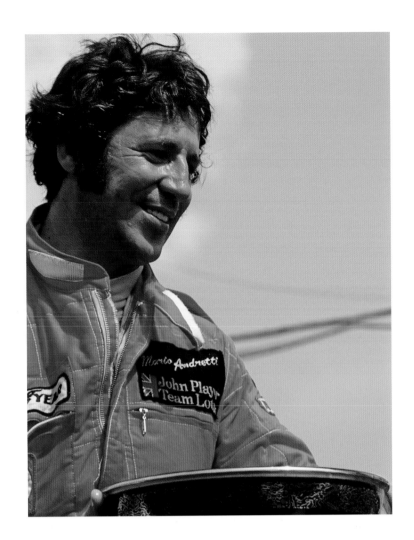

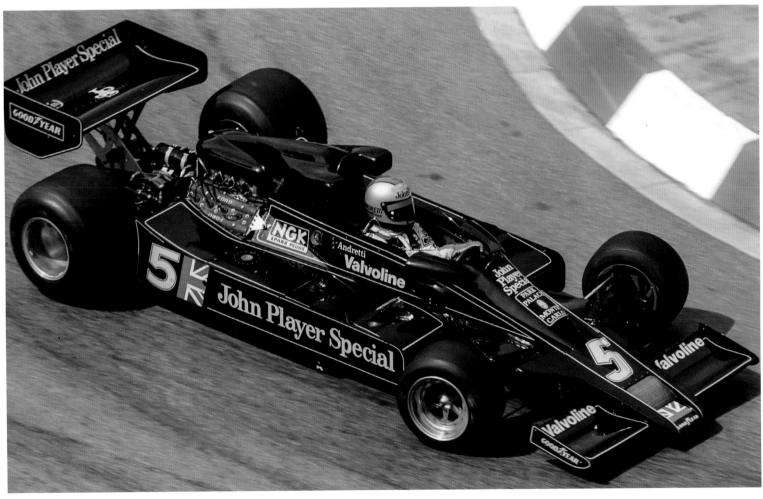

Opposite top Andretti scored twelve Grand Prix wins in 128 starts

Opposite bottom Andretti began to become competitive with the Lotus-Ford 78 in 1977 and early 1978 before the step up to the Lotus 79

Below top Having scored his first Grand Prix win with Ferrari in an otherwise undistinguished season in 1971, Andretti made a brief but emotional return to Maranello for his final two Grands Prix in 1982, putting the red car on pole and finishing third at Monza

Below bottom Andretti continued racing in the United States, winning his last race at the age of fifty-three

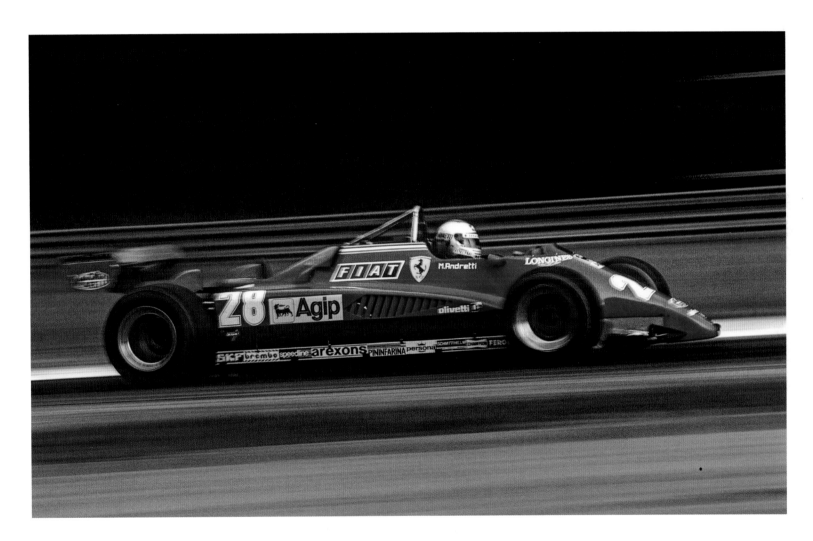

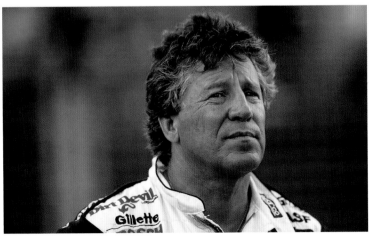

With his son and grandson becoming professional drivers, Andretti was never going to be far from race tracks, much to the delight of the media, for whom the stocky little American, with his sense of proportion and laconic one-liners, was always a journalist's dream.

There may have been F1 World Champions possessing a more outrageous talent, but never one who better personified the description 'racing driver' by excelling with such style and charisma in so many disciplines.

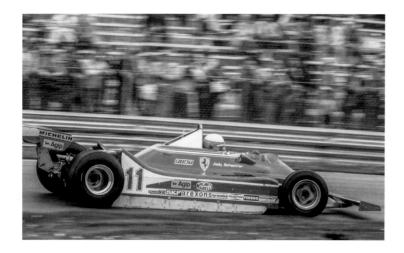

Jody Scheckter scored his second
Grand Prix win with Tyrrell at Brands
Hatch in 1974 (*right*). It was not until
joining Ferrari five years later that the
South African would win the World
Championship (*left*)

Jody Scheckter

1979

At 10.00 am on the morning of Tuesday, 15 July 1980, Jody
Scheckter announced his pending retirement at the end of the
season. The timing, just halfway through the year, was surprising.
As was the news that he would be turning down a lucrative offer to
stay for a third season with Ferrari.

Drivers tended not to walk away from one of the most desirable
seats in F1 – and certainly not as reigning World Champion. But
this was typical Scheckter. Driving racing cars had lost its appeal.
Rather than simply taking the money and going through the
motions, the surly South African would depart as rapidly as he had
arrived on the European motor racing scene just nine years before
– if less dramatically.

F1 teams taking part in a non-championship race at Brands
Hatch in March 1971 could not fail to notice the antics of an

unknown driver in a supporting race. Armed with nothing more
than a £3,000 South African Driver to Europe scholarship and
buckets of confidence, Scheckter flung his Formula Ford around
the Kent circuit and would have won but for a spin in the greasy
conditions. It was taken as a sign of an impressive natural ability
that he didn't lose control more often in an unfamiliar car on a
tricky track he had never seen before.

Eighteen months later, Scheckter was in a Grand Prix car as he
raced a third McLaren in the United States Grand Prix. There would
be further occasional F1 outings in 1973, during which Scheckter
earned the nickname 'Fletcher' after the seabird who kept
crashing into the cliff face in the book *Jonathan Livingston Seagull*.

Any suggestion of this being an unreasonable sobriquet was
to be demolished, along with several cars, at the end of the first

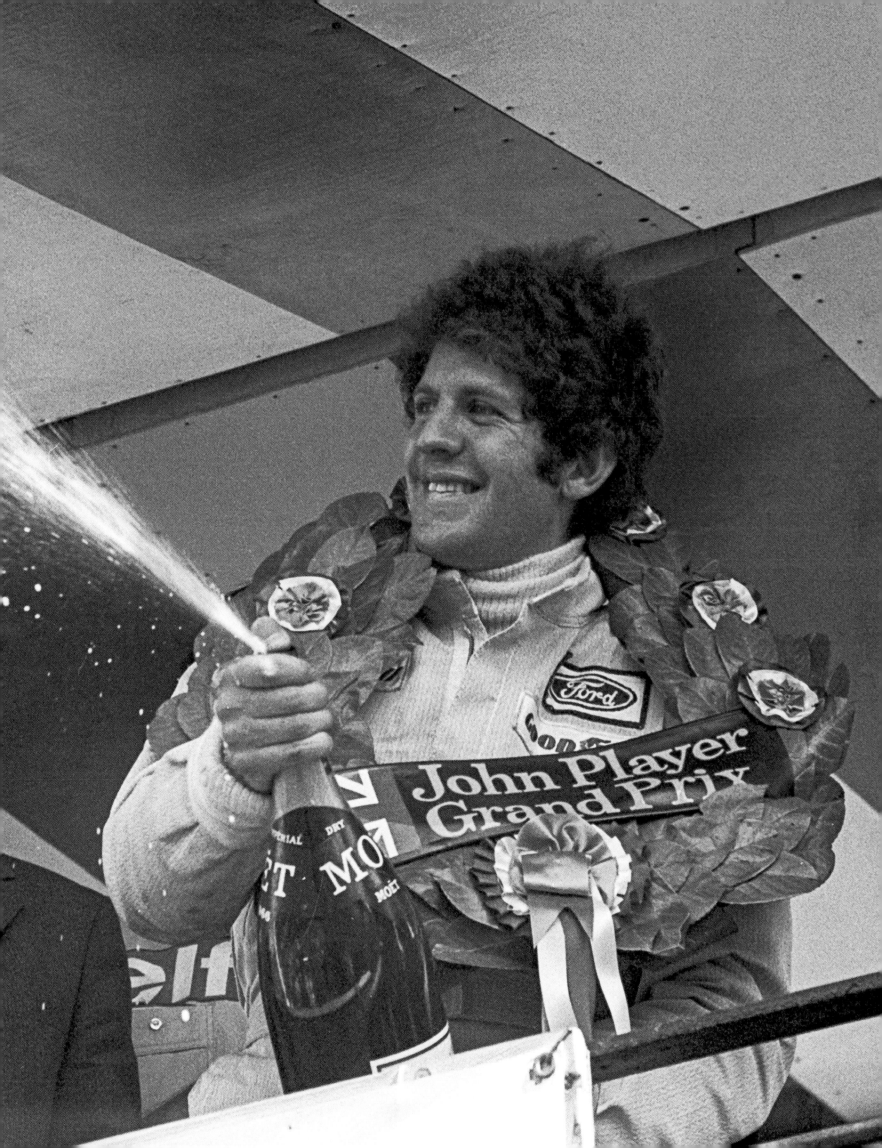

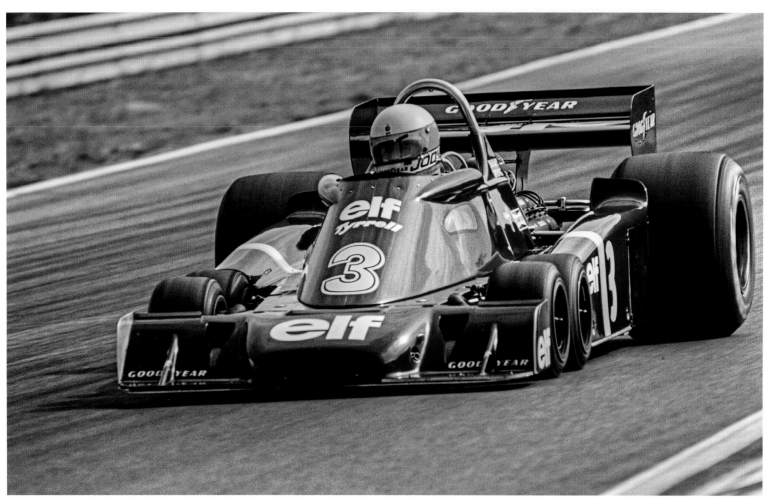

lap of the 1973 British Grand Prix when a spin by Scheckter caused a massive pile-up from which drivers were fortunate to escape without serious injury.

Nonetheless, such unrefined talent was enough to impress Ken Tyrrell, the exacting team owner giving Scheckter a good grounding in his first full season in 1974 and receiving the mutual reward of wins in Sweden and Great Britain. Further victories would be few and far between during a liaison lasting three years, Scheckter then joining the newly formed Wolf team for 1977. Understandable doubts about the risks associated with a fledgling operation would be banished with an unprecedented win first time out for the new combination in Argentina.

Searching for somewhere to test the Wolf, Scheckter boldly sent a telex to Enzo Ferrari, asking if they could use his private track at

Fiorano. When Ferrari agreed, it was a sign that Scheckter's blunt approach appealed to the irascible autocrat; more so when Jody placed second to Ferrari's Niki Lauda in the championship. Seizing his moment when Wolf's competitiveness tailed off in 1978, Scheckter bluntly told Ferrari he would like US$1.2 million to drive for him in 1979. A deal was more or less done on the spot.

It was to be a rewarding partnership. In fifteen races, Scheckter recorded only two retirements, won three times and consistently scored more than enough points to become World Champion. Twelve months later, he was saying goodbye to motor sport with nary a backward glance and not a single regret. Ferrari would not win another driver's title for twenty-one years.

Spotting a gap in the market, Scheckter investigated small-arms simulators and set up a company in the United States that

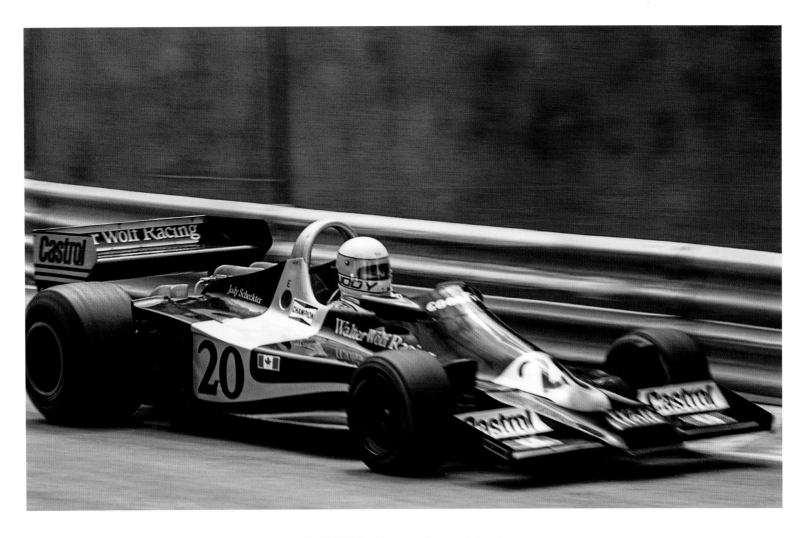

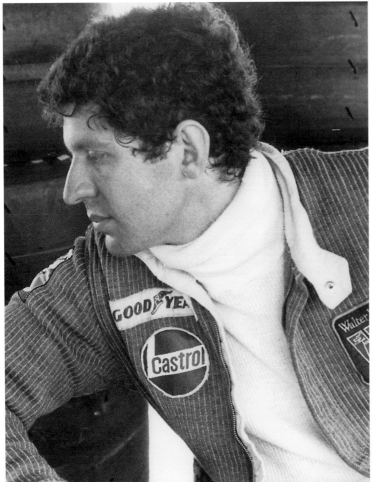

Opposite Scheckter confers with
Derek Gardner, designer of the
revolutionary six-wheel Tyrrell-Ford
P34 that Scheckter took to victory in
Sweden in 1976

Above The gamble of moving to the
fledgling Wolf team in 1977 paid off
when the taciturn Scheckter took the
Wolf-Ford WR1 to wins in Argentina
and Monaco (left)

'I was never a romantic. As a driver I was never interested in the Ferrari legend. I joined them for one reason – I wanted to win the world title and Ferrari offered me the most realistic chance of achieving that ambition. I was racing very much for myself and it was really only in later years that I became caught up in the whole drama of being a World Champion for Ferrari.'

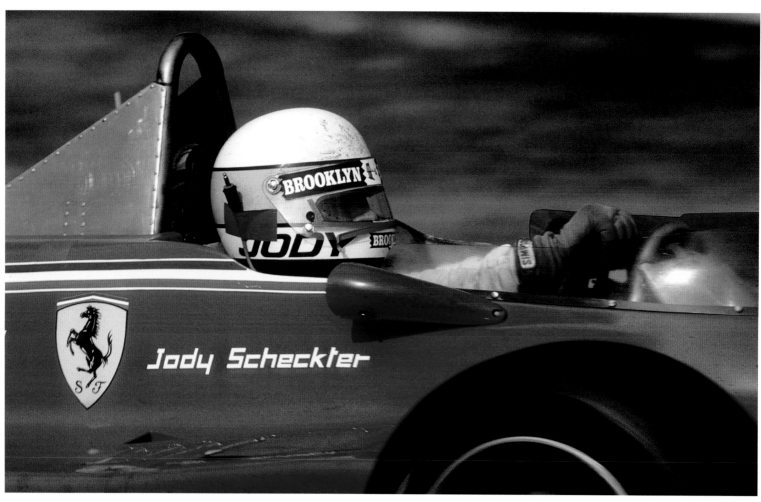

Opposite Ably supported by team-mate Gilles Villeneuve, Scheckter takes the Ferrari 312T4 to victory at Monaco in 1979 (*top*) and clinched the championship with a win in the final race of the season at Monza (*bottom*)

Below The Ferrari 312T4 gave Scheckter six podium finishes in 1979 (including Holland, *top*), in contrast to his final season in 1980 when the Ferrari 312T5 (Austria, *bottom*) brought one fifth place as the best result

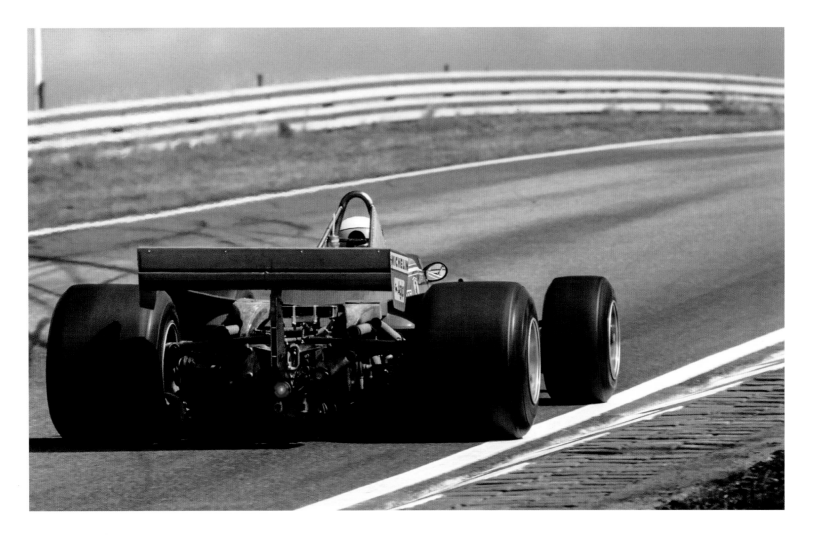

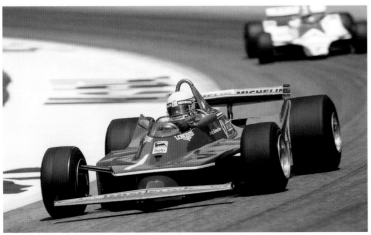

eventually employed 280 people and captured 95 per cent of the world market with an annual turnover of US$100 million. Then he sold up, moved back to Europe and entered an entirely different field – in every sense. Once again starting from scratch, Scheckter established a pioneering organic farm in Hampshire, his meticulous eye for detail studying and refining everything, literally from the ground up.

It's only when entering an immaculate stable just off the farm courtyard that a collection of his former race cars gives any clue about a vastly different life that was as brief as it was frequently spectacular.

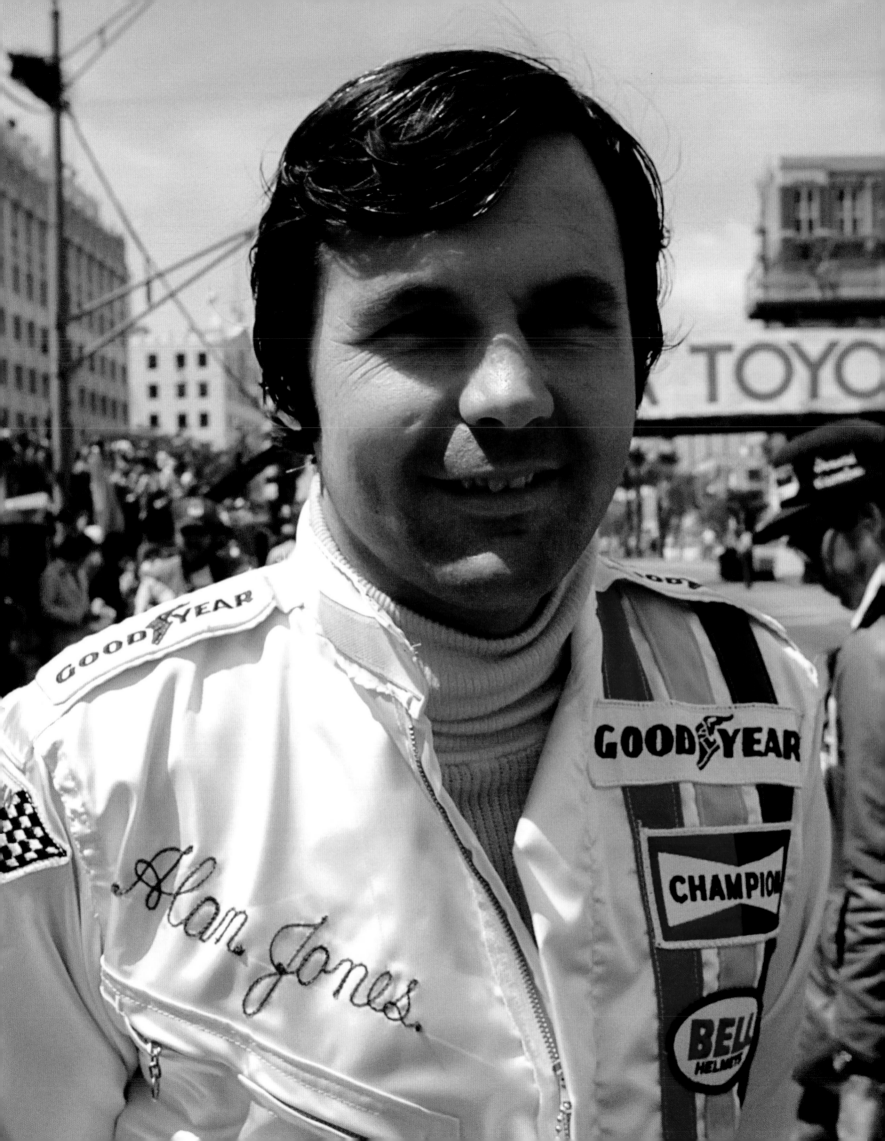

Alan Jones and Williams were made
for each other as they won their first
championships together in 1980

Alan Jones

1980

Alan Jones ran a boarding house in west London. Apart from providing a haven for backpackers from his native Australia, it was a means to an end. Having cooked breakfast for his guests, Jones was more interested in having the rest of the day free to chase whatever opportunities might arise in motor sport. They were few and far between for a driver whose CV was hardly littered with success in the various junior formulae.

The one welcome opportunity that did arise in F1 – with a privately entered Hesketh in 1975 – was grounded after four races when his sponsor had to leave the UK abruptly. Motor racing is filled with such stories. The vagaries of the sport would work in the opposite direction two years later when Tom Pryce was killed and Jones, having endured a largely unproductive season with Surtees in 1976, was invited to take the unfortunate Welshman's place.

The Shadow-Ford could scarcely be considered competitive but opportunity was to come Jones's way once more in Austria when a wet track was ideal for the heavy, ponderous car and others either retired or spun off. Jones's first appearance on top of the podium was so unexpected that the organisers did not have a copy of the Australian national anthem to hand. Jones could not have cared less.

The glimpse of skill shown that day was enough to prompt Frank Williams to offer Jones a drive in his new team. Frank's reputation was not exactly convincing but a mutual sense of pragmatism brought the two together for 1978.

Within a few months, both sides realised they were getting more than expected: Jones felt entirely at home in this compact, no-nonsense team and Frank Williams appreciated his new driver's enthusiasm for giving nothing less than 100 per cent.

Above Jones had a difficult first full season in 1976, scoring points just three times with the Surtees-Ford TS19

Right Sad circumstances would lead to a drive with Shadow in 1977, with Jones finishing third at Monza

Opposite Grabbing the opportunity of changeable track conditions in Austria, Jones would take the Shadow-Ford DN8 (*top*) to his first win and couldn't have cared less that such an unexpected result meant that the organisers were unable to find the Australian National Anthem as he stood on top of the podium (*bottom*)

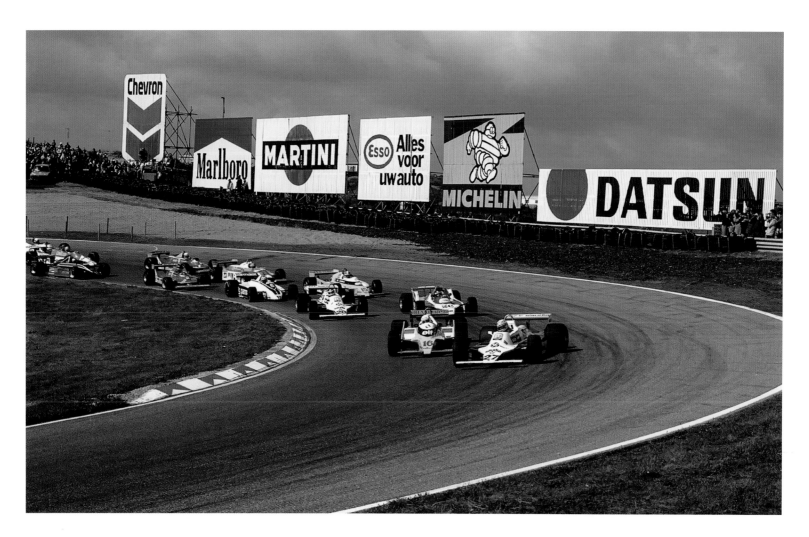

'Winning the championship has to be the most fantastic feeling of all time because, when you've been working towards one goal all your life and you come around to achieving it, it's a very emotional moment indeed. It's very hard to describe. But I do remember on the day going back to the hotel in Montreal and dancing around in the shower going: "I am the champion!"'

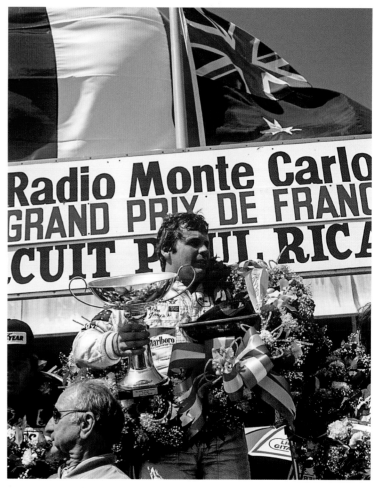

Opposite The Williams-Ford FW07 of Jones leads the Renault of René Arnoux, Jacques Laffite's Ligier and the Williams of Carlos Reutemann at the start of the 1980 Dutch Grand Prix (*top*). It would be one of the few races in which Jones made a driving error, but five wins elsewhere (including France, *bottom*) would secure the title

Left and below Good technical communication meant Jones was immediately at home at Williams and extracted the maximum from his FW07

They would flourish together, particularly in 1979 when Patrick Head laid down his credentials as a first-rate designer and engineer by producing the Williams FW07. Teething problems got in the way of early success, but once up and running Jones won four races; too late to influence the championship but a portent of what was to come in 1980. Five wins would contribute to the first world titles for driver and team.

There could have been a second for Jones the following year but for a breakdown in relationships with a new team-mate, Carlos Reutemann. Jones was not slow in coming forward about how the Argentine driver's lack of respect for agreed team orders, plus a bout of unreliability with the Williams, had cost Jones the five points he needed to claim back-to-back championships.

A refusal to either mince his words or back down was also evident in September that year when Jones turned up for the Italian Grand Prix with a broken finger, the result of an altercation with another motorist on London's Chiswick High Road. The good news that weekend for Williams was the bandaged finger poking out of Jones's right-hand flame-proof glove did not prevent him from finishing second; the bad news came when Alan informed Frank he would be quitting motor racing in a month's time.

A retreat to Australia provided a welcome change that would turn out to be no more than a sabbatical as Jones became restless. His ill-advised return to F1 a couple of years later would be as unsuccessful as the new American team he signed up with. But at least his presence was welcomed by a media who missed the honesty and wry humour that had rarely faded during a run of 116 Grands Prix leading to retirement at the end of 1986.

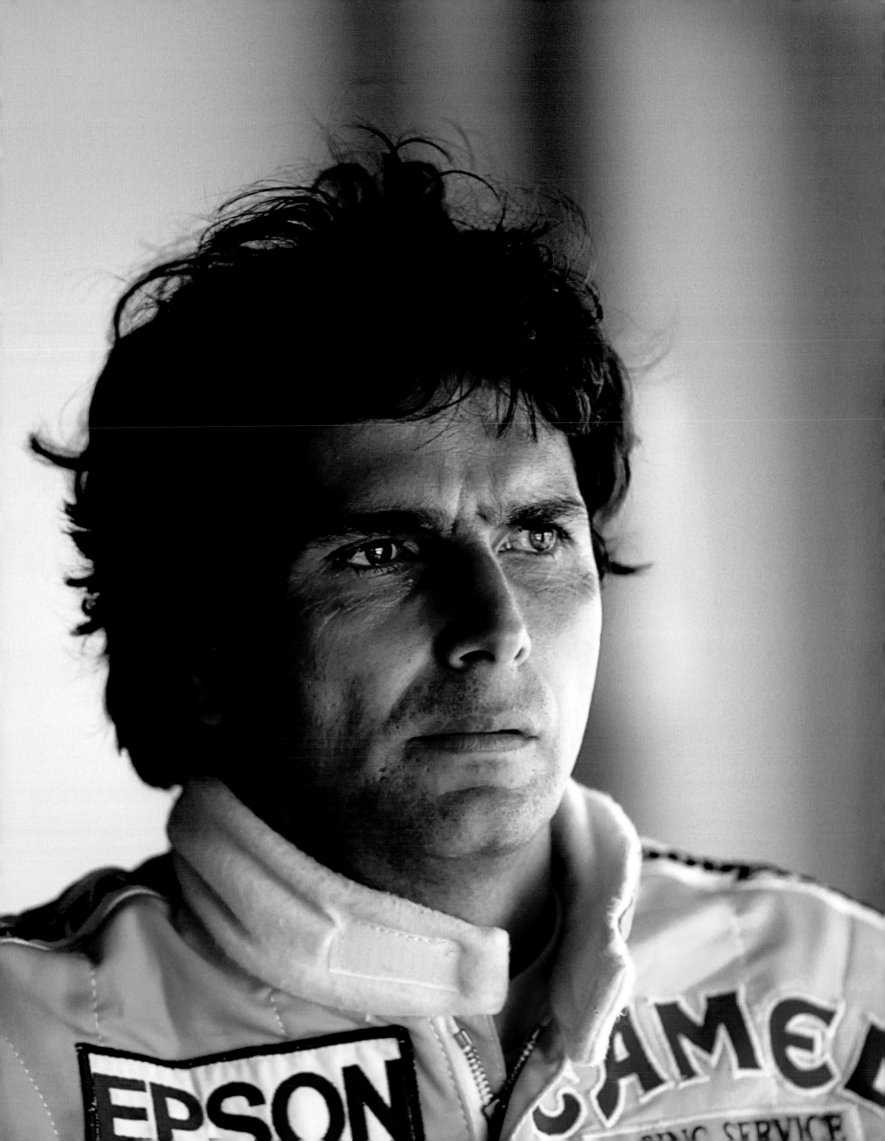

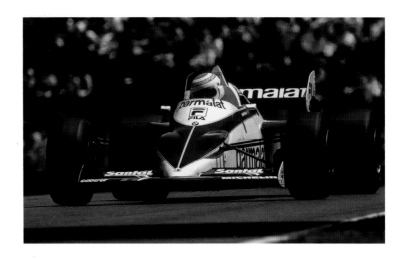

Two of Nelson Piquet's World Championships were won with Brabham, the second coming in 1983 with the Brabham-BMW BT52 (*right*)

Nelson Piquet

1981, 1983, 1987

It's not often – if ever – that Formula 1 mechanics care to run a fan club for their driver. But that's what happened at Brabham when Nelson Piquet was not just the lead driver but also a mate with no airs or graces. It exemplified Nelson's simple choices at the time; driving race cars and having fun.

That had been his ethos ever since arriving from Brazil in 1977, even though finding a drive was as difficult for Nelson Piquet Souto Maior (his full appellation before adopting his mother's maiden name) as it would be for any 24-year-old, inspired by Emerson Fittipaldi but with nothing more than a few national championships to his name and very little knowledge of the English language.

Piquet's ability spoke for him when he managed to win a couple of Formula 3 races in Europe with his own car; enough to earn a

works drive that brought victory in the 1978 British F3 Championship – and the attention of F1 teams. Almost before he knew it, Nelson was making his debut with a private entrant in the German Grand Prix that year, followed by three more outings with another small team.

His ability to stay out of trouble in such high-profile surroundings was enough to warrant a third entry by Brabham for the final races of the 1978 season in North America. Any doubts about the wisdom of such a gamble were banished straight away in Montreal. Driving an unfamiliar car on a new circuit, Piquet was faster in the wet than team-mates Niki Lauda and John Watson. It was the start of a relationship that would last for seven seasons.

Piquet not only fitted in well with the street-smart team run by Bernie Ecclestone but suddenly found himself as number-one

'To become World Champion, you need a whole load of luck; that's probably the most important thing. There's many excellent drivers who could become World Champion. But you need the right car, the right engine, tyres – and the whole team. I had all that. You must drive the car well, of course. But everything must come together.'

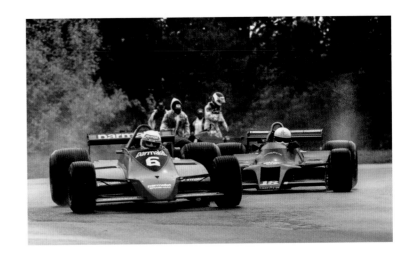

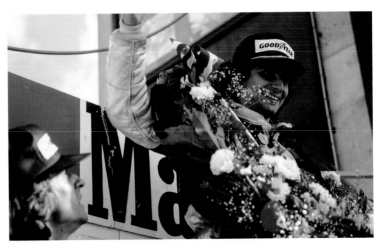

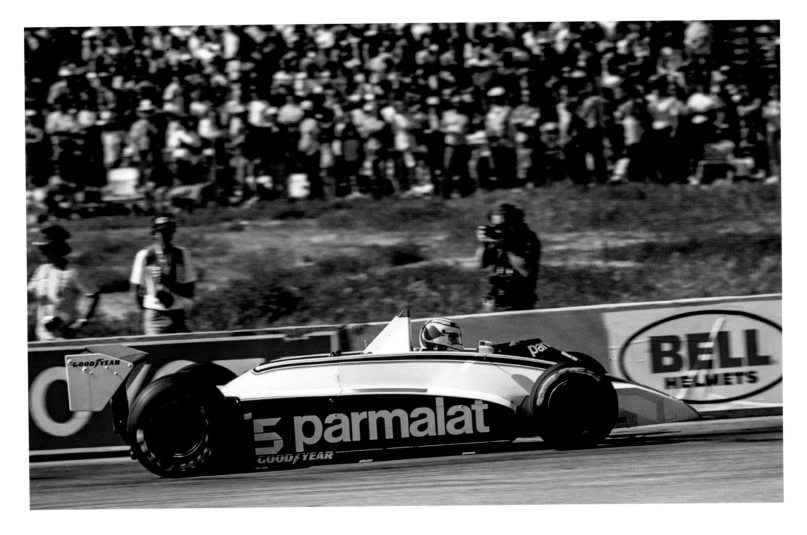

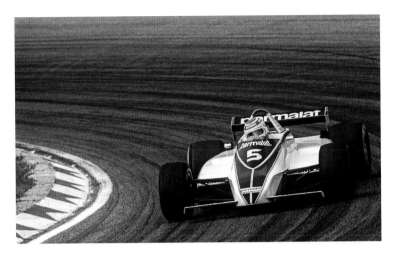

Opposite top The introduction of the Brabham-Ford BT49 at the end of 1979 would mark the beginning of Piquet's competitiveness. Here he battles with the Shadow of Elio de Angelis during the United States Grand Prix at Watkins Glen, where he would retire after qualifying second and setting fastest race lap

Opposite middle A win in the Dutch Grand Prix kept Piquet in the running for the 1980 World Championship

Opposite bottom Piquet's first win with the Brabham BT49 would come at Long Beach in March 1980

Left Having lost out to Alan Jones in 1980, Piquet won his first championship thanks to three victories with the Brabham-Ford BT49C in 1981

Below Piquet was never happier than when behind the wheel of a racing car. He waits while work is done on his BMW-powered Brabham BT50 in 1982, when he won just one race

driver at the end of 1979 when Lauda retired unexpectedly (Watson having moved on). This coincided with the arrival of a neat car from the pen of Gordon Murray and a switch from the thirsty and heavy Alfa Romeo engine to the ubiquitous Ford-Cosworth V8.

Piquet scored his first win at the fourth race of the 1980 season at Long Beach in California, another two victories putting him in the running for a championship that was eventually won by Alan Jones after the pair clashed at the first corner of the penultimate race. In 1981, Nelson was up against the other Williams of Carlos Reutemann but this time almost defeated himself through exhaustion during the final Grand Prix in Nevada.

Fitness was never a priority for a slightly built Brazilian who admitted to his laziness and a preference for sleeping in a corner rather than sweating in a gym. With Reutemann off form in Las Vegas, Piquet only had to bring his car home fifth, a task that seemed increasing impossible as the heat took its toll and he was sick in his helmet while driving on automatic pilot. Fifth place was duly achieved, although the new World Champion had to be lifted from his car at the finish.

Piquet was in better shape in South Africa at the end of 1983 when he used his potent Brabham-BMW to beat Alain Prost's Renault and claim a second title. As with his first championship, Nelson preferred to don his favoured T-shirt and jeans and celebrate with his mechanics over a plate of pasta in a local restaurant rather than be swept along at the behest of sponsors and officials.

The Brabham race team – not more than 25-strong at the time – would be devastated a year later when their man announced he

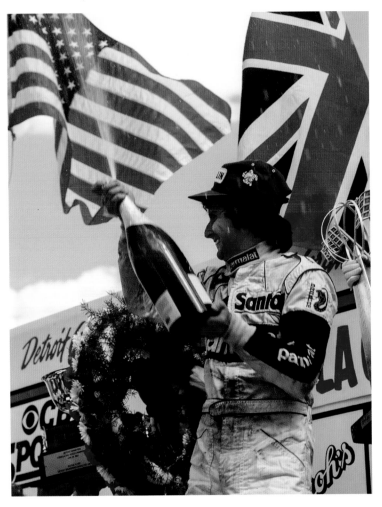

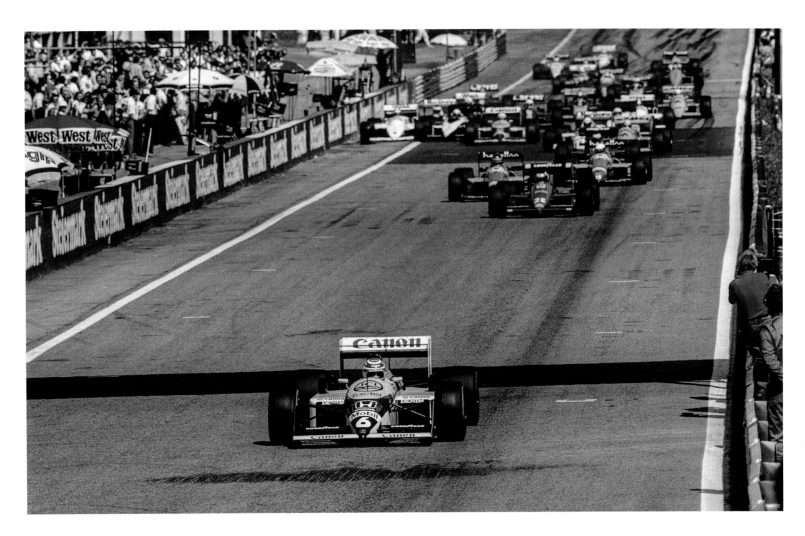

Opposite top Piquet loved the ambience and ambition of the Brabham team, particularly when they introduced mid-race refuelling and refined pit stops under the direction of technical director, Gordon Murray (in front of the car in the pit lane in Austria 1984)

Opposite far left Enjoying Grand Prix win number twelve in Detroit 1984

Opposite left Piquet won his first race with Williams in Brazil 1986 and took his third title with the Williams-Honda FW11B (*bottom*) in 1987

Above A clean start from pole with the Williams FW11B in Austria 1987

Right Piquet took his 23rd and final win with the Benetton B191 in Canada in 1991

was off to Williams, Nelson having had enough of being taken for granted, as demonstrated by Ecclestone's miserly pay cheques. He would have to work for his money thanks to the rugged presence of Nigel Mansell in the other Williams-Honda, the pair of them missing the championship by a whisker in 1986 but Piquet making it a third world title the following year.

For the next two seasons he would be an also-ran with the struggling Lotus team, although Flavio Briatore, the shrewd boss of Benetton, extracted three more wins from Piquet in 1990 and 1991, thanks to paying almost exclusively on results. Nelson needed the income to indulge in the two main extravagances of his otherwise modest existence: the use of a Citation jet to return swiftly from the race track to his luxury yacht moored in some quiet corner of the Mediterranean.

After 204 Grands Prix, however, Piquet decided he had had enough and returned to Brazil, where he established a successful satellite tracking business for trucks and managed the racing affairs of two of his sons. But he never forgot his past.

When he learned in the early 1980s that a Brazilian mechanic, who had helped him in his formative days, had been crippled for life when an irate customer used a handgun to settle his bill, Nelson did not hesitate. He bought the man a house, installed an elevator in the workshop and personally drove a van around other garages in the city, collecting unwanted equipment that might be of use to his friend.

This man would have understood exactly why the Brabham mechanics felt so attached to a shy driver who brought much more to the team than wins and championships.

Keke Rosberg

1982

Two images capture the essence of Keke Rosberg. The first from 1978 shows a Formula Atlantic single-seater in full opposite lock on a street circuit in North America. The left-front wheel is pawing the air; the right rear is kissing the concrete wall, a puff of cement and the crazy attitude of the car indicating that the driver's right foot remains hard on the throttle. As an appropriate adjunct to this already colourful scene, the car is painted bright pink in deference to the main sponsor, Excita Condoms.

The second image is of Rosberg's left hand, framed on top by a chunky gold identity bracelet and cupping a lit cigarette. Seconds later, he uses the heel of his red driving boot to grind the Marlboro into the concrete pit lane and then says: 'Okay. Let's do it.' Picking up his crash helmet, he climbs on board his 1000bhp turbocharged Williams-Honda and sets Silverstone alight with the

first ever 160mph lap of the British circuit. A slow puncture on a front tyre and a damp track in parts are almost an irrelevance in the midst of this thrilling mix of urgent nonchalance.

In between these two enduring images, Keke Rosberg became World Champion almost before anyone – least of all the stocky, cocky Finn – had realised. It was in keeping with a career pattern that had seen a spectacular maiden F1 win at the beginning of 1978 and then four seasons spent going nowhere.

It had come as no surprise to Rosberg that memories in motor sport tend to last no longer than the next race. He had won a few championships in Formula Vee but found he needed to apply the same energy to his powers of persuasion as he did to his spectacular driving.

The massaging of contacts led him in 1978 to Theodore and an

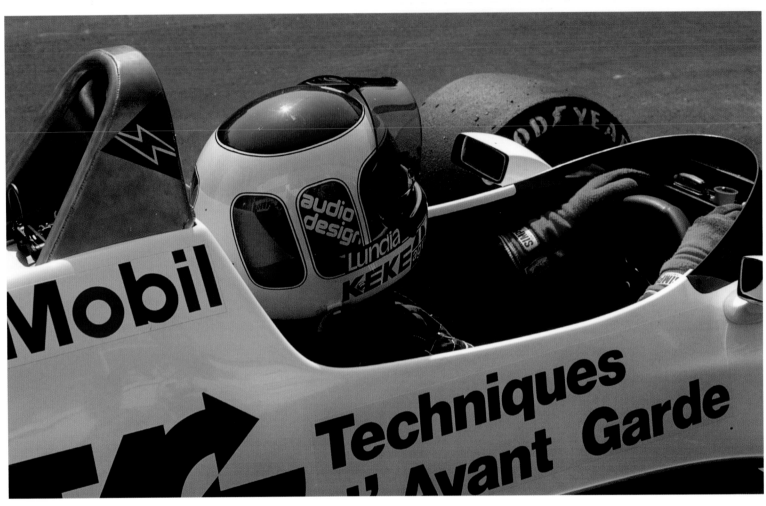

average F1 car built by the small British team. The machine's lack of top performance mattered little in the International Trophy, a non-championship race at Silverstone. When the big names of the day – Lauda, Hunt, Peterson – finished in the mud, Rosberg stayed in control on the rain-soaked track to score a totally unexpected victory.

Two weeks later, he failed to qualify the Theodore for the next race in California. And the three Grands Prix after that. Undaunted, Rosberg competed wherever he could on either side of the Atlantic, racing forty-one times in thirty-six weekends. At one point, an intermediary, having quietly pocketed sponsorship money, claimed that there were no funds to pay Rosberg to take part in a Formula 2 race at the Nürburgring. He drove for nothing, knowing the daunting Nordschleife would provide a canvas for his talent.

But not even a stunning pole position 4.5 seconds faster than anyone else attracted the F1 attention he deserved.

Just as Rosberg's relentless enthusiasm was beginning to wane towards the end of 1981, Alan Jones suddenly retired and left Williams with a seat to fill at a time when the best drivers had been accounted for. It was a lifeline – and Rosberg grabbed it with both hands.

The 1982 Williams was not particularly good but that didn't matter in a year when no fewer than eleven different drivers won races. It was a bizarre season, highlighted by Keke scoring a single victory in the Swiss Grand Prix – which was held in France. That result, courtesy of a typically powerful and energetic drive, contributed to Rosberg becoming World Champion at the final race in a hotel car park in Las Vegas.

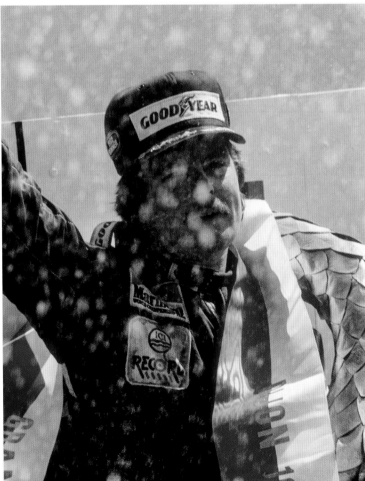

Opposite top Tough times with the Fittipaldi-Ford F8 in 1980 as Rosberg either retired or failed to qualify more often than not

Opposite bottom Rosberg used both hands to grab a late opportunity to drive for Williams in 1982

Above and left A tyre combination chosen by Frank Williams, coupled with Rosberg's equally daring driving, brought a crucial win in the 1982 Swiss Grand Prix at Dijon in France

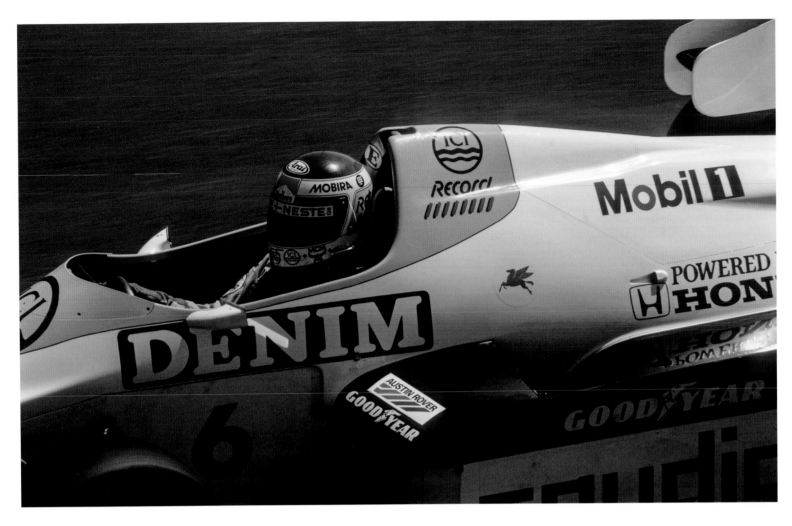

'The year I won the championship was unbelievable. Everything happened, from a drivers' strike and disqualifications, to the leader of the championship being seriously injured. And I win just one race. It was my first season with Williams and I went from zero to hero. It happened so fast that my fame, and earning potential, were lagging behind. I was an unknown champion.'

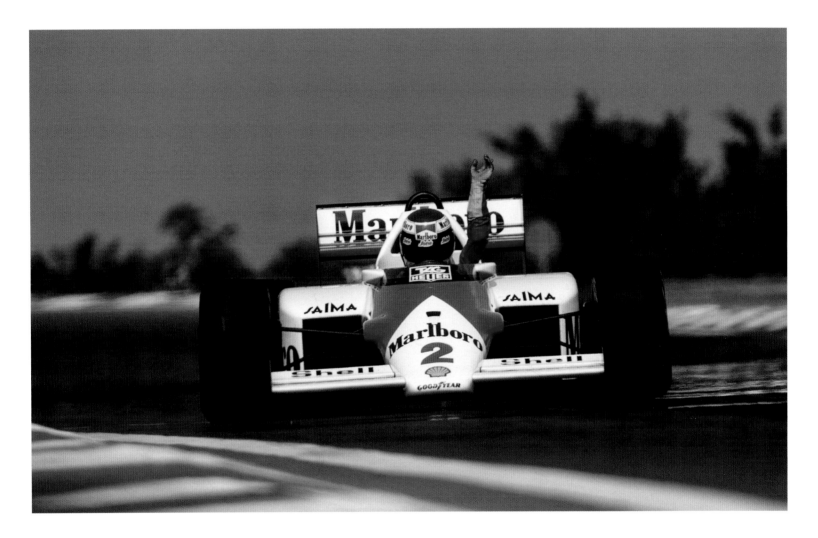

In truth, Keke had his best season the following year. The Williams-Ford may have been outrun by turbocharged rivals but Rosberg used it to great effect by bravely choosing slick tyres for the damp streets of Monte Carlo and scoring his second win. He would stand on top of the podium three more times (Dallas 1984 and Adelaide 1985 being another two gutsy and opportunist wins in difficult conditions) before joining McLaren for 1986.

Rosberg's more dramatic 'pointy' style was completely different to that of past and present drivers, Niki Lauda and Alain Prost. It took half of the season to set up the McLaren to his liking, Rosberg then claiming pole position at Hockenheim. As if to sum up his final year, however, the McLaren-TAG Turbo ran out of fuel and he was classified fifth after having led the German Grand Prix for much of the way. He would retire from 11 of the season's 16 races.

The absence of a bond with the technical director, coupled with the shock of witnessing his friend Elio de Angelis die unnecessarily during a test session in France, prompted Rosberg's decision to retire from F1 at the end of the year.

Rosberg would race sportscars and touring cars before running his own team and launching the career of his son. Having seen Nico advance to F1, Keke then stood back and, unlike some F1 fathers, kept a low profile and refused interviews. Which was probably just as well, because the stories behind such a comparatively brief but exceptionally colourful career would take some beating.

An effortless style at the wheel belied
an anxious worrier out of the car.
Alain Prost's search for perfection
brought four world titles, including the
1989 championship in his McLaren-
Honda MP4/5 thanks to four wins,
including the United States Grand Prix
at Phoenix (*right*)

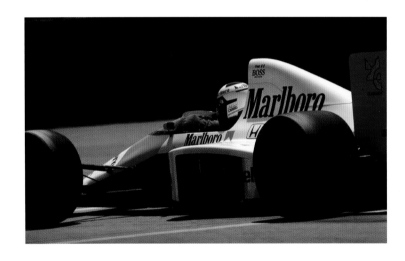

Alain Prost

1985, 1986, 1989, 1993

Alain Prost made driving a Formula 1 car look easy; his career spanning 199 Grands Prix was anything but. Despite winning fifty-one of them (a record at the time) and claiming four world titles, the Frenchman's progress was frequently bedevilled by politics outside the car and defined in many ways by one of the sport's most intense rivalries as Prost raced with and against Ayrton Senna.

The overcoming of these setbacks and challenges would help form the reputation of a motor-sport icon who, perhaps in keeping with such contrasting circumstances, never actually set out to be a racing driver.

Football was Prost's passion from an early age and the slightly built kid from the Loire region might never have altered course had he not visited a karting track, purely to keep his brother company while on a family holiday. The light-bulb moment would

be heightened that day when Alain won an impromptu race – despite having to drive with one hand because the other arm was in plaster.

Saving every franc he could and working all hours for an engine tuner, Prost got himself into kart racing, winning the French and European Junior Championships and firing an ambition to move into single-seater racing. To do this, he would need to win 'Pilote Elf', a prestigious competition run on behalf of the French oil company. In front of an influential audience at the Paul Ricard circuit on 25 October 1975, Prost received the winner's trophy from Ken Tyrrell, boss of the eponymous F1 team sponsored by Elf.

The prize was a Martini-Renault Mk17 and a season's racing that saw Prost emerge as Formula Renault champion – as you do after winning all but one of the races. Progress over the next few seasons

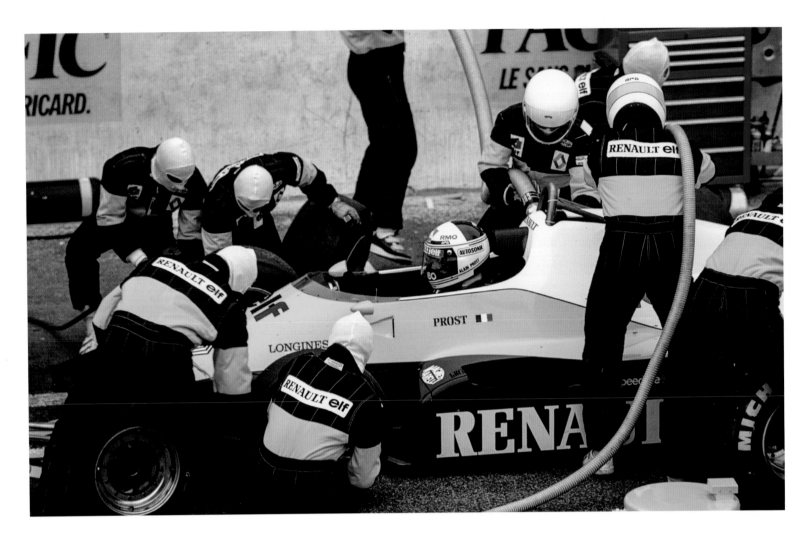

Despite winning in France (*above*) and Austria (*right*), Prost's 1983 season with the Renault RE40 was not a happy one, thanks to being wrongly blamed for the team's shortcomings as Renault narrowly failed to win the championship

Opposite Life with McLaren was much more satisfactory in 1986 as Prost took the MP4/2C to regular points scoring finishes (France, *top*; Detroit, *bottom*) and won the championship at the final race in Adelaide

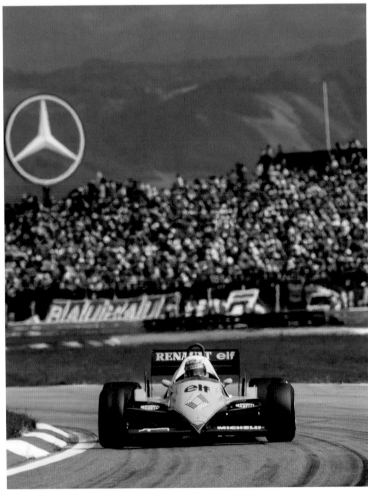

was more difficult – but not enough of a handicap to prevent him, thanks to continuous Elf sponsorship, from reaching F3 and winning the prestigious support race for the Monaco Grand Prix.

The blasé F1 entrants began to take notice and Prost was offered a drive with McLaren in the final race of the 1979 season. He turned it down. It was a typically astute and honest decision based on Prost's lack of experience and McLaren's uncompetitive state at the time. Tellingly, it did not jeopardise a subsequent test drive with McLaren that would be impressive enough to earn an F1 contract for 1980. This time, Prost accepted – and proved his initial hunch about the team's sorry state had been right as the McLaren failed frequently.

A switch to Renault for 1981 seemed logical enough as the French manufacturer began to make inroads with its pioneering decision to investigate the alternative of turbocharging allowed by the regulations. Despite Prost winning at least a couple of races each season, the Gallic liaison would become strained with each successive failure to take a championship that, to some uninformed French opinion, ought to have been Renault's by right.

Prost's disillusionment with the team and his home country reached its nadir at the final race of 1983 when he was blamed for a defeat that had more to do with Renault's incompetence than the failings of the driver. As Prost walked out, McLaren were waiting with open arms.

This was a very different McLaren, the British team having been taken over and completely remodelled by Ron Dennis and his innovative designer, John Barnard. They had gone down the turbo route with a purpose-built V6 from Porsche, Prost completing

A win at Monza with the McLaren MP4/5 helped Prost take his third title during an increasingly tense battle in 1989 with his team-mate, Ayrton Senna

the powerful team as he joined Niki Lauda. The pair dominated 1984, Lauda winning the championship by half a point and acknowledging Prost as the likely man to beat the following year. Which is exactly what happened as Alain claimed another five wins, including Monaco for a second time.

The rise of Williams-Honda meant McLaren may not have been favourites to continue their authority in 1986, but a policy of equal opportunity between the Williams drivers allowed Prost to come from behind and steal his second title at the final race. It was a last gasp for the McLaren in every sense as competitiveness slipped, pending the arrival in 1988 of the Honda engine – and Ayrton Senna.

A brilliant car in the hands of these two drivers meant a McLaren rout as they won fifteen of the sixteen races, with Senna taking his first championship. Then the dynamic within the team began to take a significant turn for the worse as Prost perceived Senna had gone against an agreed team strategy in the Brazilian's ruthless determination to win at all costs. With the driver partnership crumbling, it was almost inevitable that the two should collide while fighting for the lead of the penultimate race, Senna's ire increasing further as Prost won his third title as a result.

There would be another collision at the same circuit twelve months later, but this time Prost – who had moved to Ferrari – lost out to Senna as Ayrton walked back to the pits as the 1990 World Champion. As Ferrari's competitiveness went into one of its periodic declines, the Italians did not take kindly to Prost comparing their car unfavourably to a truck. He found himself unemployed before the final race and, after more than 175 Grands Prix, decided this would be a good moment to take a sabbatical.

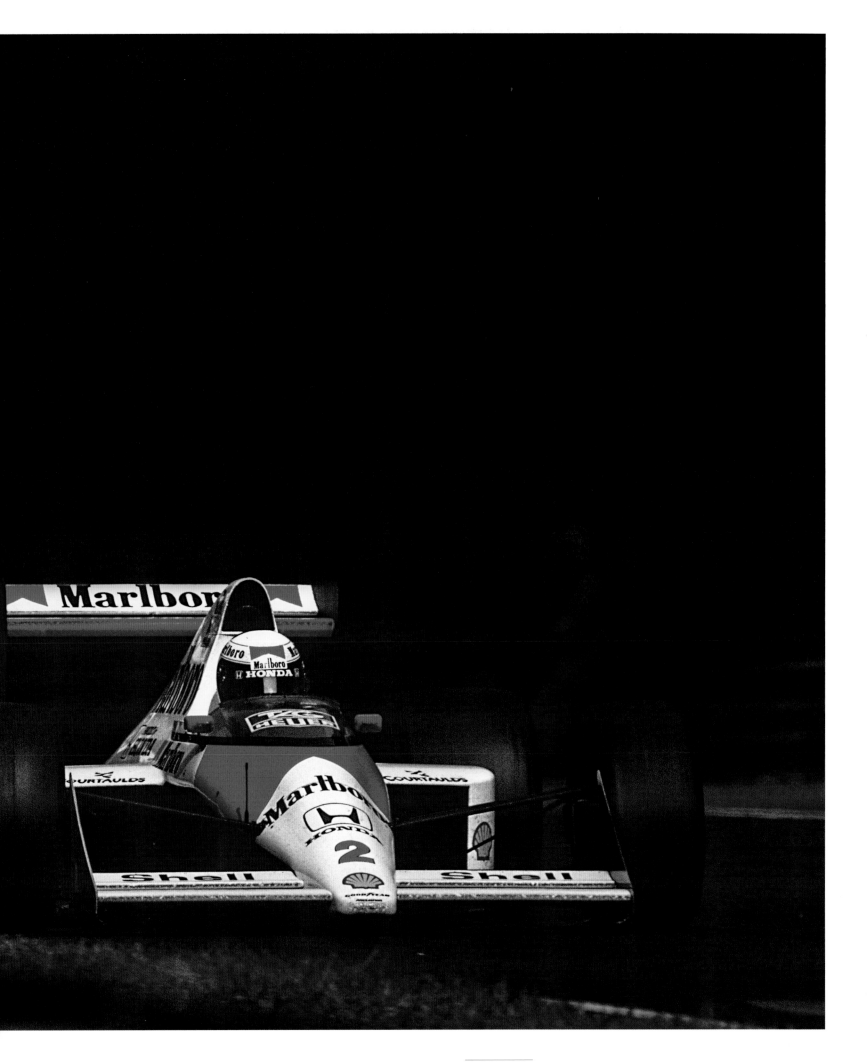

'1986 was one of my best seasons. Going into the final laps of the last race in Australia, I thought I was going to run out of fuel. You can't believe the feeling when I saw the flag and crossed the line. But perhaps the best feeling of all came the following morning. I was going down to breakfast and the morning newspapers had been left outside the bedroom doors. The headline said: Prost Wins Adelaide Thriller. And there was the photo of me; jumping for joy beside the car. I'll never forget that moment. Absolutely fantastic.'

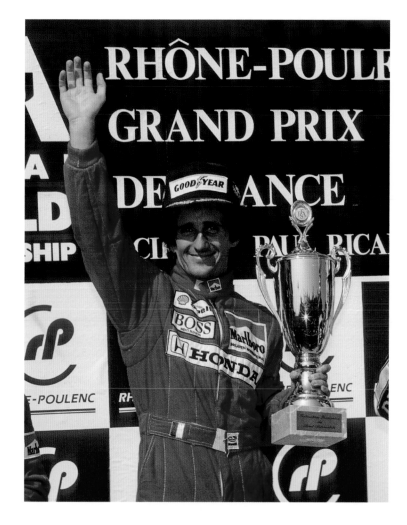

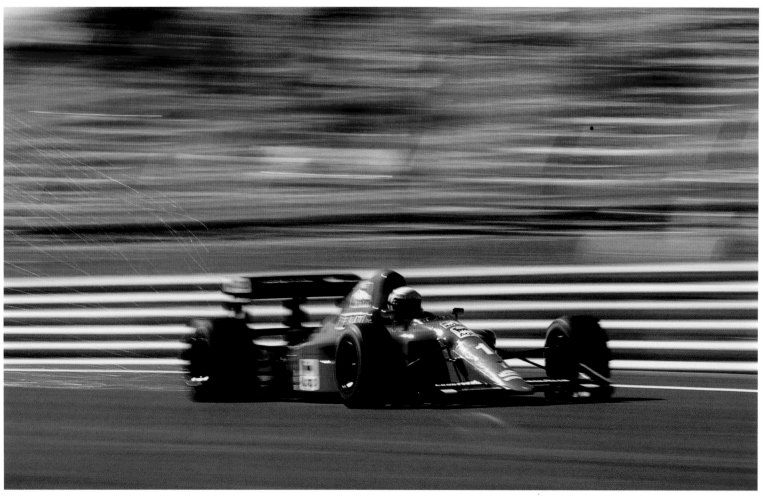

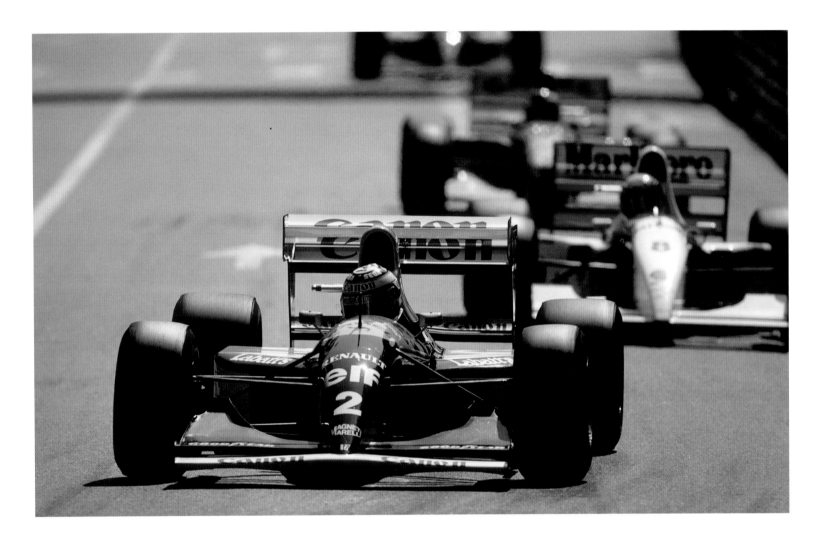

The year off clearly had no ill-effects as he accepted an offer from Williams for 1993 and walked off with his fourth title. So desperate were Williams-Renault to sign Senna for 1994, they paid off Prost, knowing Alain would never countenance another year working with his nemesis. Prost's career as a driver ended right there, more through circumstance than choice.

This had been the sixth Constructors' Championship for Williams. For a seasoned team that had seen it all, Prost's quiet presence had been a revelation. The Frenchman with the slight build and crooked nose knew exactly what he wanted from the car and the team, and applied as much precision to setting up the car as he did to driving it so effortlessly. And yet, despite the calm demeanour, Prost's perpetual worrying would be betrayed by chewed fingernails and, occasionally, a haunted look.

After a career coloured by the sort of polemics he abhorred, it was no surprise that Prost had enjoyed the straightforward ethos endemic to Williams, even though the French press once again assumed victory in 1993 was a matter of course and picked on Prost's every failing, real or imagined.

It was also typical that, on reflection, Williams' technical director Patrick Head would say of Prost: 'Alain was a bit of an enigma for us. It was like he came and he went. He came in this door and walked out the other door, did a perfect job and won a championship along the way.'

Typical Alain Prost, making driving a Formula 1 car look so easy he was frequently underrated, not least by his fellow countrymen.

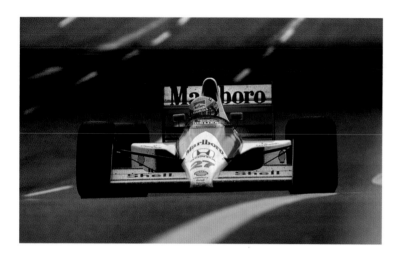

Ayrton Senna brought a magnetic quality to everything he did, both inside the car and out, winning three World Championships with McLaren, including 1990 (*left*)

Ayrton Senna

1988, 1990, 1991

Ayrton Senna was an extraordinary force. There was an intensity about the Brazilian; a sense of deep introspection that was evident in and out of the cockpit. His car control was sublime and yet there was a dramatic urgency about it that redefined commitment and simply took your breath away. His personality could vary from a ferocious focus to the gentle mien of a humble family man.

The crucial thread was a voracious desire to win, driven by the conviction that he was the fastest driver on the planet. Which he usually was – but perhaps not quite as often as he believed.

That inner confidence showed itself at the end of his first year on the European scene. He had arrived with impressive credentials in world karting, made his mark in Formula Ford – and suddenly returned to Brazil, ostensibly for good when no one had come forward to provide the Formula 3 drive he felt his talent deserved.

It didn't take long for desire to overcome pride, the name Ayrton Senna da Silva (before being shortened to a more manageable length by using Senna, his mother's maiden name) appearing in race programmes for the Formula Ford 2000 championship in 1982. The man with the distinctive crash helmet in the predominant yellow of Brazil completely destroyed the opposition.

It would not be so simple in 1983 when he stepped up to F3 and engaged in a season-long battle with Martin Brundle. Senna took the title at the final race – but not before demonstrating some alarming win-at-all-costs tactics to partially tarnish what was clearly an explosive talent good enough to attract F1 interest.

Recognising a need to learn the Grand Prix ropes, Senna turned down offers from McLaren and Brabham and chose to sign for Toleman, a midfield team at best but a compact unit devoid of

Right and below Senna's F1 career began to take off in 1985 with the striking black and gold Lotus-Renault 97T

Bottom The image of Senna's predominantly yellow helmet brought a mix of fear and respect when it filled an opponent's mirrors

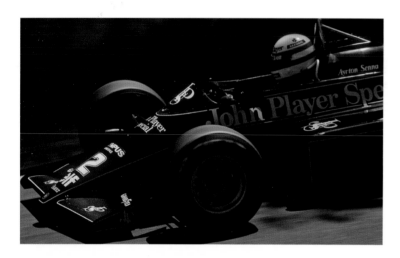

Left Senna checks the timing monitor during practice and qualifying; his name was usually at the top

Below The combination of Senna and the McLaren-Honda MP4/4 brought eight wins and his first World Championship in 1988

the pressure attached to the bigger names up front. He scored a point for sixth place in his second Grand Prix, the heat of South Africa having taken its toll as the novice was helped from his car.

Typically, Senna would address the shortcoming, but substandard fitness would be less of an issue – as would a comparatively uncompetitive car – when the Monaco Grand Prix was run in teeming conditions. Using an innate ability to find grip on the slippery streets, Senna hauled himself from thirteenth on the grid to the point of almost taking the lead just as the race was stopped prematurely. Despite having had the chance to display his potential during the world's most iconic motor race, Senna was miffed at having been denied victory.

There would be no such discussion in future years as he went on to win this classic race a record six times. The first would come in

1987, by which time he had moved to Lotus and scored his maiden victory two years before with a truly outstanding drive in a very wet Portuguese Grand Prix. As with Toleman, the time spent with Lotus was to be no more than a staging post in his master plan to become World Champion.

To do that, and receive the recognition he felt he deserved, Senna would not only need to be in a seriously competitive car but also defeat the driver regarded as being the best. And the point was, he had to be *seen* to be doing it. The perfect opportunity presented itself in 1988 with the chance to join McLaren and race alongside double World Champion Alain Prost.

Senna's thirteen pole positions in 1988 left no room for doubt about his out-and-out speed, the conversion to eight victories being good enough to give Ayrton his first world title. But seven

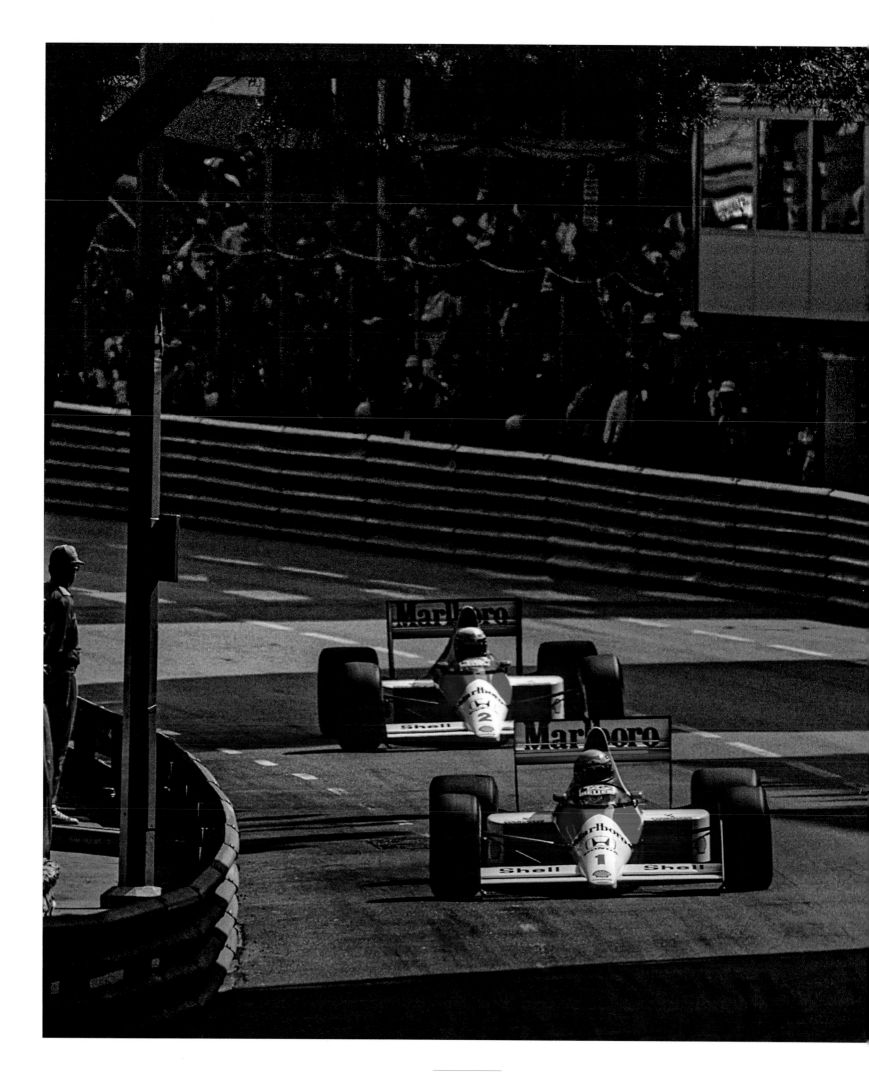

wins for Prost indicated the Frenchman's cerebral quality when setting up and maximising his car when it really mattered. It also laid down a marker that was significant enough to help turn a healthy rivalry into naked hostility.

The turning point – in Prost's mind at least – came early in 1989 when Senna disregarded an agreed plan; the distrust then festered through the season and erupted in a collision as they fought for the lead of the penultimate race in Japan. Senna was incensed, not simply because Prost had won the championship in the process but also due to Ayrton's view that the establishment had ruled against his part in the clash.

The resentment stayed with Senna during 1990 as Prost joined Ferrari and took their championship fight to the wire once more. For a second year at the same race track, Ayrton felt he had been hard done by, thanks to the actions of officials even before the race in Japan had begun. This time, in a scary demonstration of Ayrton at his most absolute, he drove Prost off the road, regardless of this being the first corner with twenty-four cars jockeying wheel-to-wheel behind them. Despite McLaren being in awe of their man's profound ability, few in the team felt comfortable with this method of winning the championship.

There would be a rapprochement three years later at the final race of the season. Senna had become champion for the third time in 1991; Prost, having won his fourth title (this time with Williams) in 1993, had decided to retire. They were both on the podium in Adelaide and shook hands, more or less at Senna's behest.

In hindsight, it would also be a significant moment since that victory would be Senna's last. He moved to Williams, only to find that their car was nothing like as competitive as the previous three.

'1991 has been a special season, winning a third championship, especially with the same team. But no matter what anyone – be it myself or any younger driver – can achieve in the future, no one will take away anything that Fangio has done in the past. He has established the titles, the records, and also he has established a way of doing things as a gentleman. All I can say is that I should be trying hard to get as near as possible to him.'

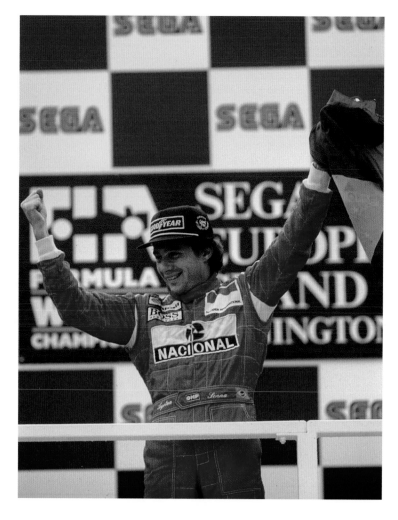

In fact, it was so unpredictable that Senna spun at Interlagos – a very rare sight, particularly in front of his adoring fans on a track he knew so well. Having gone through the first two races without scoring a single point for the first time in his career, it was an introspective Senna who arrived at Imola for the San Marino Grand Prix.

This coincided with the rise of Michael Schumacher and Benetton, a combination that had won the first two races with comparative ease. Senna, determined not to have the young upstart win a third, led at the restart (after several laps following a safety car made necessary by a start-line collision).

For reasons that have never been clearly defined, Senna left the road at Tamburello, a flat-out and relatively easy left-hand curve. The Williams struck a concrete retaining wall and ripped off the right-front wheel, sending it towards the cockpit, where part of the broken suspension arm penetrated Senna's helmet, killing him instantly. It was a complete fluke; he was otherwise completely unharmed.

The watching world was stunned. Ayrton Senna was one of the best-known names, not just within motor racing, but also in global sport. Anyone with so much as a passing interest had heard the stories of his derring-do and appreciated this charismatic man as someone very special. His many followers remembered some of the finest moments ever witnessed in motor sport, not least an out-of-this-world qualifying lap at Monaco in 1988 or a mind-blowing first lap at Donington in 1993 when he speared through the spray to move from fifth to first in a single lap.

An extraordinary force, indeed.

Nigel Mansell carried red, white and blue with pride on his crash helmet (*left*), winning the championship in 1992 with the Williams-Renault FW14B (*right*)

Nigel Mansell

1992

The British media appreciated Nigel Mansell, not only for his newsworthy thirty-one Grand Prix victories but, more often than not, the dramatic manner in which he achieved them. In fact, win or lose, there always seemed to be a story as soon as the sometimes curmudgeonly Midlander arrived in the paddock and began to hold court. But from the moment the man with the Union Flag crash helmet stepped into a racing car, he spoke a combative language noted for its absence of compromise and loved by his team and dedicated fans alike.

A need to fight every inch of the way had been part of his DNA from the moment a penniless Mansell moved from karting to single-seater racing; more than once along the way, he suffered debilitating injuries. The problem was that a cast-iron tenacity did not seem to be matched by talent good enough to make

it to Formula 1, never mind the championship status he assured everyone he was capable of.

Salvation came from an unexpected source. Colin Chapman, never a man to suffer fools gladly, gave Mansell a drive with Lotus on the basis of an impressive test session. The first hint of Chapman's perspicacity came at Monaco in 1981 when Mansell hustled through the streets to claim third on the grid, two weeks after he had scored his first podium by finishing third in Belgium.

Eighteen months later, Mansell lost his staunchest ally when the Lotus boss died suddenly, leaving his team in the hands of management who did not share Chapman's enthusiasm for their driver. A vicious circle of undermined confidence reached new depths when Mansell crashed while trying too hard as leader of the 1984 Monaco Grand Prix.

Right Mansell urges his Lotus-Renault 95T through the streets of Monaco in 1984

Below A move to Williams in 1985 was the start of a relationship that would bring his first-ever F1 win with the Williams-Honda FW10 near the end of the season

A switch to Williams for 1985 seemed ill-fated since this was a team whose founders, Frank Williams and Patrick Head, expected drivers to do what they were paid for without making excuses. But the chemistry slowly gelled and the rebuilding of Mansell's self-belief matched a rise in competitiveness as Williams established a strong relationship with Honda. When the Englishman had the crowd at Brands Hatch on its feet as he convincingly won a Grand Prix at the 72nd time of asking, the floodgates opened. Mansell claimed the next race in South Africa and set himself up for the championship the following year.

Mansell won five races in 1986, one more than Nelson Piquet. They were team-mates in name only, an intense fight between the two Williams drivers splitting the championship points and allowing the crafty Alain Prost to steer his McLaren through the middle

at the final race. Typically, Mansell's season had ended with a truly spectacular save when a rear tyre failed at 185mph. When Piquet then won his third title in 1987 and Mansell crashed out, the championship seemed further away than ever, particularly when Williams lost the all-powerful Honda engine to McLaren.

It was the work of a moment for Mansell to accept the offer of a Ferrari contract for 1989, such had been the elevation of the Briton's reputation as a talented and feisty fighter. The relationship got off to a fairy-tale start when Mansell won their first race together in Brazil. Slowly but surely, however, the liaison began to suffer from the pressure of Italian politics and the absence of tangible results, Mansell's persecution complex being fed by the belief that Alain Prost was receiving preferential treatment in the other Ferrari. When the home hero's car failed yet again during the

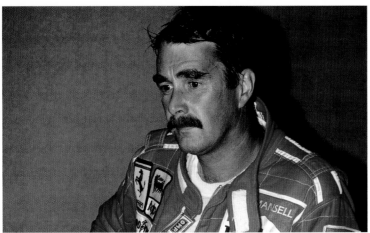

The relationship with Ferrari got off to a brilliant start with a win in the first race of 1989. By the following year, third place in Canada (*above*) would be one of the few highlights of a partnership that brought increasing despair

1990 British Grand Prix in July, Nigel dramatically announced his pending retirement at the end of the season.

Three months later, he had not only changed his mind but also decided to rejoin Williams. It was to be the timeliest move of his career. Williams designer Adrian Newey produced one of the most technically sophisticated cars of that or, arguably, any other generation. Computer-controlled active-ride suspension required the driver to trust that the car would stick despite hitherto unseen entry speeds into the corners.

Mansell's belief in himself and the Williams-Renault was such that he wrung its neck. Three-quarters of the way through 1992, he became World Champion, having won eight of the eleven races thus far. And then he fell out with Frank Williams.

This time, there appeared to be no coming back. Not that

Mansell was particularly bothered, as he established a new record by travelling to North America and winning the Indycar championship straight off. Nigel would return to Williams for four races in the wake of Ayrton Senna's fatal accident in 1994 and win the final round in Australia. That would have made a timely sign-off from F1. Unfortunately, in an ill-judged move, he signed for McLaren but only made two appearances in 1995 thanks to the cockpit of the car being too tight for his powerful build. The end of his substantial Grand Prix career would be as controversial, colourful and mildly bemusing as its beginning.

Right Mansell used five wins with Williams-Renault FW14 to finish second in the championship in 1991

Opposite top Celebrating his 1992 World Championship, wrapped up as early as Hungary in August 1992

Opposite bottom With the famous 'Red 5' on the nose of his Williams-Renault FW14B, Mansell extracted every ounce of performance from this sophisticated but tricky race car in 1992

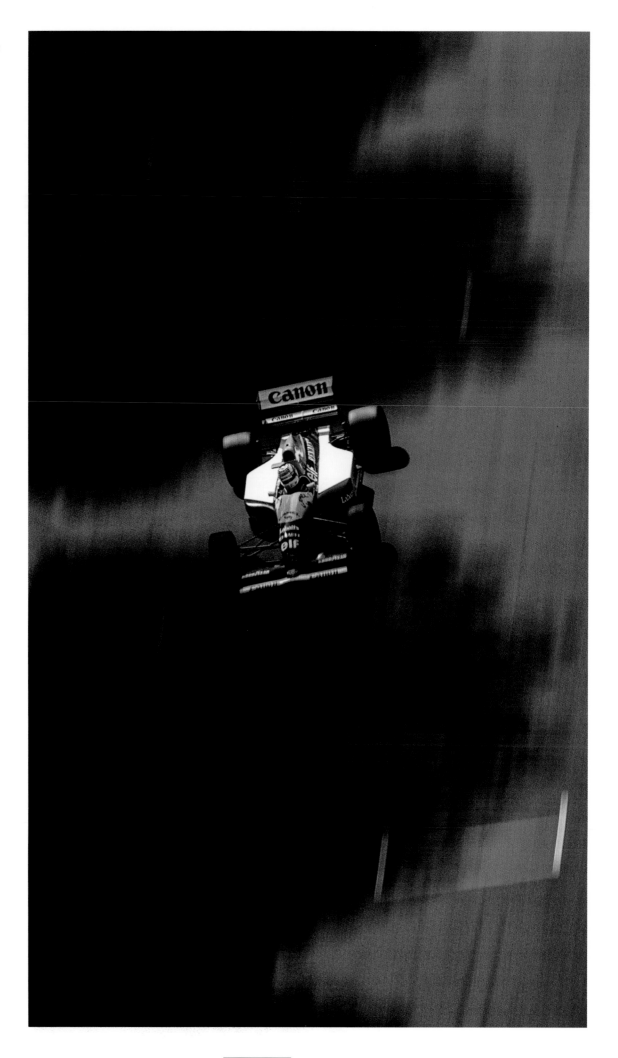

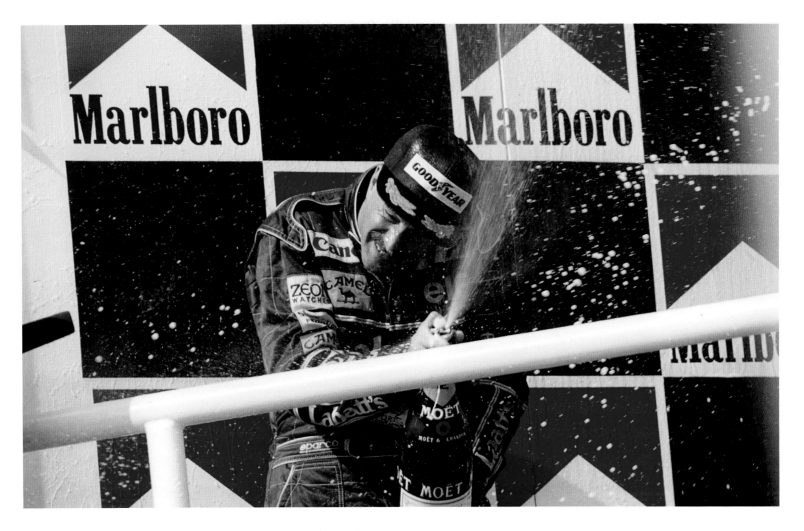

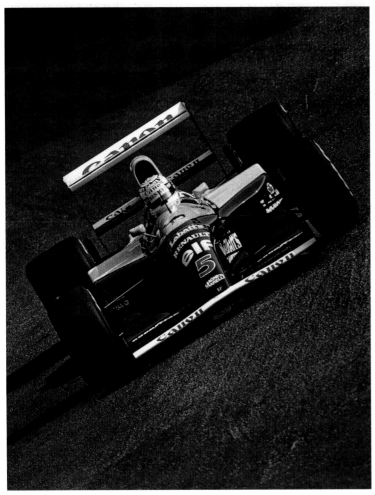

'I had a great relationship and great trust in everything Patrick (Head) and Adrian (Newey) did. I just had a love affair with that car in 1992. I was on a high because I had lost weight; I was the strongest and the most committed I'd ever been because I had spent my whole life waiting for this. I knew it would probably be my last chance to win the championship. I wasn't wrong!'

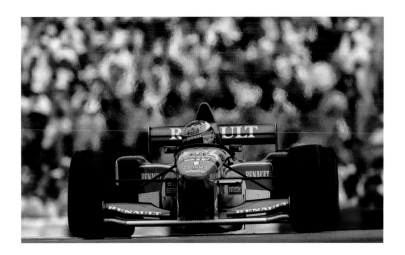

Michael Schumacher

1994, 1995, 2000, 2001, 2002, 2003, 2004

Michael Schumacher redefined many things in Formula 1, not least by rewriting the record books with statistics that seemed impossible to match when he finally retired at the end of 2012.

Seven World Championships, two more than the previous record held by Juan Manuel Fangio, raised the bar almost out of sight. Schumacher's titles were built across ninety-one race wins, an exceptional number, even when compared with the tallies of Alain Prost and the rapidly advancing Lewis Hamilton.

The central core of Schumacher's achievement would be established by several seasons of sustained brilliance with Ferrari, becoming champion in successive years between 2000 and 2004. Before that, Michael won two titles with Benetton, establishing a reputation as a fast and uncompromising driver with a work and fitness ethic not previously seen in F1.

It was his sometimes ruthless sense of entitlement that would first bring Schumacher to the attention of Ross Brawn, the engineer who would ultimately help mastermind Michael's success. As technical director with Jaguar's World Championship sportscar team in 1990, Brawn only knew Schumacher as a young German driver who had won in karting and Formula 3 before becoming a member of the rival Mercedes team. Brawn found himself having to intervene after one of his drivers, Derek Warwick, had been outraged by Schumacher's tactics on track and threatened physical retribution in the pit lane.

On a more positive note, Brawn identified Schumacher as not only the fastest in the Mercedes squad but also, for a driver so young, possessing impressive mechanical sympathy when it came to saving tyres and fuel. This would become relevant in 1991 when,

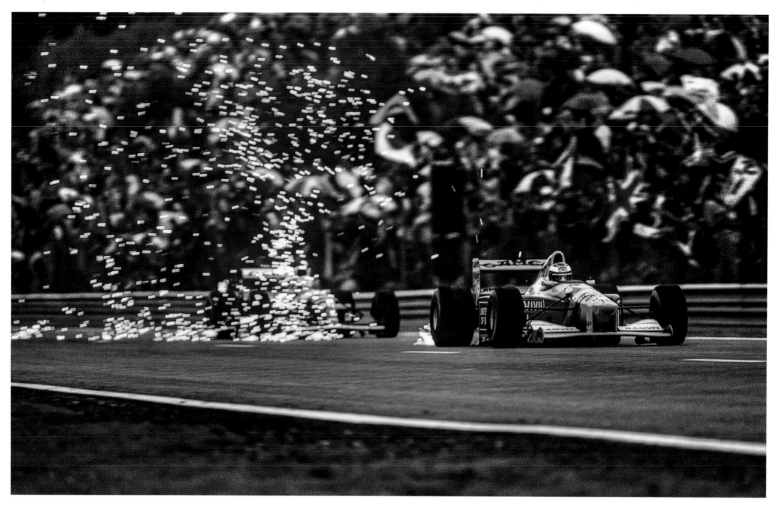

having become technical director at Benetton, Brawn watched with interest as Schumacher, aided by Mercedes money, made his F1 debut with Jordan in the Belgian Grand Prix.

Spa-Francorchamps may have been close to Schumacher's home town south-west of Cologne, but local knowledge had little to do with Michael qualifying seventh, the highest grid position for Jordan all season. Schumacher's race may have lasted no longer than a minute before clutch trouble intervened, but the point had been made. A contractual tug-of-war ensued, with Benetton winning out to begin a highly productive relationship with the 22-year-old at the next race in Italy.

Despite his narrow field of experience, Schumacher showed a quiet confidence in such heady surroundings as well as a hunger to absorb any information that would help him improve. That

came quickly as he won his first Grand Prix a year later (at Spa) and scored enough points to finish third in the championship behind the all-conquering Williams drivers.

Continual development for both the driver and the Benetton-Ford package would become a thorn in the side of Williams-Renault in 1994. The season boiled down to an intense fight that ended when Schumacher and Damon Hill collided in the final race in Adelaide, both drivers retiring, with Schumacher becoming champion for the first time.

Michael made it a world title double during a relatively untroubled year with Benetton-Renault in 1995 and then surprised many by switching to Ferrari despite the Italian team being in disarray. Even so, Schumacher managed to take three wins in 1996, none more outstanding than in Spain, where atrocious conditions

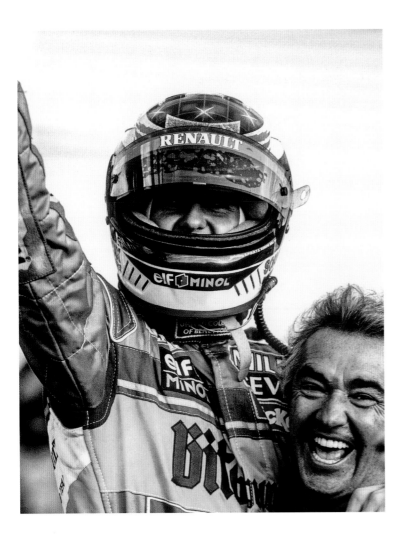

Opposite top Schumacher made a very impressive F1 debut by qualifying his Jordan-Ford 191 seventh for the 1991 Belgian Grand Prix

Opposite bottom Schumacher returned to Spa-Francorchamps a year later to score his first F1 win with the Benetton-Ford B192

Left Flavio Briatore helps Schumacher celebrate another victory together in Japan at Aida in 1995

Below On his way with the Benetton-Renault B195 to winning Monaco and, ultimately, a second World Championship

Overleaf Schumacher might have won the championship with his Ferrari F399 had he not suffered a broken leg halfway through the 1999 season

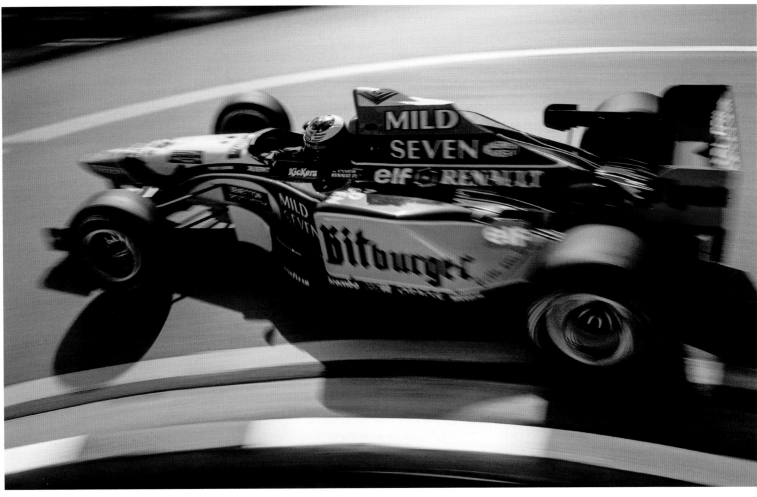

'I was repeatedly asked what my predominant feelings were at that moment (crossing the line to win his first championship for Ferrari in 2000), and on no single occasion was I able to find the right words. I didn't know what to do with this happiness.'

allowed the driver's sensitivity to overcome the shortcomings of his car.

Realising championships come from more than skill at the wheel, Michael set about moulding Ferrari around him. Persuading Brawn to move to Italy and use his specific expertise to reorganise the technical department at Maranello was a key move, one which began to bear fruit in 1997 as Schumacher got himself into the running for the championship. In another powerful climax, this time in Spain with the Williams of Jacques Villeneuve, Schumacher's chance of a third title began to slip away as his leading Ferrari developed trouble; Villeneuve closed in – and the two collided.

Whereas there had been room for doubt over the clash with Hill three years before, there was no question about this one as Schumacher turned in on the Williams. Yet the Ferrari team were as surprised as anyone when their driver returned to the pits, adamant that he had been wronged by the French-Canadian. It was only when shown a video of the incident that Schumacher quietly accepted events were not as he had imagined them to be in his imperious mind. Justice was served as Villeneuve finished the race to take the title and Schumacher was stripped of all his championship points.

Pressure mounted during the next two seasons as attention was drawn to Ferrari's failure to win the Drivers' title since 1979 – and Schumacher lost out to McLaren's Mika Häkkinen both times.

But it was not for the want of trying, the 1998 Hungarian Grand Prix being a Schumacher classic. With Michael bottled up behind the two McLarens and needing to win this race to keep his championship hopes alive, Brawn switched from a two- to a

Opposite top Powering his Ferrari F2004 through the spray to second place at Spa-Francorchamps in 2004

Opposite bottom The Bridgestone cap says '1st'; this time at the 2004 British Grand Prix

Above Leading team-mate Rubens Barrichello at the start of the 2004 Hungarian Grand Prix. The Ferrari pair were untroubled as Schumacher took his twelfth win of the season and his seventh in succession

three-stop strategy. His man would have a clear track – but he needed to find twenty-five seconds in nineteen laps in order to come out ahead after the final stop. Relishing such a challenge, Schumacher drove every lap as if it was qualifying – and duly claimed a race that by rights he ought not to have won.

Matters would be out of his control in 1999 thanks to a broken leg sustained during the British Grand Prix, but he came back strongly the following year to claim an emotional world title for Ferrari after a gripping on-the-edge fight with Häkkinen. There would be no looking back as the Schumacher/Ferrari combination produced a tour de force, dominating the next four seasons.

It was not so easy in 2005 and 2006 thanks to Ferrari suffering from a late change to the tyre regulations but, throughout those difficult days, Schumacher's enthusiasm and motivation did not

dim in the slightest. According to Brawn, his driving had a 'kind of majesty about it'.

As ever, Schumacher's influence went beyond the cockpit as he gently instilled his meticulous standards and professional principles into the thinking of the workforce. As if leading by example, Michael had raised his fitness level to such a peak that he never looked drained when those around him on the podium at times appeared close to exhaustion.

But fifteen seasons on the front line would eventually take their toll and Schumacher decided to quit at the end of 2006. After three years, however, the absence of an adrenalin surge, coupled with his towering self-belief, tempted a comeback with Mercedes in 2010. It was a mistake. Mercedes were still finding their feet and Michael had turned forty-one at the beginning of the year.

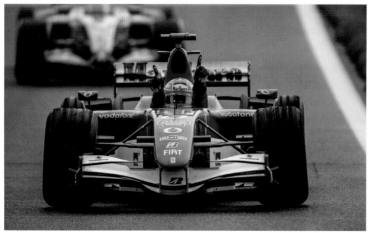

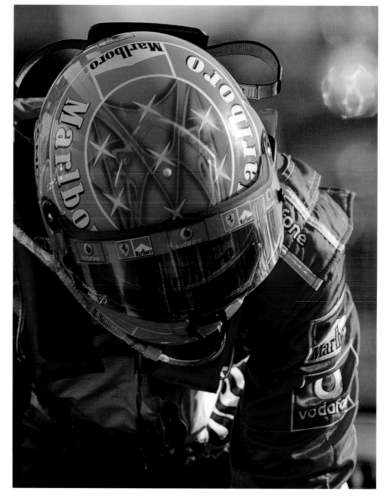

Opposite top A rare engine failure on his Ferrari 248F1 while leading the penultimate race of the season in Japan seriously dented Schumacher's chance of an eighth World Championship in 2006, his last year with Ferrari

Opposite bottom left A familiar sight in China 2006 as Schumacher celebrates win number 91 - and what will be his final victory

Opposite bottom right The familiar red crash helmet bearing seven stars for seven championships

Below top A return to F1 with Mercedes in 2010 brought little success compared with his previous crushing domination. Schumacher heads for sixth place with the Mercedes W02 in the 2011 Japanese Grand Prix

Below bottom Schumacher congratulates his fellow countryman as Sebastian Vettel celebrates his first World Championship in Abu Dhabi in 2010

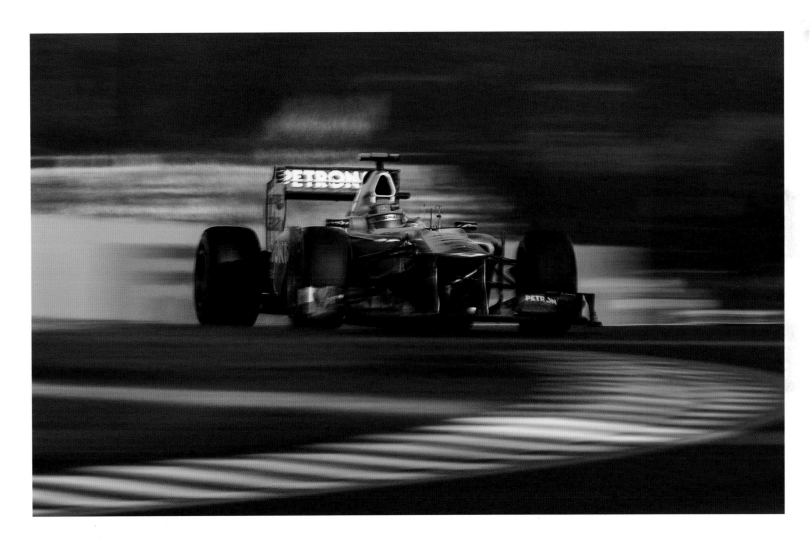

The magic might have gone by the time he retired for good, but the outstanding memories remained. Not to mention statistics that appeared unlikely to be surpassed at the time.

All of those, however, were to pail into insignificance in December 2013. A minor fall while skiing had devastating consequences as Schumacher suffered a traumatic brain injury from which he struggled to recover. The irony of the tragedy was inescapable when compared with the risks he had faced during an outstanding career as a racing driver.

Articulate, thoughtful and determined,
Damon Hill fought many battles on
and off the track to win the 1996 World
Championship with Williams-Renault

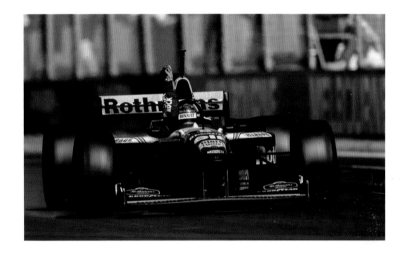

Damon Hill

1996

Damon Hill's first child arrived in March 1989. Damon was twenty-eight years old, had no money, lived in rented accommodation and yet remained determined to be a racing driver. He accepted a drive in a Japanese Formula 3000 car that no one with any sense would touch (in fact, a driver would be killed in it later that year). But Damon drove this car faster than it had ever gone before. It was all he could do in the hope that someone would notice.

In 1992, he would apply the same logic to the offer of his first Formula 1 drive with Brabham, a former great name in financial difficulties and on the point of closure. After managing to qualify the car for his home Grand Prix, Hill found the Brabham to be so uncompetitive he was lapped five times.

As far as Damon was concerned, this was adding race experience to knowledge being gained as test driver for the

Williams team. Everything added up when a race seat became available with the reigning champions in 1993, Hill earning the drive and using it to win his first Grand Prix. Having been team-mate to Alain Prost, the thought was that Hill's education would step up another notch when Ayrton Senna joined Williams-Renault for 1994.

In fact, the learning process was about to swerve as dramatically in an unexpected direction as Senna's car when he crashed fatally at Imola. Damon, a relative novice, suddenly found himself leading a team expected to win races and the championship.

A refusal by Damon to blow his own trumpet fostered Renault's lack of faith in the Englishman, but Hill quietly rose to the occasion. He not only helped pull the team together in the continuing shock and legal aftermath of Imola, but he also drove out of his skin to win brilliantly in a wet Japanese Grand Prix.

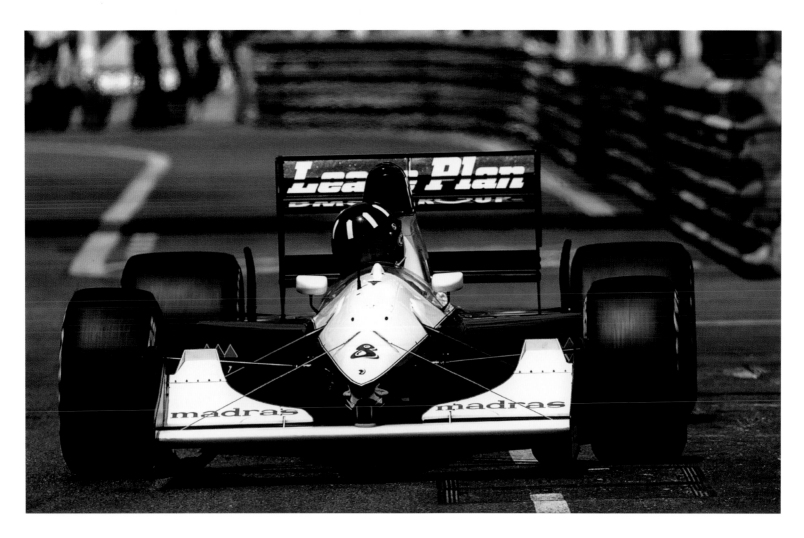

Hill had a tough F1 baptism in 1992, failing to qualify the uncompetitive Brabham-Judd BT60B six times (including Monaco, *above*) before making it to the grid for the British Grand Prix at Silverstone, where he was lapped five times

Opposite top The first of twenty-two wins came in Hungary 1993 with the Williams-Renault FW15C

Opposite bottom Retiring with engine failure from his home Grand Prix at Silverstone was part of the character-building process in 1993

The defeat of Michael Schumacher that day ensured that the championship battle between these two would continue to the final round on the streets of Adelaide. Another epic fight ended badly for Damon when Schumacher's Benetton collided with the Williams as Hill legitimately attempted to take the lead.

There was no such controversy the following year as Schumacher won his second title and crushed Hill's morale in the process. Not for the first time in his life, however, Damon would use such a potentially damaging setback to trigger a resolute recovery as he won eight races in 1996 to become World Champion. Then his career tailed off as suddenly as it had started when Williams did not renew their contract; Damon spent a season with Arrows and a final two with Jordan.

There was much more to Hill than the statistical evidence of a

championship and twenty-two Grand Prix wins. His career – in fact, his early life – had been one of turmoil and conflicting emotions, many of them the product of growing up in the shadow of a swashbuckling World Champion, much loved by the British public.

After struggling to come to terms with having a famous father, Damon would experience an altogether more devastating consequence in November 1975 when Graham Hill was killed in a plane crash. Invalid paperwork and insurance connected with the light aircraft left the family in dire financial straits. Damon was aged fifteen and the only man in the house as his mother and two sisters were forced to cope with dramatically changed circumstances in addition to dealing with such a shocking tragedy.

Swimming against a tide of confusing feelings, Damon's attempts to control his own destiny led to a variety of modest jobs

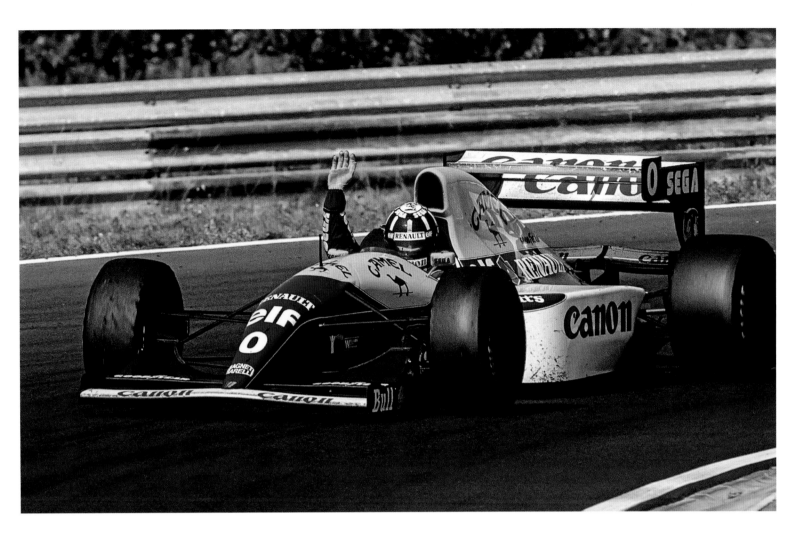

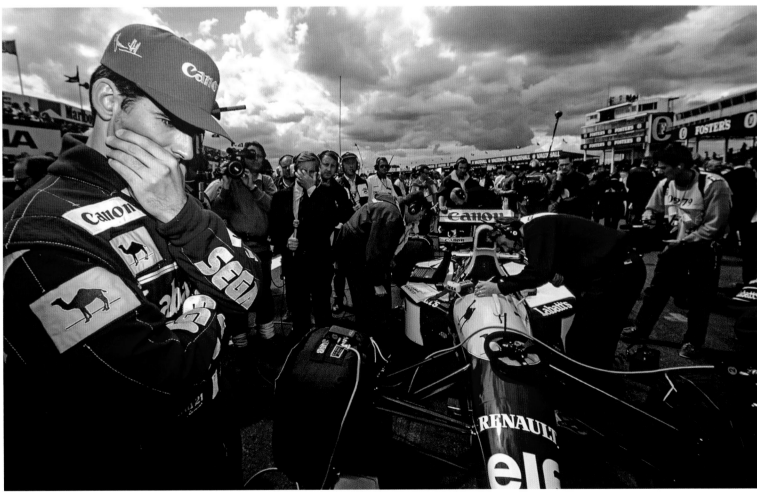

'Winning the championship is an accolade that's so well regarded and understood globally that its reach is massive. But you don't actually realise the full effect until later. When you're in F1, there's a lot of fuss and it's very immediate. But I found that I appreciated winning the championship much more as I got older. You've moved on; you're not the same person. Looking back, it was hard; but I'm glad I put myself through all that.'

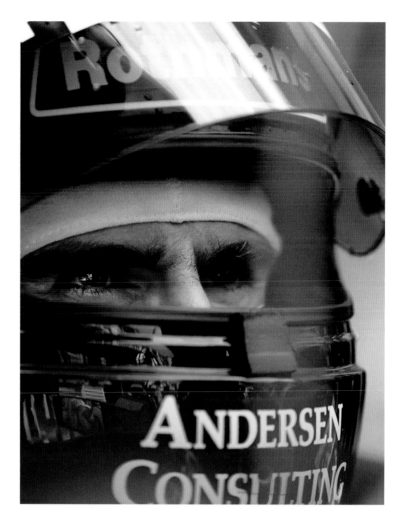

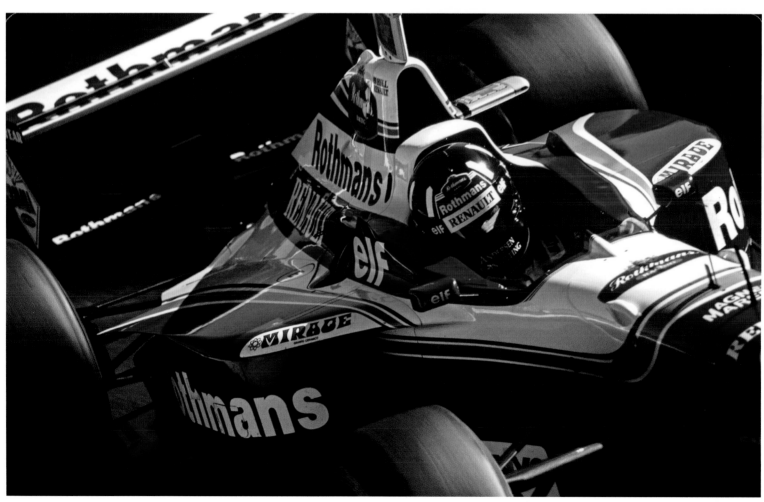

Opposite top A furrowed brow and much thought went into dealing with Michael Schumacher, Hill's main adversary in 1994 and 1995

Below A move to Jordan in 1998 brought the Silverstone-based team their first win in the rain-soaked Belgian Grand Prix

Opposite bottom Hill put his previous trials and tribulations behind him in 1996 and won eight times with the Williams-Renault FW18 to claim the world title and emulate his famous father

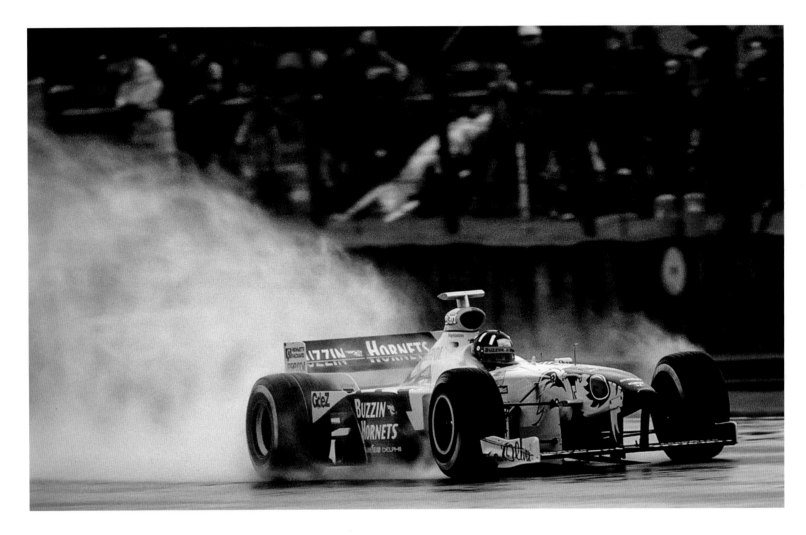

to fund a growing love of motorbike racing. When his mother, a true stalwart of the family, persuaded Damon that four wheels would be safer than two, he found himself entering a sport that immediately laid down the unreasonable typecast expectations attached to being the son of a motor-racing legend.

It was not until Damon emulated his father with equal distinction and finally quit the sport that he was able to start freeing himself from the shackles of the past. After a dark period spent dealing with depression, a more relaxed Hill emerged to lend his deep intelligence and thoughtfulness to articulate F1 punditry. Then he put it all down on paper through excruciatingly honest and revealing writing that set a towering standard for sports autobiographies.

Died blond hair, broad grin and buckets of self-confidence: Jacques Villeneuve's trademarks as he won the World Championship with his Williams-Renault FW19 in 1997

Jacques Villeneuve

1997

There is a straightforward logic – usually expressed in a blunt manner – to everything Jacques Villeneuve does. It's as if *carpe diem* has been a family motto even before his father brought a thrilling sense of free spirit to his motor racing.

Jacques was eleven when Gilles Villeneuve was killed during qualifying for the 1982 Belgian Grand Prix. Despite being at an impressionable age, Jacques was shielded from the detrimental effect of the tragedy when he was sent to school in Villars-sur-Ollon and found freedom of expression in the snow and mountains above Lake Geneva. Like his father, Jacques calculated the risks and took them to extremes that fired adrenalin and sharpened reactions. It was inevitable that he would want to transfer that love of speed across the Italian border and into motor sport.

A sincere willingness to help the bespectacled teenager was evident from the outset, thanks to his father having won the hearts of Italian aficionados with his obvious love of racing every Ferrari, no matter how uncompetitive, to the absolute maximum.

A gentle guiding hand was necessary for Jacques since, unlike other young hopefuls, he had no experience of karting. He had come straight into Formula 3 and, typically, could see no reason why he should not succeed. With a mind like a sponge, Villeneuve absorbed every detail, learning as he went. A mix of stubbornness and insouciance inured him to the widespread romantic notion that he had come to Italy to continue his father's unfinished mission.

A more physical feeling of national ownership endured in Quebec, where Jacques and his father were born twenty-one years apart. A decision by Jacques to race in Canada brought a

Above A perfect start in F1. Villeneuve lights up his tyres from pole position to start the parade lap for his first F1 race. The chance of winning the 1996 Australian Grand Prix in Melbourne would be compromised by a technical problem with the Williams-Renault FW18

Opposite top Villeneuve stayed with the same helmet colours throughout an F1 career that tailed off after a spectacular start

Opposite bottom Clipping an apex with his Williams FW19 at Monza, where he finished fifth; an unrepresentative result in the 1997 season that boasted ten pole positions, seven wins and the world title

keen expectation that was rewarded by Villeneuve Junior finishing third on the same challenging street circuit in Trois-Rivières where Gilles had once excelled.

A step-up to Indycar racing was almost instantaneous, Jacques loving the challenge despite a continuing lack of experience. When he not only won the 1995 championship but also the prestigious Indianapolis 500, the Williams F1 team took notice. Once again, enormous self-belief allowed Villeneuve to make the step with barely a second thought into a completely different kind of race car.

The romance of the Villeneuve story continued spectacularly as he claimed pole position for his first Grand Prix and might have won in Melbourne had an oil pipe not been damaged through no fault of his own. The 1996 season, boosted by four wins, boiled

down to a championship fight with his team-mate. When Damon Hill took the title, Villeneuve said that the experience had laid the foundation for a full-on assault the following year. There was an attack of sorts when Villeneuve's rival, Michael Schumacher, drove into the Williams during the final race, the Ferrari driver coming off worse in every respect as Jacques went on to become 1997 World Champion.

The title and seven wins that year would be the singular highlight of an F1 career that soon lost its momentum as Jacques jumped ship to join British American Racing, a new team that never fulfilled its much-vaunted promise. He ended his F1 journey in 2006 after less than stellar performances with Renault and Sauber.

With racing in his blood, Villeneuve competed in rallycross, sports cars – anything he could get his hands on. His work in the F1

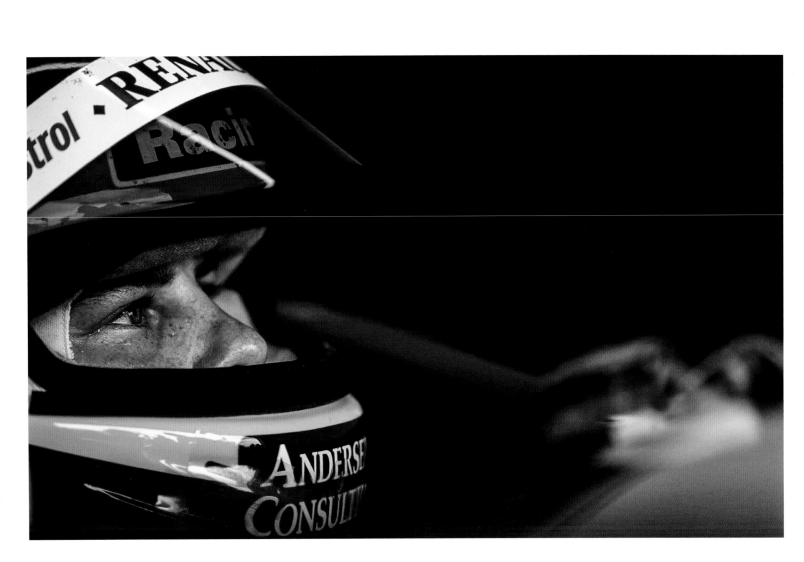

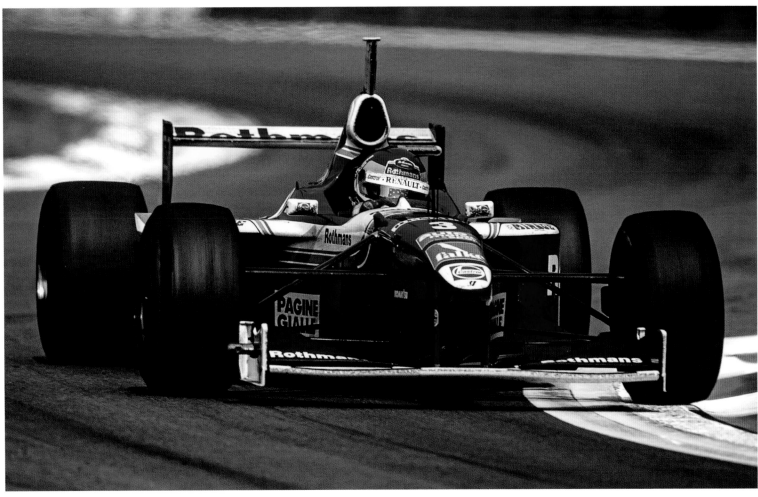

'Winning the championship was more than the culmination of a dream; it was the goal, the ultimate achievement. But it didn't have any effect on me because I thought it was only the first of many! Winning the championship had more of a social effect, but none on my driving. I kept getting better every year, even if the results didn't show it. The point is, the hunger remained.'

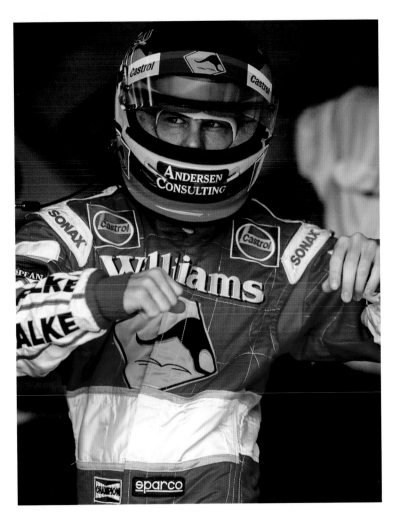

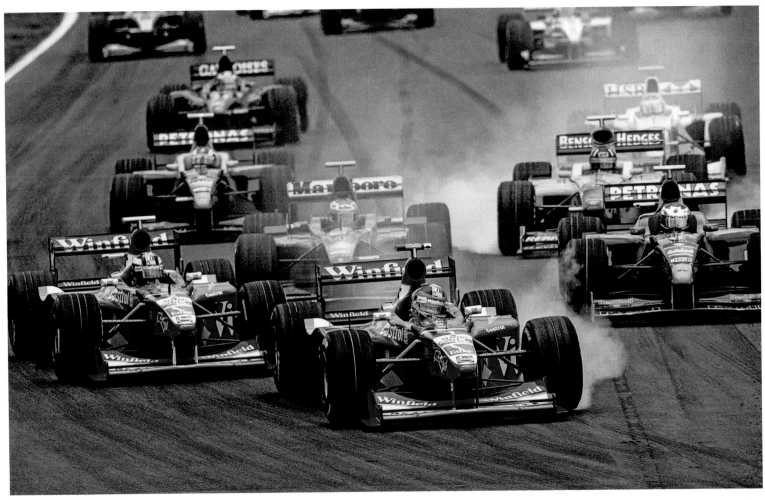

Opposite top When it came to setting up his car, Villeneuve had his own ideas – and was not afraid to express them

Opposite bottom At one of the many restarts during the 1998 Canadian Grand Prix, Villeneuve grabs a rare chance to take the lead in Montreal with his unloved Williams-Mechachrome FW20 – and immediately ran wide. He finished his home race as reigning World Champion in tenth place, six laps behind

Below top A move to a new team, British American Racing, in 2000 failed to live up to its promise. Villeneuve takes a wide line with the BAR-Honda 004 on his way to tenth in the 2002 Austrian Grand Prix

Below bottom Baggy overalls and unlaced driving boots with the tongues hanging out were an unmistakable part of the Villeneuve look

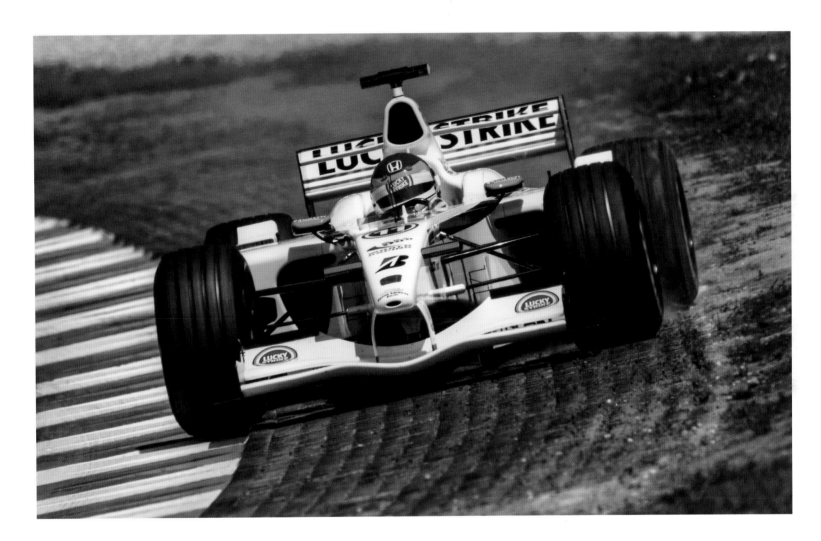

paddock as a TV pundit brought comments that were outspoken and in keeping with his previous image.

Small in stature but large in personality, Villeneuve had cut a less than conventional impression as a driver with his grunge look, oversize driving suits and racing boots worn with the tongues hanging out. That extended to the relationship with his engineers when his set-up ideas for the car veered so far from the norm to the point of being diametrically opposed to standard practice, sometimes giving the impression of being pursued just for the hell of it. But he cut a cheerful path through it all in a manner that would have made his revered father proud.

Mika Häkkinen: A quietly engaging
and ferociously competitive racer
who won two World Championships
with McLaren, the first coming in
Japan in 1998 (*right*)

Mika Häkkinen

1998, 1999

When his McLaren had a sudden rear puncture and flew off the road, the high-speed impact with the barrier was so severe that Mika Häkkinen's seat harness stretched far enough to allow his head to hit the steering wheel. Buttons on the wheel punched holes in his crash helmet. Had it not been for an emergency tracheotomy quickly and expertly performed by two surgeons who happened to be in the medical team at that particular corner, Mika would not have survived.

A cracked skull and a lengthy recuperation suggested he would be lucky to race again. Indeed, for the following month the pain was so severe he couldn't think about anything, never mind motor sport. But that incident during qualifying for the 1995 Australian Grand Prix would be life-changing for reasons beyond the obvious.

Time spent lying in a hospital bed allowed Häkkinen to recalibrate his thinking in relation to the future and his previous twenty-seven years

when motor sport had dominated virtually everything. As a karting and Formula Ford champion in Scandinavia, he had travelled south and scraped together enough money to do well in Europe and earn a test with Marlboro in late 1987. The resulting paid-for campaign set him on the road to an F3 championship and, eventually, a Grand Prix drive with Lotus in 1991.

The former championship team may have been in decline but this was F1, and Mika did enough to be chosen by McLaren, initially as a test driver and then part of the race team alongside Ayrton Senna in 1993. The Brazilian moved to Williams the following year but Häkkinen was to remain with McLaren and see them through a gradual resurgence. As a relationship began with Mercedes in 1995 for the supply of engines, Häkkinen finished second in the Japanese Grand Prix. Then came the crash thirteen days later.

As his recovery continued, Mika began to appreciate the value of life – his life – and the wider perspective beyond the frenetic world of F1. That was not to say racing had been devalued in his mind; it had merely been placed in a calmer context. Before that, however, Häkkinen needed to make the more fundamental discovery of whether or not he still had the capacity to drive a Grand Prix car, never mind get it up to the required speed.

The McLaren crew had the same thought when their driver arrived for a private test session with one side of his head shaven thanks to continuing medical checks. Immediately impressive lap times were enough to satisfy both sides that they were back in business, ready for the start of the 1996 season just four months after the accident.

Mika has a wry sense of humour and an easy-going nature but he was a man of few words as a racing driver when it came to discussing strategy beyond his immediate team. Nonetheless, frustration began to bubble to the surface in 1997 when David Coulthard won two races and Häkkinen had mechanical failures in the other McLaren. The Scotsman was leading again in Spain, the final race of the season, when team orders allowed Mika to come through and win a Grand Prix at his 99th attempt. A weight had been removed from his shoulders, just in time for a full-on fight.

The 1998 season was a superb contest between McLaren and Ferrari, Michael Schumacher winning six races, Mika taking eight and the World Championship. He made it back-to-back titles in 1999, a season that was difficult for both contenders thanks to reliability problems for Häkkinen and a broken leg for Schumacher.

The battles between these two would reach a more level and thrilling footing in 2000, none more dramatic than their encounter

Opposite top Häkkinen cut his F1 teeth with Lotus and celebrates sixth place with the Lotus-Ford 107 in the 1992 Belgian Grand Prix

Opposite bottom Häkkinen's first win came with the McLaren-Mercedes MP4/12 in Spain at the end of 1997, his seventh season in F1

Above Victory in the 1998 Luxembourg Grand Prix at the Nürburgring was one of eight with the McLaren-Mercedes MP4/13 in his first championship year

Left Häkkinen maintained a strong relationship with Mercedes-Benz following his retirement at the end of 2001

'I learned from Ayrton (Senna) that even the biggest talent is not enough. You have to work hard as well to be successful; to win the championship. Always Ayrton worked, worked incredibly hard. Nobody is born a winner. It's a lot of discipline; a lot of sacrifice.'

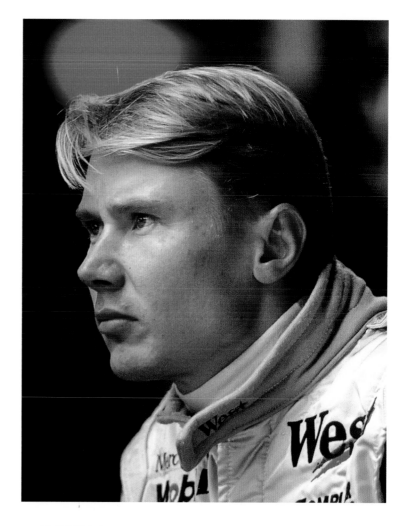

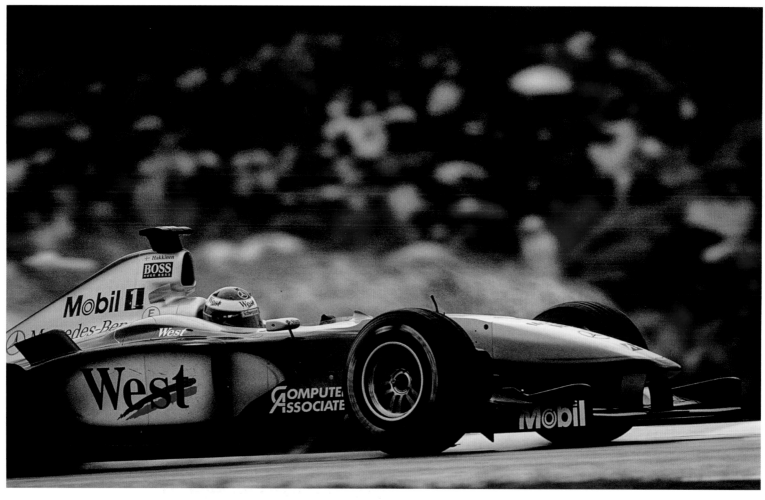

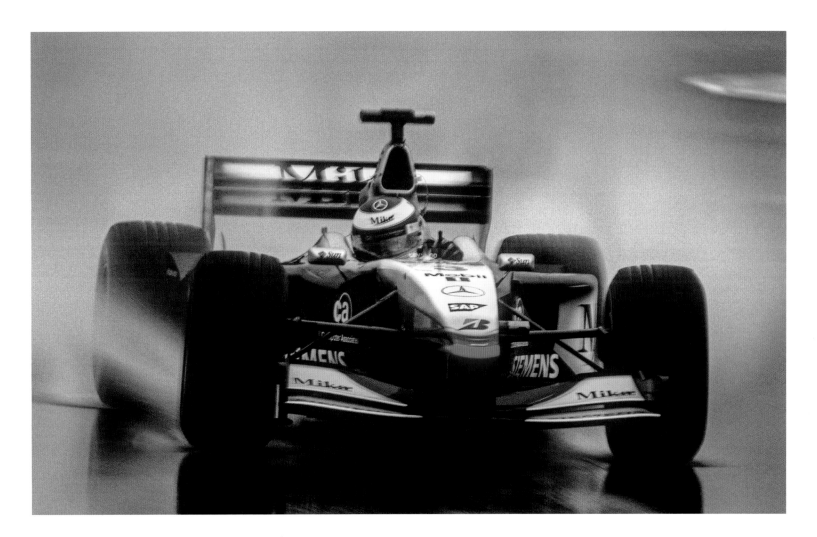

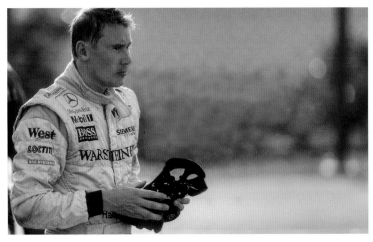

at the super-fast Spa-Francorchamps road circuit in Belgium. Schumacher was leading and repelled an attack, easing the McLaren onto grass and enraging Häkkinen as they reached 200mph on a long uphill climb.

At the same spot on the next lap, they came across a back-marker. Schumacher swooped left and Häkkinen dived right, where the track was slightly damp but gave Mika the line, and the lead, into the next corner. It remains one of the most memorably audacious moves in any championship fight through the ages.

Häkkinen finished runner-up that year and retired from F1 twelve months later. His motivation remained as sharp as ever, but his body was beginning to tire thanks to the lingering effects of an accident that so nearly robbed motor sport of one of its most quietly engaging but ferociously competitive champions.

Fernando Alonso's towering talent was such that the Spaniard should have gained more than the two World Championships won with Renault, particularly during five seasons racing for Ferrari

Fernando Alonso

2005, 2006

Protocol needed to be observed on the winner's podium following the 2005 Brazilian Grand Prix. Fernando Alonso, at twenty-four, had just become the youngest World Champion but the official interview had to wait as he took a call from the King of Spain.

Such regal communication was not only a tribute to Alonso's achievement in only his fourth season of F1, it was also evidence of an explosion of national pride within his home country. Spain had experienced neither an F1 World Champion nor even a Grand Prix driver of note before. Alonso's rapid progress through the ranks had prompted the organisers of the Spanish Grand Prix to build an additional grandstand to cope with the surge of interest. His thrusting style in the Renault had made winning a world title seem a copper-bottomed certainty to his followers rather than a brave off-chance that needed their moral support.

Alonso had felt much the same way in 2002 when he was invited onto the Renault test team after spending a season as a novice with the back-of-the-grid Minardi outfit. Fernando had viewed racing for the compact little team as an opportunity to feel his way in a pressure-free environment at the quiet end of the pit lane. It was a matter of learning the F1 ropes since, in his mind, the actual driving and racing was a formality – as it would be when your parents had placed you behind the wheel of a go-kart at the age of three.

Fernando could recall very little about how blocks had been attached to the pedals or how he had actually managed to drive the kart. All he remembered was loving the sensation of movement and speed. That would take him through the ranks and capture the interest of Renault's team boss, Flavio Briatore. The

Above Alonso learned the F1 ropes during a useful season with Minardi in 2001

Opposite top Taking the fight to Michael Schumacher and Ferrari in 2005, Alonso heads for victory in Bahrain, one of seven with the Renault R25 in his first championship year

Opposite bottom Alonso enjoyed the family atmosphere at Renault, helped by winning a second successive title in 2006

year spent testing was not wasted, Alonso being fully prepared for his elevation to the race team in 2003 – as demonstrated by pole position for his second race with Renault and a maiden win in Hungary five months later.

It was only a matter of time before the partnership would string enough victories to match and then defeat the seemingly unstoppable force of Michael Schumacher and Ferrari. Having experienced it once, Renault and Alonso savoured the taste of championship champagne for a second time in 2006.

Renault had been growing as they took complete control of the former Benetton team. Alonso loved being part of that process and thrived on the warmth of a small, hungry family that placed him at the head of the top table. It would be significant in the light of how his working environment was about to change completely.

A move to McLaren-Mercedes for 2007 made sense – on paper. The team's winning credentials were as impressive as their gleaming headquarters in Surrey. Alonso would be joined by Lewis Hamilton; a favoured member of the McLaren Young Driver Programme maybe, but an F1 novice nonetheless.

Alonso was startled from the outset when the Englishman firmly laid down a marker and showed no deference to the de facto team leader's status as a double World Champion. The relationship soured when, in Alonso's view, McLaren's management made no attempt as the season went on to correct this perceived lack of respect.

More than one championship opportunity would be lost, along with Fernando's potential, when he returned to Renault for two more years. Nothing – not even a team in sudden decline – could

'I love racing; I love to be behind the wheel every weekend. I know I could maybe have more trophies at home, or maybe I could have had better car choices, but at the time I made the decisions I thought they were the right ones, so I always follow my instinct, follow what makes me happy. When you do that you cannot regret.'

disguise the Spaniard's towering talent and it was no surprise when he was signed by Ferrari for 2010.

This was a combination the F1 world had been waiting to see. Alonso played his part but, in typical Ferrari fashion, Latin temperament and in-house power struggles managed to derail such massive promise, most notably in their first season when a badly fumbled strategy in the final race snatched defeat from certain victory despite the Ferrari not being the fastest car.

In 2014, Hamilton started to rattle off championships while Alonso's frustration had begun to ferment with his advancing years. The driver once adored by Renault and the media became touchy and thwarted. Ferrari, encircled by the rapacious Italian media, is not a forum for any driver's grievance, no matter how justified when describing the management's inadequacies. The

parting of ways was only a matter of time but, as had become an increasingly sad hallmark of Fernando's career, he chose to make another wrong move and rejoin McLaren in 2015.

This may have been a decent advert for the virtue of rapprochement but it came at the start of the worst slump in McLaren's long history. Alonso would never get close to a single win, never mind a third championship that had seemed a formality a decade before.

Despite his relentless attack and commitment on track, Alonso's departure from F1 at the end of 2018 without further royal calls from Madrid was the regrettable sign of a lost opportunity for such an outstanding talent.

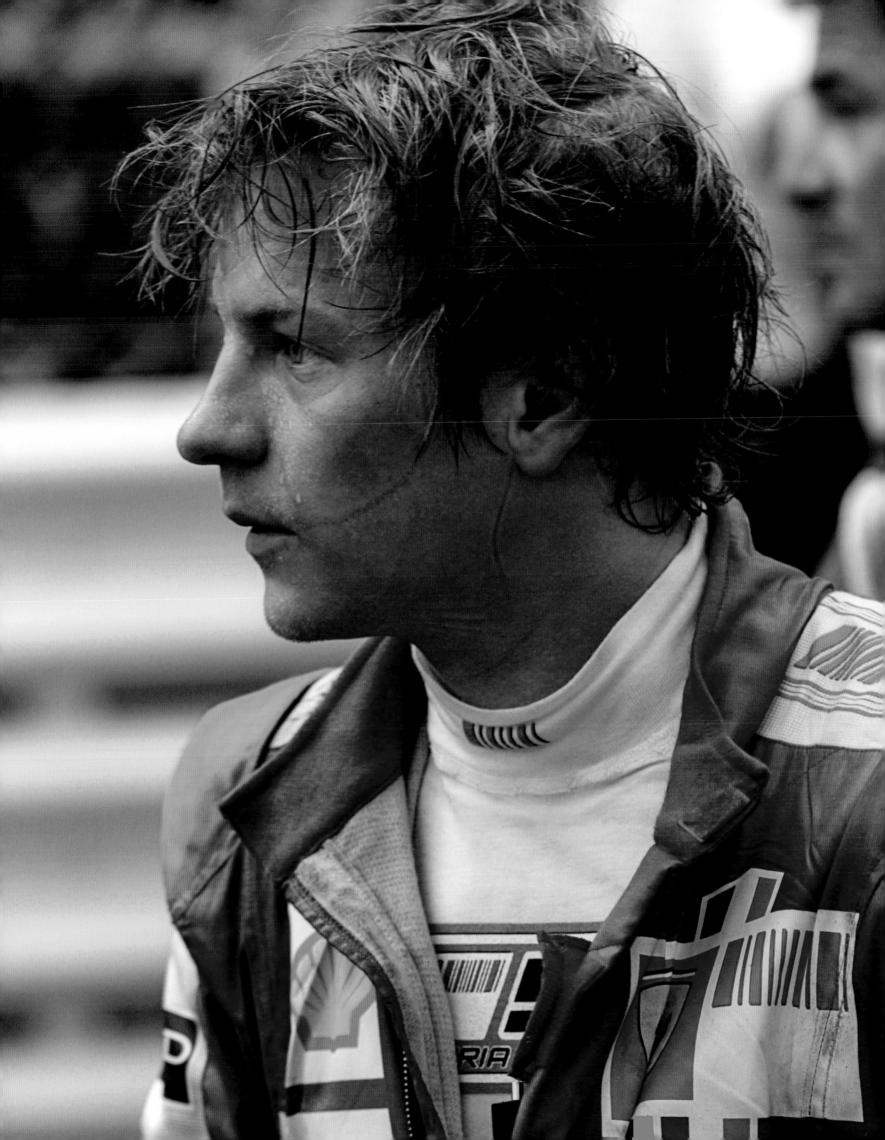

Kimi Räikkönen rarely got into a sweat over anything outside his fast and often spectacular driving, the Finn calmly using his Ferrari F2007 to snatch the World Championship at the final race of 2007

Kimi Räikkönen

2007

Not long after finishing sixth and scoring a point in his very first Grand Prix, a group of journalists asked Kimi Räikkönen twenty-one pertinent questions about such an impressive performance. Not one of his answers was longer than twenty-five words; most, a mere measured handful. It was not that the novice was being rude or was incapable of forming a response; this was simply Räikkönen's minimalist way of dealing with whatever life had to throw at him.

When asked if he had ever been to a Grand Prix before, Räikkönen startlingly admitted the first Formula 1 race he had ever seen was the one he had just been in. In some ways that should not have been surprising, since the 2001 Australian Grand Prix represented only his 24th motor race – ever. Such a remarkable statistic underscored a natural talent that had just been confirmed throughout an error-free weekend in his Sauber-Ferrari.

Peter Sauber had been persuaded to give Räikkönen a trial that did two things; it made a positive impression on the previously sceptical F1 team owner and prompted an official enquiry into the unknown 21-year-old's suitability for the required Super Licence, given Räikkönen's almost complete lack of experience. Kimi had answered all of that better than any subsequent responses to post-race questions trying to establish more about the identity of this monosyllabic Finn.

Nothing seemed to faze him. Räikkönen accepted the offer of a seat with McLaren-Mercedes for 2002 despite the pressure associated with a team that had finished either first or second in the previous four World Championships. Räikkönen would stay with McLaren for five years, during which time he developed into a relentlessly fast driver, always on the spectacular limit in the car

Above Räikkönen made an immediate impact in 2001 by finishing sixth in his first Grand Prix with the Sauber-Petronas C20 in Australia

Opposite top left and right A fine win from pole with the McLaren-Mercedes MP4/20 at Monaco put Räikkönen in the running for the 2005 championship

Opposite centre left There was just one victory in 2004 but it was a brilliant drive as Räikkönen beat Michael Schumacher at Spa-Francorchamps

Opposite bottom Engine failure at Monaco summed up a disappointing final season with the McLaren and MP4/21 in 2006

and the complete reverse when out of it. A growing fan base, not to mention his mechanics, loved such quiet indifference, Kimi earning the nickname 'Iceman', which he happily displayed on his crash helmet.

But for unreliability with a potentially fast car, Räikkönen would have won two championships. Brilliant performances with McLaren would define the peak of his career, even though winning the title with a move to Ferrari in 2007 might suggest otherwise. The irony was that Ferrari succeeded largely because in-fighting allowed McLaren to give away a championship that should have been theirs, Kimi winning more races than anyone else by remaining detached from the paddock politics.

Räikkönen would never feel as comfortable with the Ferrari/Bridgestone combination as he had with the more useable grip

from McLaren and Michelin. A decline in performance and interest eventually led to two seasons in rallying and NASCAR racing but the lure of F1 and an offer from Lotus brought a return in 2012. Experience and race-craft earned a victory in each of the two seasons he remained with Lotus before Ferrari surprised many by re-employing a driver who was deemed to be past his best in terms of service to a championship contender.

In fact, it suited Räikkönen as much as it worked for a team that kept his public-relations duties to a minimum and allowed him freedom to play at his country's traditional pastime of alcohol, often harder than he appeared to work as a racing driver. Ferrari knew he would support their number one, Sebastian Vettel, without quibble and provide an apolitical stopgap while the team waited for a younger driver to become available. That moment

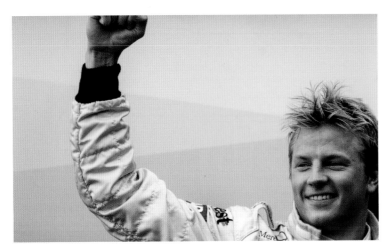

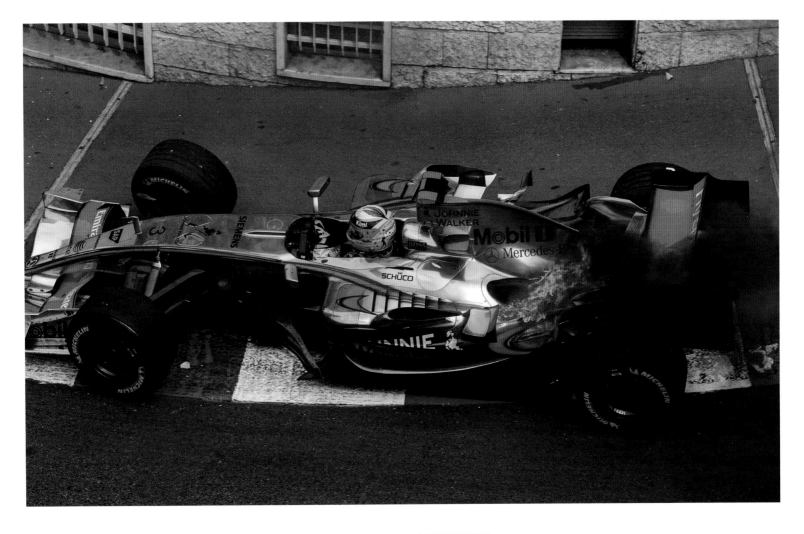

'I'm perfectly capable of staying indoors at home for a week without going anywhere. I enjoy just existing. I don't think of Formula 1 for twenty-four hours a day.'

came with the arrival of Charles Leclerc for 2019, but not before
Räikkonen had used all of his experience, inherent speed and
guile to earn his 21st Grand Prix win in October 2018.

Throughout it all Kimi remained a figure of bemused calm in
the midst of the emotional cauldron of F1. And he wasn't done
yet, Räikkönen returning to Sauber for 2019. This was where it had
started eighteen years previously. And, appropriately, the answers
to questions would remain as economic and concise as they
always had been.

Lewis Hamilton moved among the truly great champions in 2018 when he claimed a fifth world title, four of them having been won with Mercedes-Benz

Lewis Hamilton

2008, 2014, 2015, 2017, 2018, 2019, 2020

As a youngster competing in karting, Lewis Hamilton was heavily influenced by Ayrton Senna. By the time Senna had won forty-one Grands Prix and three world titles in 1993, Hamilton was eight years old and beginning a motor-racing career that would actually surpass his hero.

As British Karting Champion that year, Hamilton got to meet Senna. Whereas other Formula 1 drivers had tended to ignore the youngster, Senna extended a firm hand, looked Lewis in the eye and spoke as one racer to another. It epitomised all that Hamilton had expected and, poignantly, exacerbated his deep sense of sorrow a few months later when Senna was killed during the 1994 San Marino Grand Prix.

But the inspiration had been deeply ingrained, Lewis drawn by what he described as the Brazilian's dramatically different style of very fast driving, coupled with a warrior-like refusal to be beaten. Senna's performances had an unmistakable edge. Hamilton would bring the same sense of excitement and anticipation to F1 from the moment of his first Grand Prix at the age of twenty-two.

His debut with McLaren was almost preordained, Lewis having boldly introduced himself to Ron Dennis in 1994 and informed the McLaren boss that he intended to drive for him one day. Quietly impressed by such polite audacity and confidence, Dennis watched with increasing interest as Hamilton won championships in Formula Renault, Formula 3 and GP2; impressive progress that effectively guaranteed a place alongside Fernando Alonso for the 2007 F1 season.

Having built up a warm relationship with the McLaren team during the preceding years, Hamilton already felt part of the

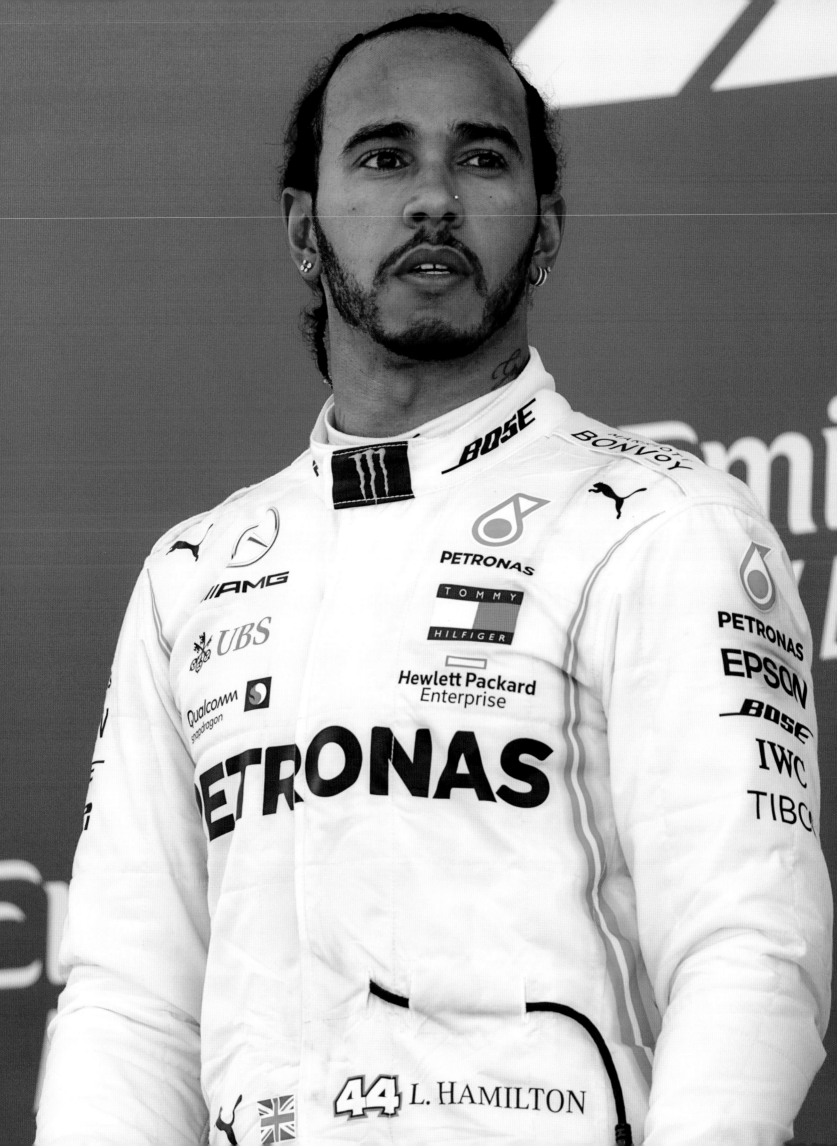

family. Technically he may have been a rookie, but he didn't drive like one from the moment the lights went out at the start of his debut in Melbourne. By running round the outside of Alonso at the first corner, Hamilton immediately laid down a marker, not just for a team-mate with two World Championships, but for F1 as a whole. This was not a novice's bravado. It was, as Lewis said simply, 'Just the way I drive.'

That quiet self-assurance would extend to winning his first Grand Prix five races later in Canada, followed by another in the United States at the end of the following week. Having smashed through a glass ceiling that usually remains impenetrable for a season or more, Hamilton was on a roll.

In the process, Lewis was crushing Fernando's sense of entitlement. The resulting internal conflict – coupled with a shocking crisis as the McLaren technical department was accused of spying on Ferrari – would have a deleterious effect, Hamilton and Alonso tying for second and losing by a single point in a championship that one of them ought to have won.

Alonso's departure left the way clear for Hamilton to enjoy a second season that was less threatening from within his own team. The challenge, in fact, would come from outside in the shape of Felipe Massa, the pair having won five races each as they arrived for the finale on the Brazilian's home patch.

In a race of unbearable tension as a shower doused the greasy Interlagos circuit during the closing laps, Massa's Ferrari crossed the line first to apparently win the championship thanks to Hamilton being sixth. But at the very last corner of the season, Hamilton's McLaren-Mercedes demoted a struggling Toyota and seized the

Opposite top The relationship with Fernando Alonso during their season together at McLaren became difficult when Hamilton won four races (including the United States Grand Prix, *opposite bottom*) to challenge for the 2007 title

Overleaf Pole, fastest lap and victory with the Mercedes F1 W05 in Malaysia would kick off Hamilton's championship year in 2014

Left and below Seven pole positions and five wins with the McLaren-Mercedes MP4/23 in 2008 would put Hamilton in the running for a first World Championship that would only be settled during the last lap of the season

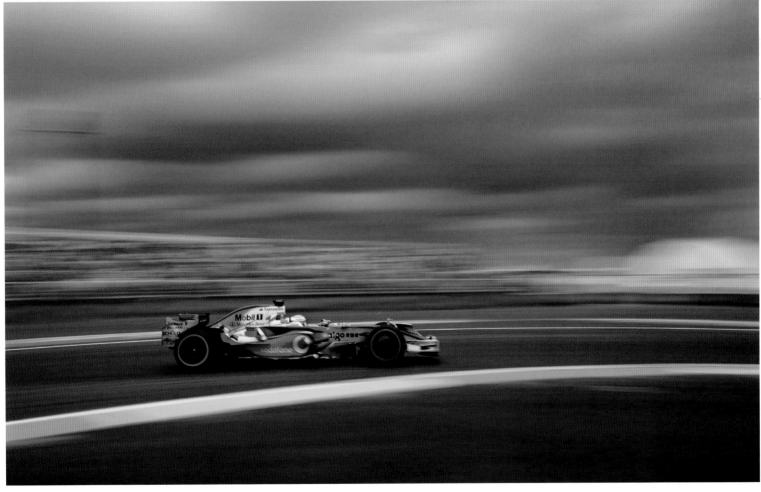

'Every championship has been different. They've required different agility, different approaches; presented different challenges. Each time I wanted to see how far I could raise the bar because you have to expect your opponents to do the same. But each time, winning the championship brings an unbelievable feeling. I never in a million years dreamed I would win five.'

extra points needed to become the youngest World Champion.

The chance of a second in succession was never on the cards. Jenson Button and Brawn quickly gained the upper hand in 2009 but a couple of wins the following year saw Lewis lead the championship halfway through 2010 before the Red Bull team began a dominance that would last for four seasons.

An important part of any champion's progress is being in the right place at the right time. Hamilton seemed to be ignoring that when, after a further three comparatively unproductive seasons (he never finished higher than fourth in the championship), Lewis decided it was time to break away from McLaren and join his childhood karting team-mate, Nico Rosberg, at Mercedes for 2013. With just one win and another fourth place in the championship, the wisdom of the move would be questioned. But the timing, in fact, would turn out to be perfect.

Mercedes were better prepared than anyone for a major change in engine formula, Hamilton winning four of the first six races in 2014, Rosberg taking the other two. By the season's end, Hamilton had become champion for the second time with eleven victories, one more than he would achieve in 2015 as he wrapped up a third world title to equal the score of his idol, Senna.

Stung by defeat for the second year running, Rosberg bounced back in 2016, the two Mercedes drivers taking an intense fight to the wire in Abu Dhabi, where Rosberg became champion – and promptly retired.

Showing no sign of doing the same, Hamilton came back stronger than ever in 2017 to see off a challenge from Sebastian Vettel and Ferrari to claim his fourth championship. When Ferrari initially raised their game even higher in 2018, Hamilton responded

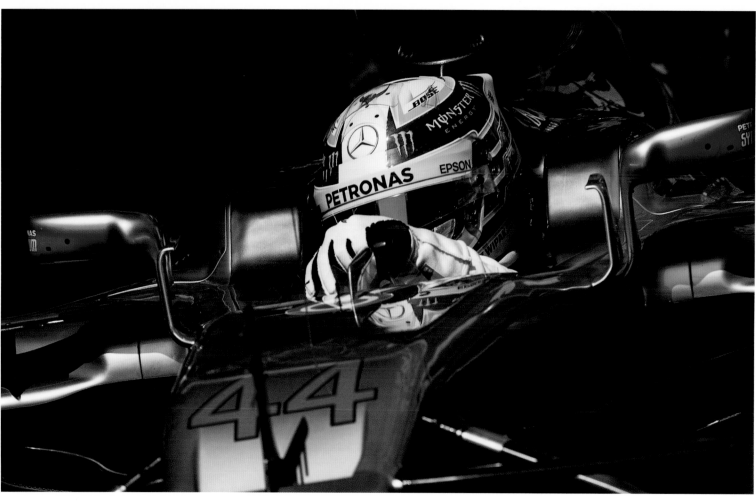

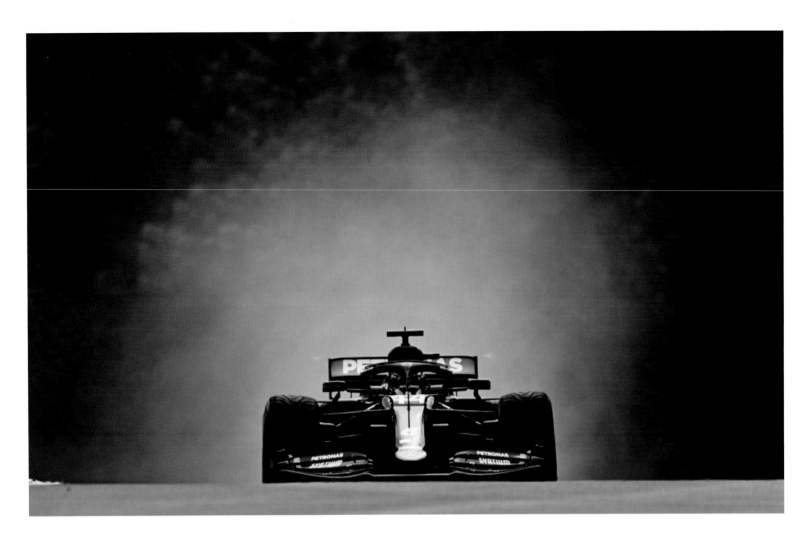

Opposite top Hamilton and the Mercedes race team celebrate their first World Championship together in Abu Dhabi at the end of the 2014 season

The winning for car #44 continued into 2017 (Monaco, *opposite bottom*), through 2018, 2019 and on to 2020 (Hungary, *above*; Austria, *right*)

with a sublime season to become only the third driver in the history of the World Championship to have won the title five times.

That became six in 2019, with Hamilton winning six of the first eight races. He shared the lead of the championship briefly with his team-mate, Valtteri Bottas, before powering once more into a world of his own. Ferrari fumbling another potential challenge may have aided Lewis, but his race performances possessed a sense of calm and authority, plus a now familiar innate affinity with speed that somehow remained undiminished by the relentless slog of 13 seasons in Formula 1.

Hamilton's self-assurance reached new levels in 2020 when using his elevated sporting platform to bring the attention of motor racing – and the world at large – to the vexed question of diversity and equal rights. Despite the global reaction (not always positive),

the reigning champion remained totally concentrated on what he did best, exceeding Michael Schumacher's record of 91 wins and matching the German's seemingly unbeatable tally of seven world titles.

He might have become a world superstar, but Hamilton never forgets his humble origins on a council estate to the north of London. He never gives anything less than total focus and friendship when working with the Mercedes team to help maximise one of the greatest natural talents in the history of the World Championship. And all of this is invariably supported by a firm handshake while looking you in the eye.

A slow burner initially, the story of
Jenson Button's rise in F1 culminates
in 2009 with one of the most
unexpected and popular backdrops
to any World Championship

Jenson Button

2009

When Jenson Button finished the last race of the 2008 season in Brazil, his car caught fire in the pit lane. It was probably the most reasonable thing the Honda could do, since that car had been a dog to drive all year.

Button was not far short of his 29th birthday and had claimed just one win in more than 170 Grands Prix. As if to accentuate the corrosive effect of the calendar, Lewis Hamilton, five years Button's junior, was celebrating his first World Championship after just two seasons. It seemed Button's career had just gone up in smoke with his unloved car.

Fast-forward to exactly the same place almost twelve months later. Button bounds from one of the nicest cars he will ever drive to receive the rapturous welcome awaiting the 2009 World Champion. The transformation in a single season would

make one of the most engaging and popular backdrops to any championship story. And a major bonus for Jenson would be having his tearful father waiting to embrace him.

John Button, a former rallycross champion, had coached his son through karting from an early age and shepherded him into Formula 3 where, in truth, he scarcely set the world alight. But there was something about Jenson's smooth, economic technique that suggested to McLaren, Prost and Williams that the lanky, shy teenager would be worth a test drive.

All three teams were impressed, with Williams offering a contract for 2000. Given his memorable name and such a rapid rise, Button was immediately hailed a potential star by the British media. He quietly dealt with the pressure but, despite scoring a point in his second Grand Prix and showing impressive speed

at difficult tracks such as Spa and Suzuka, the drive was only ever likely to last for one year as Williams waited for Juan Pablo Montoya to become available.

The honeymoon was definitely over as Button moved to a less hospitable environment at Renault and a car that did not suit his effortless style. Nonetheless, Jenson used the next two seasons to adapt his driving and build a relationship with his engineers and mechanics. He took that experience with him to BAR-Honda and gradually increased competitiveness to the point where he finished third in the 2004 championship.

It was Button's bad luck that this coincided with Michael Schumacher in his pomp, although good fortune would come his way in Hungary two years later when, at his 113th attempt, Jenson used his delicate skill to win a Grand Prix in wet conditions.

The team was now owned wholly by Honda, the Japanese company going on to prove that they were better at building engines than cars, particularly the one that set itself on fire as the 2008 season ran its course. By then pulling the plug, the Japanese firm appeared to be taking Button down with them.

Having taken charge of this ailing outfit, Ross Brawn used compensation from Honda to regroup while negotiating a deal for the supply of Mercedes engines. The team would be named Brawn and become a byword for clever interpretation of the technical regulations covering the car's rear diffuser. Whereas first acquaintance with the 2008 Honda had told Button everything he didn't want to know, his excitement knew no bounds after just a couple of laps testing the Brawn-Mercedes.

Such optimism was more than vindicated when he won six of

'Winning races is very much a living-in-the-moment experience – it's awesome. But winning the championship was more of a relief, because of the pressure I had put on myself. That pressure is agonising, but the euphoria when you finally cross the line is just incredible. You can finally breathe again. I totally love it.'

Opposite His sixth win of the season in Turkey (top) would be Button's last in 2009, the British Grand Prix (bottom) bringing pressure and disappointment with sixth place

Seven seasons with McLaren-Mercedes brought some outstanding results including wins in Japan in 2011 (*left*) with the MP4/26 and Belgium in 2012 (*below*) with the MP4/27

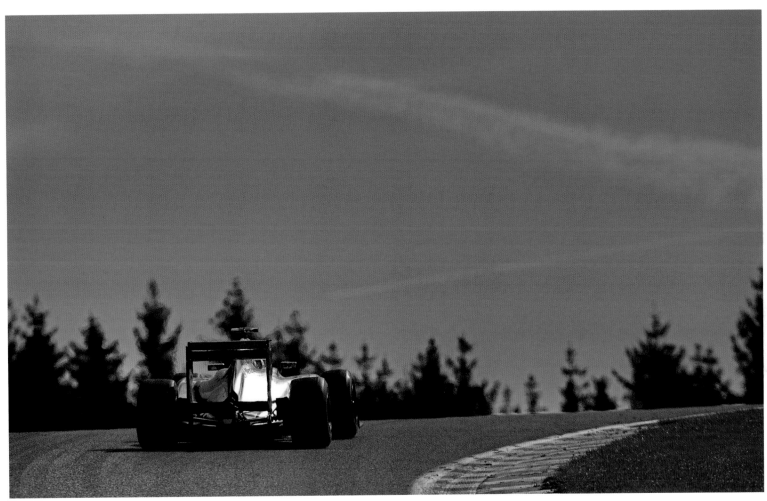

the first seven races, the accumulation of points providing a handy cushion when his progress stalled as the competition began to catch up in the second half of the season. But Jenson held his nerve, particularly when putting in a storming drive at the title-defining race in Brazil.

If the championship was unexpected, then a sudden switch to McLaren came as a complete surprise, particularly as Button would be inviting direct comparison with Hamilton in the other car. It was a sign of his composure and self-belief, not to mention commitment and bravery; Button relished an in-house fight underpinned by mutual respect. There would be races when the McLaren-Mercedes would be better suited to Lewis, and days when Jenson was untouchable.

Button would win another eight Grands Prix and none would be more dramatic than Canada in 2011. He went through every emotion and experience in the book: a collision with Hamilton; a drive-through penalty for speeding behind the safety car; another collision in the wet conditions; a fall to 21st and last after a pit stop to deal with a puncture; then a remarkable comeback in slippery conditions that saw Button snatch the lead on the last lap.

Apart from a one-off appearance in 2017, Button effectively retired from F1 at the end of 2016. He had competed in more than 300 Grands Prix, leaving behind a legacy of easy-going charm and an inner steel that had carried him through moments of despair, none more so than walking away from that smoking Honda in November 2008.

Sebastian Vettel

2010, 2011, 2012, 2013

The little Toro Rosso team could scarcely believe it when Sebastian Vettel fell into their lap halfway through 2007. Established the year before as a support network for Red Bull, the Italian squad had been struggling with drivers showing neither speed nor aptitude. Toro Rosso knew about Vettel as a member of the Red Bull Junior Team but the young German's future seemed to be increasingly and nationally aligned with BMW.

Vettel had won eighteen of the twenty races in the 2004 German Formula BMW Championship and then the BMW Sauber team had given the nineteen-year-old his F1 debut in the 2007 United States Grand Prix following Robert Kubica's crash in the previous race. Vettel finished eighth at Indianapolis to become the youngest-ever points scorer. Then BMW let him go – and Toro Rosso seized their opportunity.

It was a revelation. Unlike his predecessors, Vettel asked incessant questions, absorbing information and using his intelligence to act on it in a mature and cheerful manner beyond his years. Through the second half of 2007 and going into the following year, Toro Rosso were gradually raising their own game, the combination scoring points regularly as the 2008 season moved towards the team's home race in September.

Against all odds, Vettel not only claimed pole for the Italian Grand Prix but also scored an astonishing victory in atrocious conditions. He did not make a mistake of any consequence on the slippery track despite the massive pressure induced by leading all the way.

Vettel attributed his control, both physical and mental, to being unable to afford wet tyres as a youngster and having to race

his kart on slicks. The big-time pay-off for such fingertip finesse in only his 22nd Grand Prix brought more records as youngest F1 pole sitter and race winner. It was only a matter of time before his elevation to the senior team.

Results aside, Red Bull knew all about Sebastian Vettel thanks to the eighteen-year-old having had the nous to drive all the way to England from his home in Heppenheim, knock on the door of the team's headquarters and ask to have a look around. Just four years later, this would become his racing home as he teamed up with Mark Webber to form a sometimes sparky relationship with the no-nonsense Australian.

The partnership developed a critical edge as the Red Bull car began to come good. Vettel had won four races to Webber's two in 2009 but a more equal spread of results, allied to both being

in the 2010 championship reckoning, contributed to a collision as they fought for the lead in Turkey. Vettel was not reprimanded for his impetuosity and the in-house battle continued to the final round in Abu Dhabi. Despite Webber and Ferrari's Fernando Alonso being ahead on points, Vettel came through to win the race and become, at the age of 23 years and 133 days, F1's youngest World Champion.

This cemented a warm relationship that had been quickly established with his mechanics as Vettel's impish sense of humour demonstrated an uncanny ability to mimic complete passages from popular British television comedy programmes. The grins grew wider as Vettel and Red Bull were unstoppable and Sebastian added another three championships, usually through exquisite control of a car in which he had complete faith.

Opposite top Vettel made a stunning impression when he led all the way in difficult conditions to win his first Grand Prix with Toro Rosso at Monza in 2008

Opposite bottom Going into the final round of the 2010 season in Abu Dhabi as an outsider with the Red Bull-Renault RB6, Vettel came away with his first world title

Above A win at the penultimate round in Brazil with the RB6 set him up for the championship decider in 2010

Left The trademark single digit, raised thirty-eight times with Red Bull, became a familiar sight between 2009 and 2013

Overleaf Brazilian confetti for win number four in 2010

'Winning four titles? It's such a big number. To join people like Michael (Schumacher), (Juan Manuel) Fangio, (Alain) Prost is very difficult to put into perspective. I'm way too young to understand what it means. I might be sixty one day; maybe then I will understand. It's difficult to realise something that nobody can take away from you.'

Then circumstances changed in 2014. It's true that Vettel suffered the lion's share of unreliability that helped Daniel Ricciardo – promoted from Toro Rosso – to burst the World Champion's bubble with three wins to a stark zero for Sebastian as he struggled with the regulated loss of a double diffuser from which he had previously extracted maximum performance. The relationship between the two drivers had been good but the time seemed right for Vettel to accept an offer from Ferrari. Besides, it would be a golden opportunity to emulate his childhood hero, Michael Schumacher.

It started well as Vettel won his second race in a red car and finished on the podium five times in the first six races. There would be another two wins in 2015, but nothing like enough to counter the crushing domination of Mercedes.

Ferrari had been one step behind from the start of a sweeping change to the power-unit regulations in 2014. Rather than improve, the technical shortfall brought the knock-on effect of instability within the management structure. Vettel failed to win during 2016, but improvements to the car during the next two seasons brought wins that, crucially, still fell short of filling the painful void of no championship for Ferrari since 2007.

This became a self-perpetuating spiral of frustration producing poor strategy calls that, in turn, fostered a lack of confidence. Red Bull had been sufficiently well run to allow Vettel to focus on what he did best, whereas at Ferrari he became unnecessarily concerned about the way the team was operating. Meanwhile, for anyone familiar with Ferrari's volatile history, the pressure from the boardroom and Italian media became recognisably invasive and damaging.

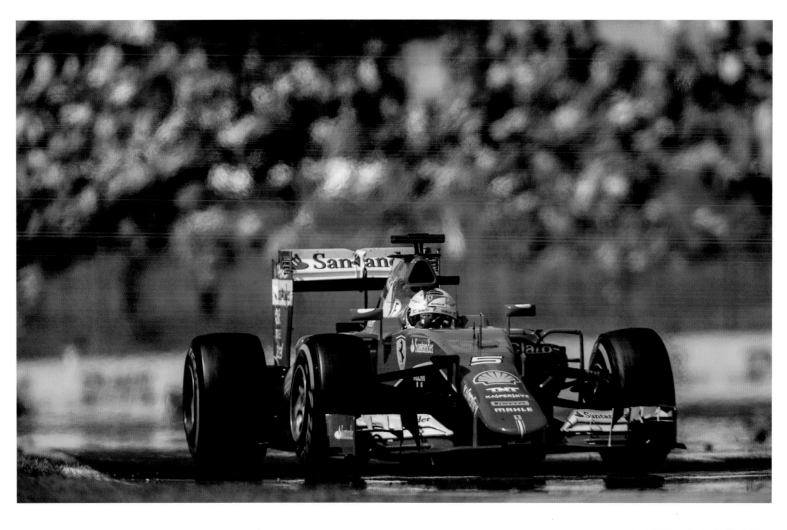

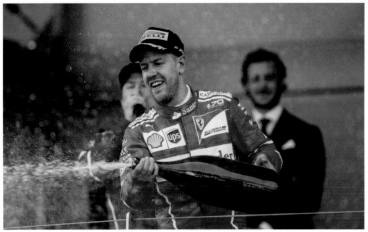

Wins with Ferrari (Hungary 2015,
opposite top; Monaco 2017,
opposite bottom left) were generally
in disappointingly short supply

Unfortunately for Vettel, his personal performances, particularly in 2018, would become public evidence of such internal turmoil. He made several mistakes that had an effect on his championship. The German Grand Prix was a disastrous example of how a simple error – briefly locking his brakes while leading on a greasy track – would lead to retirement against the crash barrier and a 32-point swing in the championship as his rival, Lewis Hamilton, went on to win at a vital moment in the season.

Ferrari running into a development cul-de-sac that took three races to reverse out of did not help Vettel. And neither was his demeanour improved by a difficult relationship with a surly team principal who would be sacked at the end of the year.

Sebastian had plenty to think about as he retreated into the off-season before the start of his fifth year with Ferrari. As if he did not have enough problems, Vettel had to contend with the arrival of Charles Leclerc, promoted from Alfa Romeo Sauber. The Monegasque, ten years Seb's junior, was as confident and precocious as Vettel had been when he moved up to Red Bull in 2009. Not only was Leclerc proving faster, he was also not afraid to assert himself, Vettel's response bringing an edge to the atmosphere within Ferrari.

Sebastian needed to make full use of his preference for shunning the intrusions of social media and embracing privacy. He prefers to quietly enjoy life with his young family and listen to music rather than exploit the public profile of a likeable World Champion. A four-time World Champion.

Nico Rosberg's wish to follow in his father's footsteps as World Champion was made even more difficult by having Lewis Hamilton as team-mate at Mercedes. After being defeated in 2015, Rosberg combined thoroughness, willpower and skill to win the title at the end of an intense mental battle during the final race of 2016. Mission accomplished, he promptly retired

Nico Rosberg

2016

Nico Rosberg was offered a place at Imperial College in London to study aerodynamics, but turned it down. Getting that far indicated a worldly awareness stretching beyond a typical teenage obsession with becoming (like his father) a racing driver. Paradoxically, the decision was informed by Nico having recently received practical experience of aerodynamics when testing a Williams Formula 1 car.

The physical and mental pull of the latter was enough to persuade the seventeen-year-old that an extensive schooling in karts, Formula BMW and Formula 3 would provide a solid foundation for his future rather than opting for the comparatively more mundane world of engineering.

Rosberg's victory in the 2005 GP2 Championship (the final stepping stone to F1) prompted Williams to seriously consider

Nico for a race seat. Part of the assessment process included an engineering aptitude test to determine a potential driver's ability to absorb information and understand his car and its tyres. Rosberg attained an exceptionally high score.

A more public enquiry would be answered by his progress at the wheel. The first response was impressive as Rosberg set the fastest lap and scored points on his debut (2006 Bahrain Grand Prix) despite the Williams being powered by a Ford-Cosworth engine which was considered feeble compared with the more advanced power units elsewhere. At the next race in Malaysia he qualified third, ahead of Michael Schumacher's Ferrari. Despite the accompanying attention, Rosberg avoided being swept along by an overexcited media agenda immediately linking him to his father.

Below Rosberg made an impressive F1 debut in 2006 by scoring points and setting fastest lap in Bahrain with the Williams-Cosworth FW28. Such early promise would prove difficult to fulfil

Opposite top Rosberg moved to Mercedes in 2010 but the arrival of Lewis Hamilton four years later ensured it was difficult for Rosberg to make the most of the competitive Mercedes F1 W05. Rosberg (with Hamilton to his right) starts the Canadian Grand Prix from pole but ended the season with five wins to Hamilton's eleven

Opposite bottom Third place in Australia would be one of the few highlights with Williams in 2008

Nico had been born in West Germany a few days after Keke Rosberg had won the 1985 Detroit Grand Prix. The fact that the 1982 World Champion had also been driving a Williams added to a misplaced sense of expectation that went into reverse when Nico struggled to do better than ninth in the championship during his first three seasons with the largely uncompetitive Williams.

The fourth year, 2009, was good enough to catch the attention of Ross Brawn as the championship winner that year managed the takeover of his eponymous team by Mercedes. It took a season for the operation to begin to gel. Brawn's good faith would be justified in China 2012 when Rosberg took pole position and won thanks to managing his delicate tyres to perfection.

The dynamic within the team began to change the following year when Lewis Hamilton arrived from McLaren. These two knew

each other very well, having competed and shared time together in karting. There was mutual respect but the friendship was about to be tested as Mercedes continued to edge forward as a serious championship contender.

Rosberg opened the in-house score with a peerless victory at Monaco, the place where he now lived and where his father had produced an equally faultless win thirty years before. But there would be no time for sentiment as Hamilton gradually gained the leading edge, finishing ahead in the championship in 2013 and winning it the next year as Mercedes began a crushing run of superiority.

With no one else in the fight, Rosberg's reputation came under an intense spotlight in 2015, particularly when Hamilton won ten Grands Prix to Nico's six. But three of them had come in succession

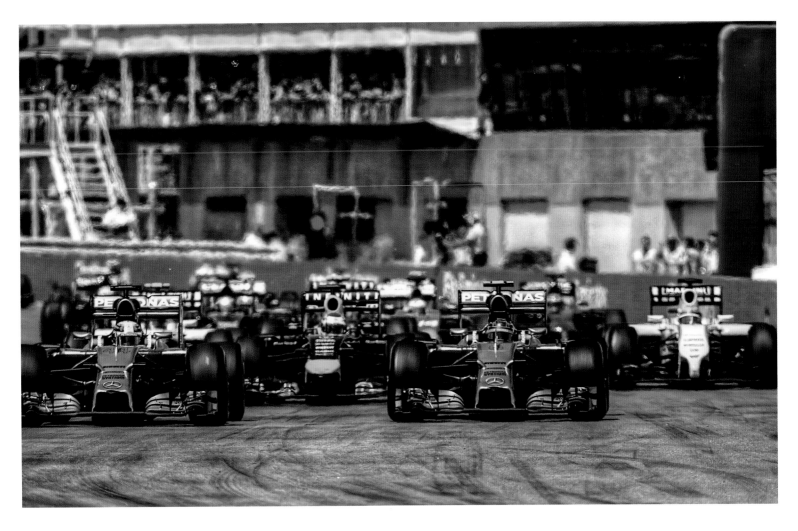

'I didn't drive just to receive credit for winning or whatever. I drove to win the World Championship – and I achieved that. It was my childhood dream and that's what I was so excited about. Afterwards I wanted to celebrate with the people who supported me. My dad and my mum had played such a big part; my mum on the private side and my dad for the career steps. Their support all the way was massive.'

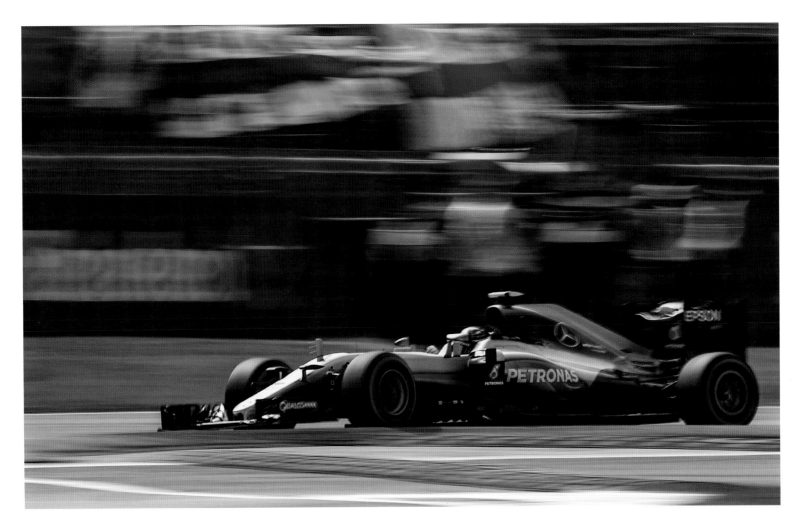

Opposite top Rosberg started the 2014 Abu Dhabi Grand Prix from pole but a problem with the Mercedes F1 W05 dropped him out of contention

Opposite bottom A win from pole in Spain 2015

Above His seventh win of 2016 in Italy kept Rosberg in contention during his championship year

Right Just like his father 30 years before, Rosberg added the 2013 Monaco Grand Prix to his growing tally of victories

at the very end of the season; a sign that, rather than be mentally destroyed by Hamilton's consistent and frustrating ability to find that extra fraction of a second, Rosberg was giving full focus to beating the driver considered to be the best of his generation.

Nico knew better than anyone how difficult this would be. Occasionally criticised for being too cerebral in his approach and preferring not to engage in small talk in any of the five languages he spoke with fluency and intelligence, Rosberg was thought to be too calm and polite in the face of defeat.

For 2016, he made that work in his favour. Applying himself like never before, Nico won the first four races and made every championship point count. Going into the final round in Abu Dhabi, Hamilton and Rosberg had nine wins apiece with Nico holding a narrow points advantage. Second place would be good

enough but Hamilton, in the lead, was backing Rosberg into the attacking Ferrari of Sebastian Vettel. With this season of tireless endeavour under threat during the final miles, Rosberg held on after an hour and forty minutes of unbearable tension.

Rarely has there been a more exhausted champion facing the world, the strain of twenty-one races clearly etched across his handsome features. A few days later, Rosberg surprised everyone by quietly announcing his retirement as he made the trophy he craved most his last.

Opposite Max Verstappen's 2021
championship campaign gathered
serious momentum in Austria with a
win for the third race in succession

Right Verstappen had a look of
serious intent from the moment he
arrived in Formula 1

Max Verstappen

2021

Of the thirty-four Formula 1 drivers in this book, Max Verstappen is the only one who, it could be claimed, was born to become World Champion. His mother, Sophie Kumpen, competed in karting. His father, Jos, made it to Formula 1 and established a reputation as a tough, uncompromising racer. It almost went without saying that their only son would become an integral part of the motor racing circus in which he was growing up. It was no surprise when Max began karting at the age of four.

Although born and raised in Belgium, Max felt a strong affiliation with neighbouring Holland, particularly when his father had always favoured racing in his home country. Max held a Dutch licence and had won national championships by the time he stepped up to international karting in 2010. At the age of 15 in 2013, he won the world karting title and was ready to move into Formula 3.

Although he would never win a major championship in any junior formulae, Verstappen's rise to Formula 1 was extremely rapid, such was his perceived potential. When he took part in first free practice for the 2014 Japanese Grand Prix as a prelude to a full-time seat with Toro Rosso the following year, Verstappen became the youngest driver to run during a Grand Prix weekend.

The records continued as his Grand Prix race debut in Melbourne in March 2015 established a benchmark for a driver aged 17 years and 166 days. Despite occasional questionable incidents that incurred the wrath of fellow drivers – one of whom branded him 'dangerous' – Verstappen carried off 'Rookie of the Year' and 'Personality of the Year' awards at the end of 2015. But none of these achievements would match what came next in such a meteoric career.

'I don't think I've changed. Of course, you get more experience and you experience more things in life. But, you know, my Dad always told me you have to try and be yourself because, at the end of the day, that's what people appreciate. And that's how they respect you.'

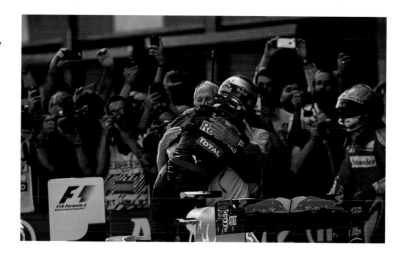

Toro Rosso was a 'B' team to Red Bull; a nursery slope for promising talent to prove their case for inclusion in the energy drink company's front-line attack on the championship. It was one thing to learn the ropes while racing mid-field with Toro Rosso; quite another to endure the white-hot heat of expectation at the head of the field. When the Russian driver, Daniil Kvyat, buckled under this pressure as Red Bull's second driver four races into the 2016 season, he was ordered to swap places with Verstappen by returning to Toro Rosso.

Given Red Bull's ruthless reputation, this may have seemed a very tough call - for both drivers – but Verstappen immediately grabbed the opportunity with both hands, qualifying fourth in Spain. He may have been assisted by the Mercedes drivers (and race favourites) taking each other out on the first lap, but

Verstappen withstood enormous pressure from the experienced Kimi Räikkönen to become the youngest driver to win a Grand Prix at the age of 18 years and 228 days.

Any charitable feelings Räikkönen may have had towards the young novice disappeared later that year in Belgium when they collided at the first corner and Max defended his lead with enough vigour to cause the normally phlegmatic Finn to claim Verstappen was going to cause "a huge accident sooner or later". Much of the mounting criticism was deflected at the end of the year by a spectacular drive in the rain in Brazil as Verstappen made a late stop and climbed from 16th to third. This was more than adequate justification for the many hours spent on wet Dutch days at an empty kart track as Jos coached his son on the finer points of car control.

Opposite top Red Bull's Helmut Marko greets Verstappen after his spectacular first Grand Prix win in Spain in 2016

Opposite bottom Verstappen quickly earned a reputation for taking his Red Bull to the limit – and sometimes beyond

Above Enjoying the winning moment. A familiar sight – ten times over – for Verstappen in 2021

There were two victories in 2017 but it seemed that neither these nor Verstappen's deft touch would count for much as his reputation continued to be mired in controversy – made worse by an insouciance that, for some critics, bordered on arrogance. He was involved in incidents in the first six races of the 2018 season, the most damaging in terms of lost points for Red Bull coming in Azerbaijan when a fierce fight for fourth with his team-mate, Daniel Ricciardo, resulted in a collision. Tension mounted further at Monaco when Ricciardo won the classic street race after Verstappen had made life difficult for himself by crashing during practice.

Despite nagging doubts among observers about an absence of the necessary consistency to become World Champion, Verstappen's self-belief and sense of calm remained resolute.

It all came together in 2021 when, for the first time, Red Bull produced a car that was competitive from the start of the season rather than, as had been the case, only coming together at its end. Lewis Hamilton, having always wished to have a fight on his hands, relished the battle as these two went head-to-head, the title being settled in a hugely dramatic last lap of the season. The pressure on each driver was huge but Verstappen, as had been his wont, simply shrugged it off to fully justify the belief and trust of a family born to go motor racing.

Index

Page numbers in *italics* refer to illustrations

Acknowledgements

This book is the brainchild of mainly myself and Lucy Warburton, emerging from discussion with the publisher about how to follow on from *The Pursuit of Speed* and make further use of the wonderful work of Cahier, *père et fils*. I would like to thank Paul-Henri for a continuing and thoroughly enjoyable collaboration as enthusiasm for this great sport took us on another absorbing journey.

I would also like to pay tribute to the team at White Lion Publishing for making everything come together so effortlessly – not always a given during the creation of a book such as this! And a word, too, for David Luxton who facilitated the project with his usual quiet professionalism and valuable support.

Finally, I am most grateful to Bernie Ecclestone for kindly providing the Foreword. Our discussion that day, as we reflected across the decades, provided a fitting reminder of why these World Champions are so special and why it has been a pleasure and a privilege to be a part of this book.

Maurice Hamilton

When Maurice Hamilton and Lucy Warburton came up with the idea of making a celebrative book for the 70th anniversary of the Formula 1 Championship, I was of course immediately on board! We had previously worked together on *The Pursuit of Speed*, which was a real success, and I knew that with White Lion Publishing we could produce another winner with such a great subject.

None of this would have been possible without the magnificent photographic work of my late father, Bernard Cahier, and I am forever indebted to him for having given me the chance to become a Formula 1 photographer myself, and our common work becoming what is known as The Cahier Archive, a one-of-a-kind photographic collection.

And finally, we had to find a suitable, knowledgeable person to write the Foreword, and when Maurice suggested Bernie Ecclestone, I knew we had found the right man. Who else today has seen all the World Champions actually race, and has known them personally? So thanks for that, Bernie, you're a pretty unique and amazing character.

Paul-Henri Cahier

First published in 2020 by White Lion Publishing, an imprint of The Quarto Group.
The Old Brewery, 6 Blundell Street
London, N7 9BH,
United Kingdom
T (0)20 7700 6700
www.Quarto.com

This revised and updated edition first published in 2021 by White Lion Publishing, an imprint of The Quarto Group.

Text © 2020, 2021 Maurice Hamilton
Photography © 2020 The Cahier Archive
Foreword © 2020 Bernie Ecclestone

All photography courtesy of The Cahier Archive with the following exceptions:
Front cover, back cover bottom middle left, 234–7 © Martin Trenkler; p. 15 © The Klemantaski Collection; p. 213a Clive Mason – Formula 1/Getty; p. 213b Mark Thompson/Getty

ISBN 978 1 78131 946 8
Ebook ISBN 978 1 78131 947 5

10 9 8 7 6

Design by Glenn Howard
Printed in China

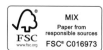

Brimming with creative inspiration, how-to projects, and useful information to enrich your everyday life, quarto.com is a favourite destination for those pursuing their interests and passions.

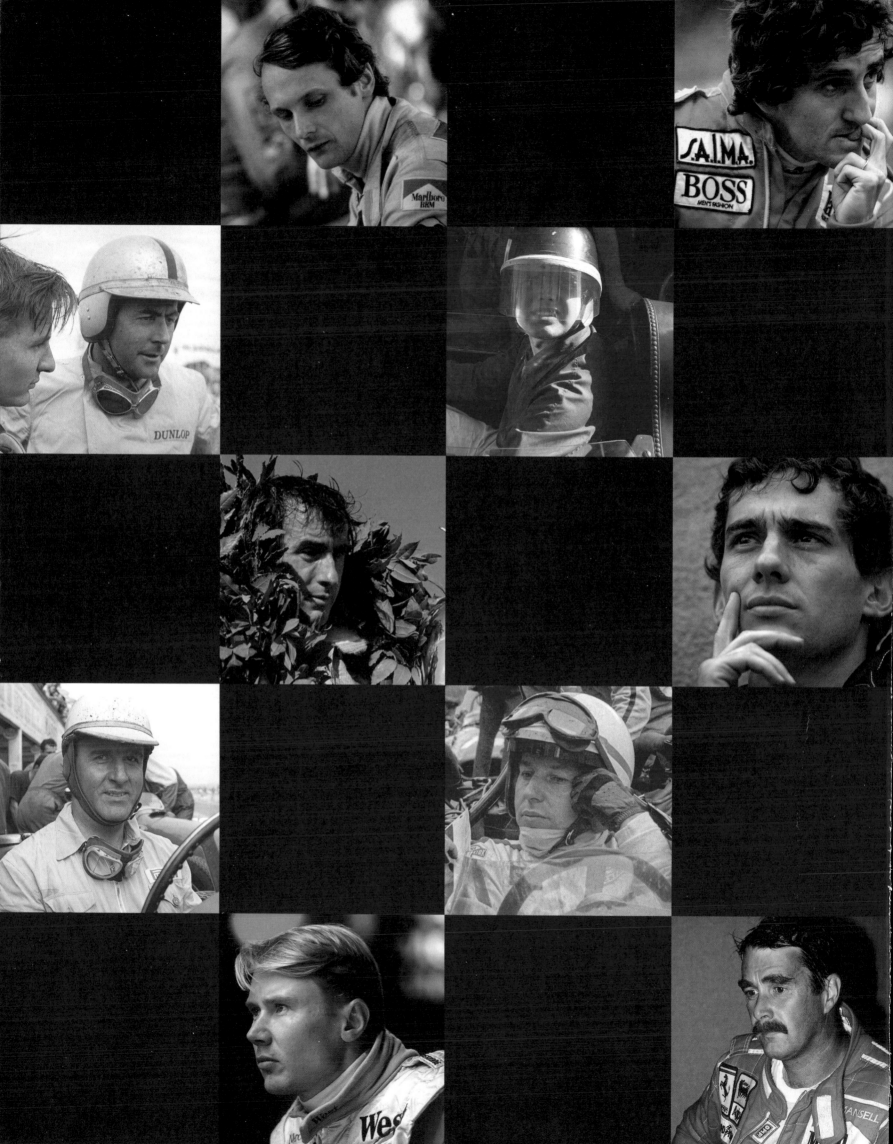